1 MONTH OF
FREE
READING

at

www.ForgottenBooks.com

By purchasing this book you are eligible for one month membership to ForgottenBooks.com, giving you unlimited access to our entire collection of over 1,000,000 titles via our web site and mobile apps.

To claim your free month visit:

www.forgottenbooks.com/free94690

ISBN 978-0-265-45890-7
PIBN 10094690

For support please visit www.forgottenbooks.com

CATALOGUE

OF THE

ROYAL UFFIZI GALLERY

IN

FLORENCE

FLORENCE

EDIT. BY THE COOPERATIVE PRINTING ASSOCIAT.

Via Pietrapiana. N.° 46

1897.

INDEX

PART THE FIRST

Sculptures.

PART THE SECOND

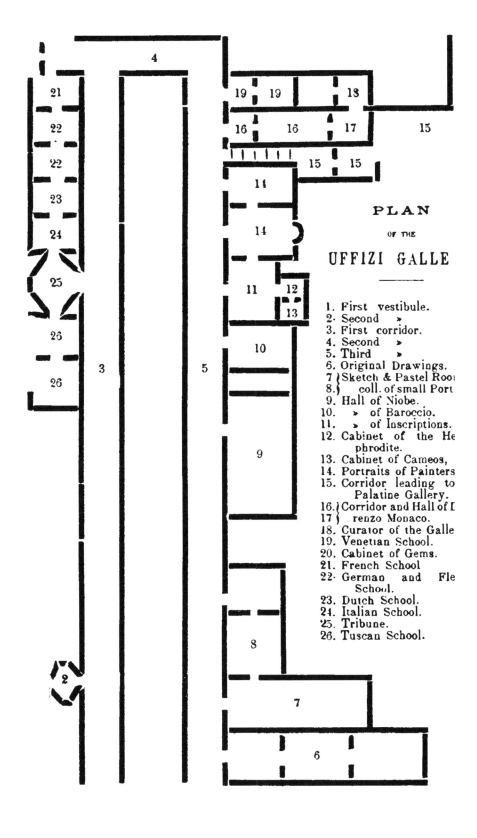

PLAN

OF THE

UFFIZI GALLE

1. First vestibule.
2. Second »
3. First corridor.
4. Second »
5. Third »
6. Original Drawings.
7. {Sketch & Pastel Roo
8. } coll. of small Port
9. Hall of Niobe.
10. » of Baroccio.
11. » of Inscriptions.
12. Cabinet of the He
 phrodite.
13. Cabinet of Cameos,
14. Portraits of Painters
15. Corridor leading to
 Palatine Gallery.
16. } Corridor and Hall of I
17. } renzo Monaco.
18. Curator of the Galle
19. Venetian School.
20. Cabinet of Gems.
21. French School
22. German and Fle
 School.
23. Dutch School.
24. Italian School.
25. Tribune.
26. Tuscan School.

Rules for Artists.

Native Artists may get free admission to the Galleries, Museums, etc., by showing a document from one of the Royal Academies of the State, attesting their qualities.

Foreign artists only need to be introduced or recommended by their Consuls.

To make copies an introduction is necessary from one of the directors or presidents of our public Schools of art or Academies.

List of public Galleries, Museums, &c.
to be visited in Florence.

Entrance Fee	For grown people	For children
Uffizi Gallery (Uffizi Lunghi)	L. 1,00	L. 0,50
Palatine or Pitti Gallery (Piazza de' Pitti)	» 1,00	» 0,50
Ancient and Modern Gallery (Via Ricasoli,54)	» 1,00	» 0,50
Buonarroti Gallery (Via Ghibellina, 64 .	» 0,50	» 0,25
National Museum (Via del Proconsolo, 2).	» 1,00	» 0,50
Archæological Museum) (Via della Co- Gallery of *Arazzi*) lonna, 26) . .	» 1,00	» 0,50
Museum of St. Marco (Piazza S. Marco, 1)	» 1,00	» 0,50
Gallery of works in pietra dura (Via degli Alfani, 82)	» 0,50	» 0,25
Medicean Chapel (Piazza Madonna) . . .	» 0,50	» 0,25
Cenacolo di Foligno (Via Faenza) . . .	» 0,25	— —
Cenacolo by Andrea del Sarto (San Salvi).	» 0,25	— —
Cenacolo by Ghirlandaio (Borgognissanti, 34)	» 0,25	— —
Fresco by Perugino in the Convent of St. Mary Magdalene de' Pazzi (Via della Colonna, 1)	» 0,25	— —
Cenacolo di S. Appollonia (Via Ventisette Aprile	» 0,25	— —

The Buonarroti Gallery is never visible on fête days, and is open from 9 to 3 on other days. The admission

is free every Monday and Thursday. — All the other
Galleries, Museums, etc., are open daily from 10 to 4,
with the exception of the following fête-days:

1. New year's day.
2. Epiphany.
3. The King's birth day.
4. Easter.
5. Ascension-day.
6. Corpus Domini.
7. National fête-day.
8. St. John's day.
9. St. Peter and Paul's day.
10. Assumption.
11. XX September.
12. All-Saints day.
13. Immaculate Conception.
14. The Queen's birth day.
15. Christmas day.

On all other fête-days the admission is free. The
Cenacolo by Ghirlandaio and the Fresco by Perugino
are only open from mid-day to 4.

THE UFFIZI GALLERY

The Uffizi Gallery was founded and unceasingly enlarged by the Medici. Although originally engaged in trade and industry, this family, even before it obtained the supreme power in Florence, did all in its power to encourage and foster the fine arts, science and literature. The first of the Medici who collected at his own expense pictures and sculptures with which to adorn his private mansions and the city of Florence, was Cosimo of Giovanni, of Averardo, known as *Pater Patriæ*. His example was followed by Lorenzo the Magnificent, the first Grand-Duke Cosimo I, and the son of the latter, Francesco I. It is to Francesco that we may really attribute the formation of the Gallery. He took advantage of the great building which Cosimo I had projected to lodge all public offices; of which the foundations had been laid on Giorgio Vasari's plans in 1500. This building, Doric in style and rectangular in form, has

porticoes where it starts from Palazzo Vecchio, ends at the Loggia d' Orcagna and is crowned by a terrace that runs along all three of its sides. It appeared to Francesco that the terrace on the eastern side of the palace, once it were shut in, would be a fitting place to receive the pictures, sculptures, and other artistic wealth that his ancestors had accumulated at their own expense, and which were now scattered among the various mansions of the family. He therefore entrusted the architect Bernardo Buontalenti with the duty of transforming the terrace into a gallery. Buontalenti executed his work well: he ornamented the place with marbles, had the ceiling painted by first-rate artists, and built other rooms on to the corridor, notably the octagonal one known as the *Tribuna,* which is paved with rich marbles and roofed by a dome inlaid with mother-of-pearl.

Ferdinand I, successor to Francesco I, still further enriched the gallery: he it was who bought in Rome the Venus known as the Venus of the Medici, the work of Cleomenes son of Apollodorus. The Grand-duke Ferdinand II caused the southern and western arms of the terrace to be covered in, thus adding two new corridors to the gallery. He also enriched it with many new treasures, among which should be specially mentioned the very interesting collection of cameos and gems. In this he was materially helped by the advice of his brother, the cardinal Leopold, to whom we owe the collection of drawings by old masters, and the beginning of that unique collection of portraits of Italian

and foreign artists painted by themselves, to
. which additions are still being made.

Ferdinand II had a worthy successor in Co-
simo III, who, besides buying medals and other
antiquities, caused many sculptures to be removed
from the Boboli Gardens to the Gallery, and
enriched the Tribuna with the celebrated statues
of the Venus of the Medici, the Knife-grinder,
and the Wrestlers bringing them from his villa
at Rome. After the death of Giovanni Gastone,
last of the Medicean Grand-dukes, the Electress
Palatine Anna Maria Luisa dei Medici, his sister
and heir, bequeathed to Tuscany both the real
and the personal property which she had inherit-
ed (including, of course, the Gallery, pictures, sta-
tues, libraries, gems and other precious objects),
on condition that the rulers of Tuscany should
preserve things as they then were, and should
not remove from the Capital anything destined
for public use.

The substitution on the throne of Tuscany of
the house of Lorraine for that of the Medici
did not interfere with the preservation and
growth of the Gallery; for Francesco I enriched
it with antiquities of great price, and Peter
Leopold I, who succeeded him in 1765, continued
the work of his predecessors, accumulating in
it all the good paintings which were scatter-
ed here and there in the public offices. He
restored the western corridor, 57 metres of which
had been injured by fire, built new rooms, and
threw open the Gallery to the public.

Little was done during the reign of Ferdi-
nand III, on account of the political troubles

which disturbed Europe at the end of last century and the beginning of this. But Ferdinand's son, Leopold II, extended the Gallery by building an immense hall to receive the Greek statues, illustrative of the Niobe myth, which cardinal Ferdinand dei Medici, afterwards Grandduke, had bought to adorn his villa on the Pincio at Rome. Under Leopold II, too, the collection was enriched by the addition of 900 objects excavated in Thebes and Abydus; and the valuable collection of engravings was partially put into order. When, in 1859, the Grand-ducal government came to an end, and Tuscany was incorporated in the Kingdom of Italy, the new Government continued to enrich the Gallery with works of art and to improve the *locale*. In the first place a rational arrangement was attempted of the works of art, which had hitherto, it must be confessed been in a state of some confusion; and means were also sought of exhibiting to the public at least a part of those pictures etc., which, for want of space, were heaped up in the store-rooms. This was rendered possible by the founding of the National Museum in the Palazzo Pretorio; to which, in 1864, were sent the bronzes of Cellini, Donatello, Ghiberti and Giambologna, as well as the sculptures of Benedetto da Rovezzano and of Verrocchio, together with some basreliefs of Luca della Robbia. And in 1866, still with object of extending the exhibition of the works of art, it was resolved to open to the public that part of the corridor built by Cosimo I after the plans of Vasari, which, starting from the Uffizi Gallery, is carried

over the Arno by the Ponte Vecchio, and thus
joins the Uffizi with the Pitti Gallery. In this
corridor a great number of drawings were ar-
ranged, a quantity of beautiful tapestries, some
sketches by famous painters, and a collection of
pictures of birds, quadrupeds, fishes and flowers
painted in distemper by Bartolommeo Ligozzi.
Later on, when the Archæological Museum was
opened, the tapestries, to which many others
were added, were carried thither, and arranged
on the top floor, thus forming a special gallery;
the drawings were placed in glass cases along
the first and third corridors of the Uffizi Gallery;
and Ligozzi's paintings were removed to the
Natural History Museum. A series of portraits
of the Medici, of noble Florentines, of men of
science and of other famous personages filled
up the space thus left empty in the corridor
which connects the two Galleries. Even so,
however, there was not sufficient space to exhi-
bit many works of art which still remained in
the store-rooms now to order those already
exhibited on any reasonable principle. Many
plans were therefore considered for increasing
the *locale,* and it was proposed to erect a large
building in which to collect all the objects from
the galleries and museums, disposing them in
logical and rational order; but financial reasons
hindered the execution of this project. It was
then thought that the Medicean theatre, under-
neath the Gallery, might be turned to account.
In 1865 this theatre had been transformed into
a hall for the meeting of the Senate, Florence
being at that time the provisional seat of the

Italian government; and it was now suggested
to incorporate it with the Gallery. Plans, di-
viding into ten large rooms, were placed before
the Minister of Public Instruction, and speedily
approved. In the year 1890 the work was begun,
and the new halls will be finished as soon as
possible, thus rendering it practicable to arrange
worthily and reasonably the precious collection
of paintings that belongs to this Gallery.

PART THE FIRST

ANTIQUE SCULPTURES, GEMS, CAMEOS, ETC.

On the Stairs.

Some busts of a fine style.

Bacchus. A marble statue. Similar to that which is seen in the Museum in Rome, except that the stagskin which hangs from his shoulders and the position of his left arm is different. The pedestal is antique, and bears an inscription still in a good state of preservation.

First Vestibule.

Here the busts are collected of the various princes who have contributed to the Gallery or have later enriched it. Some of them are in porphyry, and were carved by means of a certain kind of very hard tempered steel, obtained by a special method, which is said to have been invented by Cosimo I, just for this purpose,

in the year 1555. *Battista del Tadda* a Faesulan sculptor was the first to employ this, and the secret was then revealed to Raphael Curradi, who, after the model of Orathius Mochi, a pupil of Caccini, sculptured the bust of Cosimo II which is also here.

The Latin inscriptions which are on the base of each bust to indicate the role of the different Tuscan rulers in the formation and successive increase of the Gallery, were composed by the Abbot Lanzi, with the exception of that which is under the portrait of Leopold II, written by the Comm. Jean Grysostomus Ferrucci.

I. *Lorenzo il Magnifico*, in marble.
II. *Cosimo I*, in bronze.
III. *Francesco I*, in marble.
IV. *Ferdinando I*, in porphyry.
V. *Cosimo II*, in porphyry.
VI. *Ferdinando II*, the head alone, in porphyry.
VII. *Cardinale Leopoldo*, in marble.
VIII. *Cosimo III*, in marble.
IX. *Gio. Gastone*, in marble.
X. *Ferdinando III*, in marble.
XI. *Leopoldo II*, in marble.
XII. *Vittoria della Rovere*, in marble.
XIII. *Magdalene of Austria*, in marble.

STATUES.

2. **Mars Gradivus,** a bronze statue larger than life. The figure is nude, with a helmet on its head, a stick in its right hand and a sword in its left. — It was taken from Rome, in 1788.

3. **Silenus** holding a little Bacchus on his arm: a group in bronze; an old cast from the original, which is kept at Rome in the Villa Pinciana.

This copy was brought from Rome in 1788. An ancient group similar to this, but in marble, is in the Louvre Museum at Paris.

Second Vestibule.

16, 17. **Two quadrangular columns** in marble, which seem to have been raised to celebrate the exploits of the personage to whom they were dedicated. They are all covered with carved figures of ancient arms of all kinds, musical instruments, flags, portable altars and in short every sort of old warlike utensils used in battles by sea or by land, or for religious purposes when marching or resting on battle fields. The carvings of these columns are quite in Roman style, but the form of the objects represented is Greek, and may be interesting to those who apply themselves to the study of ancient arms.

18. **A marble horse** (life size). It has been supposed to belong to the group of the Niobe family but it was discovered in a different place.

19. **A marble boar** (life size). Of this fine Greek work a copy is kept in the Louvre Museum, and another one in bronze made by Tacca adorns the fountain before the portico of Mercato Nuovo, in Florence.

20· **Apollo**, a statue larger than life. Holding a torch in his hand and looking upwards. The torso and right leg, which are the only ancient parts of it, have been spoiled by a modern attempt to restore it (perhaps with the intention of changing it, into a Prometheus, kindling his fire at the sun).

21. **Adrian** (larger than life). The simple and noble style of the drapery of this statue is particulary worthy of remark.

22. **Trajan** (larger than life) is clad in the armour proper to the Roman emperors. The cuirass is rich in ornaments of a most exquisite stile. It was brought from Rome, in 1789.

23. **Augustus,** haranguing (larger than life), holds a volume in his left hand; his drapery is exceedingly fine and minutely carried into detail, but not quite natural. The head is modern.

24, 25. **Two dogs** (life size).

26 to 33. **Eight busts,** five of which are of men and three of women.

34. Above the entrance-door, a bust of the *Granduke Peter-Leopoldo,* by Carradori.

First Corridor.

STATUES, BUSTS AND SARCOPHAGI.

37. **Pompeus.** A bust in marble (life size). He was son of Pompeus Strabo, being born in the year 648 A. U. C. and dying at the age of 59.

38. **Hercules killing the Centaur Nesso.** A marble group (life size). Hercules stands wearing his lion skin and *parazonius* on his left arm, with which he grasps the right arm of the Centaur, while he is catching hold

of his hair with the other. The expression of pain seen on the monster's face is very remarkable.

The Hercules and the head of the Centaur are modern.

39. **The different epochs in the life of a hero.** A sarcophagus in marble. On the left side *the birth* is represented. The mother is sitting, looking at her child, who is held over a basin by its nurse. It is nude and looks up at a globe placed on a little column, on which Urania foretells the destiny of the newly born, while another woman is stretching her right hand to the globe, and holding a volume in the left. *The education* of the child is then seen. He is clad in a tunic, in the act of reading from a book, held before him by his tutor. A woman stands behind, bearing a tragical mask in her right hand. The fore-part of the sarcophagus represents *the wedding.* The cloth stretched behind the figures shows that the ceremony takes place in a room. The bride-groom is dressed in a *toga* holding a scepter in one hand, and the right hand of his bride in the other. The bride is veiled in the *flammeum.* Juno stands behind, placing her hands on their sholders. Hymen is waving his torch, and a woman is seen standing by the bride and an old man by the bridegroom. *A sacrifice* is shown in the fourth bas-relief. The sacrificer, dressed in a tunic, stands before a temple, holding a palm in its left hand, and with the other pouring a liquor from a goblet (*patera*) on to an altar. Two attendants half naked, one of whom kneeling, keeps the head of a bull bent, while the other lifts his poleaxe to kill the animal. Behind the altar stands a player of a double flute (*tibia*). The fifth composition represents the hero after a victory. He stands on a stone, dressed in a tunic and mantle (clamys) in a field, followed by the personification of Victory. A nude boy and a woman dressed in a tunic are before him in a suppliant attitude ; behind them stands a soldier with lance in hand. Then a *hunting party* is represented, by an elderly man mounted on a horse and bearing a spear in his right hand, followed by another on horse-back equally armed ; two hounds run before them towards a wild boar standing by a rock. The last section con-

tains the figure of the hero in old age, sitting at a door, clad in a cuirass, and holding a long spear. A soldier kneeling takes off one of his greaves; the other having been already taken off is seen lying on the ground with two shields. Another soldier is standing with a sword unsheated in his hand. At the back of the sarcophagus the following inscription is written: « ROMANUS ROMULUS. »

40, 42, 47. Three busts representing **Augustus** in different ages. The number 40 however has exactly the features described by Suetonius. The hair is a little crisp, the brows are thick and meet; the ears are small and well shaped; the nose is prominent and slightly hooked.

41. **Julius Caesar.** A bust with a bronze head. Its features are very like those of this emperor in the most authenticated medals, but the antiquity of this bust is however doubtful. Julius Caesar was born in Rome in July, 654th A. U. C. 100 years before the Christian era. He was the son of Lucius Julius Caesar and Aurelia and was not only a great warrior but was also a great promoter of the fine arts, and several of the ancient Roman Museums were founded by him. This bust may have been made before he obtained from the Senate the privilege of wearing the laurel crown; a privilege which was the dearer to him (as they say), because it served to hide his baldness which he much disliked to show in public.

43. **Julius Caesar.** Another bust in marble. The antiquity of this one is certain.

44. **Atys.** A statue larger than life. A modern restorer intended to change it into a barbarian king; its torse however, which is old, clearly indicates its primitive subject.

45. **Proserpine,** the daughter of Jupiter and Ceres ravished by Pluto. **A sarcophagus.** At the two extremities are two personifications of Victory bearing flowers and fruits in the folds of their dresses, which they spread like aprons before them. Between them,

to the left, is a figure of Mercury, naked, except his shoulders which are covered by a mantle (clamys). He bears the *caduceus*, and holds the reins of Pluto's horses, gallopping over a figure lying with the *cornucopia* in its left hand, representing the Earth. Above is a flying cupid, holding his torch. Pluto is in his chariot and holds the desolate Proserpine with both his arms bound. Minerva stands before him and seem to reproach him, while three girls stand by her near an altar, one of them holding up Minerva's shield before the goddess, in order to calm her. Then Ceres is figured, with a torch in her left hand, on a chariot, dragged by serpents : a man follows the chariot, beneath whom a woman is lying, her elbow leaning on a *crater*. On the left side of the sarcophagus is Mercury, leading a veiled woman to Hades ; on the right, Hercules calling another veiled woman out of the tartarean gates. — This sarcophagus belonged to the Michelozzi family, who purchased it in 1787.

46. **Livia**, a bust. This princess who possessed an extraordinary beauty and wit but a corrupt heart and mind, was the daughter of Livius Drusus Callidianus, a descendent of the illustrious family of the Claudiuses. Several provinces honoured her by coining medals to her with the adulatory titles of *Mater Patriæ* and *Genitrix orbis*, which Rome never granted to her.

48. **Marcus Agrippa**, son in law of Augustus. The head of this bust is splendid and wonderfully represents what Tacitus narrates about this illustrious man.

49. **Julia**, daughter of Augustus was first the wife of Agrippa and then of the emperor Tiberius. She possessed the most admirable beauty, and Domitianus had her represented in the form of a goddess. This bust and that of Agrippa belong to the best epoch of the Roman sculpture.

50. **Tiberius**, was born in the year 712 A. U. C. (42 A. D.), and was the son of Tiberius Claudius Nero and Livia. This bust appears to have been made in the first years of his reign, as his dissolute, cruel, and turbulent life, while he was on the throne, altered his

look entirely and his face was all spotted with blains in his latter years. He died at the age of 78, having reigned for 22 years.

51. **The god Pan with the young Olympus.** A marble groop (life-size). The whole figure of Olympus is modern, and the right arm of the satyr is partly restored. — Come from Rome in 1788.

52. **Athlete.** A statue (larger than life). He is naked, except his left arm wrapped in his clamys or *ephaptides*, which hangs from it. The head is a little turned to be right, and the arm raised. The half of this is modern.

53. **Antonia**, a bust. She was a daughter of Marcus Antonius and Ottavia the sister of Augustus and mother of Claudius. The sculptor has perfectly succeeded in representing in this bust, by a remarkable sweetness of features and modesty in the expression of the eyes, the well known merits of this matron, whom Caligola himself honoured with the proud title of Augusta, granting to her the honours due to Vestals.

54. **Drusus**, was a brother of Tiberius: his life was glorious but short, as he died at the age of 39, in consequence of a fall from a horse.

55. **Agrippina.** She was the wife of Germanicus and mother of Caligula. The high and noble feelings which adorned the mind of this virtuous empress, are well expressed in her features.

56. **Hippolytus.** The front-side of this sarcophagus is divided into two parts by the pillar of a gate, and represents two different subjects, one of which is the temptation of Hippolytus; the other is Hippolytus hunting a wild boar. The first part bears the figure of Phaedra, sitting among some girls, one of whom is tearing her own hair, and another one bears a volume in her hands; a young cupid is before her holding his torch in his right hand and his quiver in his left. The old nurse is speaking to Hippolytus, but he turns his back upon her. He wears a *clamys* and holds a spear in his left hand. Behind him is a hunter standing with his right arm placed on the neck of a horse,

and his left grasping a spear. Another hunter follows him, with two hounds. Beyond the pillar is Hippolytus naked, on horse back, accompanied by another horseman; both followed by Diana, hunting a stag. Then Hippolytus is seen hunting a wild boar. On the right side of the sarcophagus Hippolytus is represented in the act of making a drink offering to Diana, by pouring a liquor on a fire kindled upon an altar. On the other side is a hunter holding a hound by the collar.

57. **Drusus**, a bust. He was the son of Tiberius and Vespania Agrippina: he was assassinated by his own wife Livilla.

58. **Victory**, a life size statue. She wears a tucked dress, loose on her shoulders, one of which is uncovered. Her mantle is gathered on her left arm; her head is diademed; her right hand is raised and holds a laurel crown; while the other bears a palm. This statue has no wings, and this shows that it was made in the epoch when the Roman armies were already victorious everywhere, so that Victory could no longer fly from them; just as an Italian writer once said, about a statue similar to this, which a thunderbolt had deprived of its wings: « *Roma, regina delle Nazioni, il tuo nome sarà immortale; la Vittoria non può fuggirti* (1). » — The right arm, the left hand and the neck are modern. It was given as a present to Francis I of the Medicis by Card. Lezio.

59. **Athlete.** Life size. He is naked and standing. He has a vial in his arms, looking at it stedfastly. His right leg is leaning on the trunk of a palm-tree, from which some dates are hanging. — Both arms have been mended.

60. **Caesar Britannicus**, a bust. He was the son of Claudius and Messalina, and brother to Nero, who had him poisoned after having deprived him of his rights to the throne.

(1) O Rome queen of nations, thy name is immortal, and Victory can no longer fly from thee.

61. **Caius Caesar Caligula.** The perfidy and cruelty of this emperor's mind are well expressed in this bust, which is so much more precious as the tribune Cassius Cherea who delivered Rome from this tyrant, ordered all his statues, busts and medals to be destroyed, in order to disperse any record of his disgraceful reign.

62. **The Dioscures.** Sarcophagus. It is related that Ida and Lynceus sons of Anphareus of Messenes were the lovers of Thebea and Ilaria daughters of Leucippus. Castor and Pollux sons of Jupiter (the Dioscures) also fell in love with them and ravished them; whence the hatred among the pretenders. This is the subject of this sarcophagus. The two corners of its front side are decorated with two personifications of Victory. Between them the rape of Leucippus' daughters is represented as follows: Each one of the Dioscures bears his beloved on his shoulders; they are both naked or simply clad in their *clamides*. One of the girls, dressed in a tunic, presses her right hand on her ravisher, striving to escape from him, while a woman runs to help her. The other girl is grasping her mother Philodices' mantle trying to detain her who is flying away with her husband. All these people are pursued by Ida, Amphareus' eldest son, who is rushing after the rival of himself and brother; but Lynceus prudently tries to stop him by opposing his shield to him. The left side of the sarcophagus bears the figure of a naked man with clamys, and a woman whose hand he holds. Behind this is an urn upon a pedestal. A curtain is spread behind the figures. On the other side is a man standing, with his left hand upon an altar; a woman stands by the opposite side of the altar, laying her right hand upon it. Behind her is an urn upon a pillar. — This sarcophagus has been mended in differente parts. It was brought from Rome in 1788.

63. **Valeria Messalina,** a bust in alabaster with marble head. This empress was the wife of Claudius and is famous on account of her licentiousness and cruelty. Tacitus has described her life and tragical death.

64. **Claudius.** The dulness and poverty of soul of

.this emperor, which rendered him despicable to every body, and of which he was himself the victim, are well expressed in this bust. His reign lasted 13 years and 20 days.

65. **Claudius Domitianus Nero**, a bust in basalt. This tyrant reigned 13 years and 8 months.

66. **Faun**, a statue. He is standing and crowned with vine-leaves and ivy, and is looking at a bunch of grapes which he holds in his right hand. A little panther is at his feet, with one of its paws around the trunk of a vine. The right arm and the neck are modern.

67. **Atlete**, a statue larger than life. He holds a small lance high in his left hand, while he keeps a wand in the other, partly wrapped in a cloth. His right leg is leaning on the trunk of a palm-tree. — Both the arms and a part of the left leg are modern.

68. **The Labours of Hercules**, a sarcophagus on which eight different subjects are represented. The first is the slaughter of the Nemeian lion. Hercules is naked, crowned with vine-leaves, and drags the dead lion along on the ground. The second is the fight of the hero with the hydra of Lerna. He holds his club high in his right hand, and with the other he presses one of the four serpents springing from the head of the hydra. The third is Hercules bearing the wild-boar of Erymanthus on his shoulders : under the head of the beast Eurystheus half hidden in the bronze Dalius is lying, with his hands raised. In the fourth composition the hero is naked, and grasps the horns of the Cerinean hind, pressing at the same time its back with his knee. In the following one he is bearded, and darts his arrows against the Stymphalides, one of whom has already fallen dead ; the other is wounded. The sixth group represents Hercules also naked and armed with his club, in the act of taking away the girdle from the waist of Hyppolita, the queen of the Amazones, who is lying down on her shield. Then he is seen again, clad in his lion skin, his right hand raised and his left grasping the club. Above his left shoulder a spring

of water is falling from a rock. This is supposed to represent the cleansing of the Augean stables. The last group which is on the left extremity of the urn, represents Hercules vanquishing the Maratonean bull. The hero is nude and grasps the left horn and the right leg of the beast, while he keeps his left foot upon the head of a horse. Another horse of which the head and fore-legs alone are visible is lying a little aside. These two animals signify Hercules' victory over Diomede's horses. This sarcophagus has been mended in several parts.

69. **Poppea.** She was Nero's wife or mistress; the finest woman in her time, as may be seen from the delicate features of this bust.

70. **Nero**, a bust. Its modelling is remarkably good, as well as its expression of the perfidy and cruelty of this emperor who so soon forgot his own *utinam nescirem*. His hair is divided into curls, after the fashion he had taken from Grece, as Suetonius relates.

71. **Nero** in his childhood. Its countenance is sweet and quite different from the aspect represented in the other bust. This is rightly considered one of the most precious in the collection.

72. **Galba.** This bust is a clever work, but rather defective as a representation of his moral character. This emperor reigned six months, and therefore his busts are rare. He was killed in a mutiny raised by his rival Otho's friend, and his head was cut from his body and sold to a freed slave (*libertus*) who bought it in order to insult it before the tomb of his master whom Galba had caused to be executed.

73. **Hercules labours.** A sarcophagus similar to N° 68.

74. **Pomona.** A nimble figure, the head of which is crowned with fruits and ivy. A part of its gown is lifted by both hands, and full of grapes and different kind of fruits. The hands, feet and part of the gown are modern.

75. **An Athlete.** Similar to the Nʳ 52, 59. The hands have been mended in several parts.

76. **Julia.** Titus' daughter and wife of Flavius Sabinus. Domitian, her uncle, having fallen in love of her, had her husband killed and repudiated his own wife, in order to marry her. — The head alone.

77. **Otho,** a bust. He succeeded Galba on the throne of Rome, but Vitellius was almost at the same time elected by the legions he led in Germany, so that a civil war arose and the two competitors met with their armies in France and then in the valley of the Pò where forty thousand people died in one battle, to support the ambition of two men. The day after that awful havock Otho killed himself in order to stop the civil war, as te best historians affirm, so that his death was lamented by his subjects, and his name was honoured. He held his scepter not longer than three months, and died in 69 A. D. aged 37. He was quite bald and wore a small round wig, with short and crisped hair. — As to the artistic value of this bust, Winckelmann says it is one of the finest ever seen.

78. **A sarcophagus** decorated with various figures of Nereides, Tritons, Delphins, and winged cupids, carrying baskets full of fruit and flowers. The natural grain of the stone being bluish here and there seems to imitate the sea waves.

79. **Julia,** Titus' daughter. This bust is admirably well done and preserved.

80. **Vitellius.** This bust corresponds exactly to the description of this emperor's aspect left by Suetonius, and gives a perfect idea of his famous addiction to gluttony and every excess in banqueting.

81. **Urania,** or perhaps *Geometry* or *Astronomy,* after the modifications which it must have undergone in various restorations. Its very clever and fine drapery renders this statue most remarkable. Its size is a little larger than life. The right arm and a half of the left one, as well as the feet and the hem of the garment are modern.

82. **Ariadne,** a statue larger than life. She is crowned with laurels and vine leaves, and holds a bunch of grapes

in her right hand. Her left foot rests upon a part of a tripod which stood once by her side. This statue is much similar to one in the Museum at Rome, which is now called a Ceres, since a bundle of ears has been put in her hand, in a recent restoration. The two arms and a part of the neck are modern.

83. **Julia,** Titus' daughter. The head alone.

84. **Sarcophagus.** Sea deities, two of which are supporting a shield which was probably destined to bear an inscription.

85. **Vespasianus.** The head is carved with admirable skill and its lineaments well represent the magnanimity of this emperor. His forehead is wrinkled, the eyes are rather hollow, but not stern looking, the nose is hooked, the face oval, and in short his physiognomy bears an expression of great dignity, in every part. His reign lasted ten years.

86. **Domitia,** wife of Lucius Elios Lamia, a Roman senator, and then of Domitianus. The dressing of her hair is that which they called *galericula,* on account of its resemblance to a helmet. This bust also is precious. as a work of art.

87. **Titus,** son of Vespasianus. The majesty, beauty, greatness of mind and benevolent disposition which characterized this prince and caused him to be a lasting source of happiness to the whole civilized world, are cleverly expressed on this precious piece of marble. Of his busts several copies have been repeated, but they are nevertheless rare, because of the short duration of his reign, which did not last longer than two years and two months.

88. **Ganymedes.** The size of the figure is as large as life, but the eagle with which it is grouped is rather gigantic. The work is fine but its artistic value is not easily perceived on account of many spots in the marble. — The head, and arms, and also a part of the eagle are modern.

89. **Sarcophagus.** *The nine Muses with Apollo.* It is much wasted by age. — Clio, crowned with laurel

bears a volume and a trumpet; Erato, crowned vith flowers, the double pipe and a mask, Calliope, a volume; Urania a sphere; Melpomene is to be recognised from the mask and club she holds, according to what Aristophanes says, that Tragedy was sacred to Hercules; Apollo, almost naked, stands by her left side, with his tripod and snake; then Euterpe comes and then Therpsicore. The following one leaning at a column is very likely Thalia. The last one is Polymnia.

90. **A Vestal.** The base bears the name of Lucilla. She is holding a cup in one of her hands, while the other is stretched towards the sacred fire placed by her right side. Her face has a pleasing expression of modesty and her figure is noble and beautiful. Her attitude is like that of the vestals seen on medals. Her hair is dressed under a veil, and this might put an end to the dispute held among the archaeologists, whether the Vestals used to let their hair grow again after having had it cut. The celebrated Lanzi supposes it to be a Plautina. The state of preservation of this statue is remarkable. Its left hand alone and the fingers of the right have been restored.

91. **Domitia**; a bust not so fine as N. 86.

92. **Dcmitian.** This bust does not represent that expression of a strong mind and that beauty which is seen in some medals; which may be caused by having tried to restore it after another bust of this emperor, not authentic.

93. **Nerva.** His nobility of mind, by which he was raised to the throne of Rome, is well shown in this bust. It is a little larger than life.

94. **Domitia.** A bust little larger than the other two of this empress: N. 86 and 91.

95. **Sarcophagus,** on which the *Chase of Meleager* is represented. This subject is repeated on several Etruscan sarcophagi. It was probably chosen as an allusion to the extinction of the flame of life or to commemorate the exploits of a hero. Meleager was the son of Oeneus king of Calidonia and nephew of Elimus king of the

Tyrrenians. A monstruous boar which used to waste Anceus' vineyard was killed by him, with the help of Theseus, Jaso, Pirithous, Castor, Pollux and the nymph Athalanta. She wounded it and Meleager killed it by a second wound on its shoulder, and then gave its skin to Athalanta as a trophy. Pisippus and Theseus, brothers, to Althea and uncles to Meleager, indignant at seeing such an honour paid to a girl, robbed her of the skin, whereupon Meleager killed both, and married Athalanta, by whom he then had a son whose name was Parthenope. Altea became mad, when she knew of the death of her two brothers, of which she revenged herself on her own son, by throwing on the fire the fatal brand on the perseveration of which Meleager's life depended. The hero felt his entrails burnt, as soon as the brand was on the fire, and expired when it was reduced to ashes. The basrelief on the left side of the sarcophagus represents a monument to Meleager.

96. **Trajan.** This bust is the finest of the three of this emperor in this gallery. He was born at Italica in Spain and was the first foreigner raised to the throne in Rome. Under his empire which lasted nineteen years and six months many Spaniards settled in Rome, thus filling the void left by the dispersion of several Roman families under Nero and Vespasian.

97. **The Muse Calliope.** Several parts of this statue are modern, viz, half of the right arm, the left hand, and the feet with all the lowest part of the figure.

98. **Trajan.** A bust. Smaller than life.

99. **Hercules.** The pedestal is antique and the subject on it analogous to the exploits of this hero. This statue was made to stand isolated. It is one of the best copies of the famous Hercules by Glyco (*Ercole Farnese*). The head is very expressive and the torso is fine and very well preserved. Pausania speaks of a statue similar to this, which existed in Attica. In a medal of Massimianus is also a figure of Hercules much resembling this. Both the arms are modern. This statue was sent from Rome to this gallery in 1788.

100. **Marciana,** sister to Trajan.

101. **Trajan,** a colossal bust.

102. **Marciana,** another bust.

103. **Plotina,** the wife of Trajan, This empress was very modest and this perhaps the reason of her busts being very rare. This one is also a splendid work of art.

104. **The Muse Polyhymnia,** entirely wrapped in her mantle. The drapery is fine but not very carefully carved. The hand is new.

105. **Sarcophagus.** *The case of Meleager,* very similar to N. 95.

106. **Mercury.** A statue larger than life. His right leg is leaning on the broken trunk of a palm; his right arm is raised with a purse in the hand; the other hand is modern.

107. **Matidia,** daughter of Marciana, niece of Trajan and grand mother of Adrian. This bust has not a great artistic value, and has been much restored.

108. **Adrian.** The head is fine; the hair is carefully dressed and the beard is long and thick, which was very uncommon in that time and is said to have been used by this emperor in order to hide some scar he had on his cheek. This bust is splendid and affords a good idea of the state of the Art under this emperor.

109. **Adrian.** Another bust representing this emperor much younger.

110. **Sarcophagus,** on which the triumph of Bacchus is represented. Some chained slaves precede Arianna's chariot which two tigers are drawing: while that of Bacchus is drawn by two centaurs, male and female. The figure standing by Bacchus is Acratos. A winged Victory precedes the chariot, and some cupids, fauns and menades follow it.

111. **Elius Caesar;** adopted by Adrian and destined to be his successor if he had survived him. He was

handsome and inspired veneration by his noble aspect, notwithstanding his feeble health. This bust well represents the beauty of his features as well as the nobleness of his mind.

112. Venus with a little Cupid bearing a reversed torch in his hand. The torches which are often seen in the hands of figures representing Venus or Cupid are a symbol of the passion which these two divinities kindle in the hearts of men. The arms and a part of the right leg of the goddess are modern.

113. Venus. This statue formerly represented a victorious Venus and held an apple in its right and, as it is seen from an engraving in the *Museo fiorentino,* 3ᵈ table. Hercules Ferrata had it restored it in 1557, and the arms which are *stucco* were then made in the attitude of those of the Venus de Medici. It is a little larger than life. The head is antique, but it problably belonged to another statue.

114. Sabina, wife of Adrian, and daughter of Matidia. This bust is fine and very carefully executed.

115. Antoninus Pius; a splendid bust, quite like the heads in the different medals and old statues of this excellent prince, which are very numerous. His reign lasted 22 years and six months.

116. Faustina, the mother. A bust remarkable for its artistic value and perfect preservation.

117. Faustina. Another bust.

119. Apollo, with the serpent. A statue larger than life and very fine in its antique parts; but the attitude given to the right arm which is all new, is very different from the original one, which certainly was the same that is seen in all the statues representing Apollo Lycius, and just as it is in that which was once at Versailles and is now in the Parisian Museum. The restored parts of this statue are: the head, the right arm, a half of the left one, and portions of the legs.— It was taken into this gallery in 1794.

120. **Galerius,** the son of Antoninus, in his childhood. He died about the age of 15. — A bust.

121. **Apollo,** with a sea-bird at his feet; a statue larger than life. The head is old but does not belong to this statue. Both the arms, and the left foot are modern.

122. **Annius Verus,** the son of Marcus Aurelius. A child about seven years old, who died just at this age.

Second Corridor.

123. **Cupid.** A statue larger than life, in a very queer attitude. — Both the arms are modern.

124. **Two Children wrestling,** one of whom is lifting the other by the waist. The right hand of one of the two is modern.

125. **Morpheus or Sleep;** a lying statue with wings at its head and feet, and two poppies in its left hand. A lizard is at its feet, according to ancient belief, that such little reptiles used to watch by persons asleep, and to whake one, whenever a venemous animal approached. The right foot and a part of the left one are modern.

126. **A child** dressed in a short tunic, in a fold of which he has some walnuts. He represents very likely one of those who used to scatter walnuts at weddings. The lowest parts of the legs are modern.

127. **A child** winged and lying on a sleeping lion. It is probably a symbol of Love. The right knee and foot are modern.

128. **Bacchante,** dancing. A leopard is at her feet: her dress which is light and waving in the wind makes the whole figure lively and pleasing. The half of both the arms is new.

36. **A Roman matron,** similar to N. 35. The head is probably modern.

131. **Faustina,** the young wife of Marcus Aurelius. She was deified, and took the title of *Mater Castrorum.*

132. **Annius Verus.** Much finer than the other bust

N. 122. Without any fear of exaggeration this bust and that of the little Nero may be considered the finest busts of children ever seen.

133. **Minerva**, a statue in the antique greek style, but much restored. — The arms are modern, the head is antique, but it probably belonged to another statue.

3. **Young Athlete,** or Doryphorus of Polycletus.

135. **Faustina.** Another bust of the same.

136. **Marcus Aurelius Antoninus,** the philosopher. There are four busts of this personage in different ages. This one seems to belong to the time in which he was adopted by Antoninus; that is to say between 15 and 20. His reign lasted 19 years and 10 months.

137. **An altar.** It is round and its top is hollow, with some holes around its edge. It was formerly believed that the bas-relief which adorns it represented Alcestes saving her husband Admetus from death, by sacrificing herself for his sake, since Apollo had obtained from the Fates that Admetus' life should be prolonged, provided a voluntary victim were sacrificed for him. His wife Alcestes was the victim, but Hercules took her back from Hades, to restore her to her husband. The veiled figure was supposed to represent the revived Alcestes. It is now thought that this figure may represent Iphigenia led to the place where she is to be sacrified. Agamemnon is veiled and one of the priests is cutting the hair of the intended victim. The following figure represents the people as it is shown by the word *laos,* written behind it. The work is of an antique Greek style, and a Greek inscription which is under the base of this monument, says that it was made by Cleomenes.

138. **A nude boy,** called *il Giovine della spina.* This charming figure is often found in bronze or on engraved stones. He has been pricked by a thorn in one of his feet and looks at it with great attention. It is supposed to represent a conqueror in the Olympic games. The hands, the left foot, and a part of the right one are modern.

139. **Marcus Aurelius.** This bust was probably made about the end of the reign of this emperor. It is very

expressive and the beard and hair, rather rough, are very well executed.

140. **Marcus Aurelius.** Another bust with a shorter beard. It is considered one of the finest in this collection.

320. **The Genius of death,** or **Sleep.** The restorer has misunderstood the subject, reducing this statue to a Cupid, by putting a bow in its hand, instead of the inverted torch.

141. **Pedestal** of a candelabrum, which was dedicated to Mars, as is shown by the bas-relief which adorns it representing six genii carrying the arms of the god. Upon this pedestal is placed a little triangular altar adorned with three figures of women, in very shallow relief. The upper part of this is restored. — It was brought from Rome in 1788. In the Louvre Museum there is an antique pedestal like this, but a little smaller.

150. A **nude boy,** standing, supposed to represent Nero in his childhood. It is remarkable for its artistic value and perfect preservation.

142. **Minerva or Pallas Athene.** A statue in a fine Greek style. The head which is not one piece with the torso, is antique however, but probably not its own. The right arm and a part of the neck are modern.

129. Sarcophagus. The fall of Phaeton. The figure of Phaeton falling headlong into the Eridanus is in the middle of the bas-relief, with the Heliades, his sisters, changed into poplars.

On the back of this sarcophagus in a very shallow bas-relief a race in a circus is represented, particularly remarkable, as it bears inscriptions giving the names of the chariots which take part in the race (*Libyo, Jubilatore, Dicatesyne, Eugrammo*) as well as those of the drivers written by the heads of each: (*Liber, Polyphemus, Trofimion*). The name of the fourth driver is wanting, but some interpreters have supposed it was *Entyones.*

130. A **colossal head,** placed on this sarcophagus. A fragment of a figure representing *a river.*

143. **Lucius Verus.** He shared the supreme power with his brother Marcus Aurelius in the throne of Rome. Capitolinus says he was as immoderate and debauched as Caligula, Nero and Vitellius. He reigned nine years with his brother.

144. **Lucius Verus.** Another bust.

149. **Young Bacchus,** sitting by a vine and plucking off a bunch of grapes, while he is holding a cup in his left hand. — The arms and a part of the left leg are modern.

145. **Venus Anadyomene** (Venus' birth from the sea). The head, the arms and the left leg are modern. A similar statue is at Rome, and one in the Museum at Paris; both equally antique.

146. **A Nymph** extracting a thorn from her foot. The head the right hand and the feet are modern. The original part of the statue is a very good specimen of antique Greek art.

147. **Commodus,** son of Marcus Aurelius and Faustina. His weakness of mind which made him so unworthy of sitting on the throne, is well expressed in his features. His busts are rare, as the Senate ordered them all to be destroyed, in order to wipe out even the memory of that tyrant. He reigned 12 years and nine months.

148. **Marcus Aurelius.** The fourth bust of this emperor.

134. **Venus,** in the act of girding on Mars' sword. The head, the feet and the vase covered by a cloth are modern.

151. **Lucilla,** daughter of Marcus Aurelius and Faustina, whom she resembled in her luxurious life.

152. **Lucius Verus.** The third bust of this emperor.

35. **A Roman matron** recumbent on a seat is leaning on her left elbow. She is supposed to represent *Agrippina,* the mother of Nero, from her likeness to the portrait of that empress, which is kept in the Farnesian gardens (Orti Farnesiani). This statue was bequeathed to the Granduke Gio. Gastone by signor Andreini.

Third Corridor.

153. **Crispina**, wife of Commodus. This bust represents the empress in her most flourishing age, not long after her marriage.

154. **Commodus**. A second bust of this emperor.

155. **Marsyas**. A nude statue larger than life. It is hung on the trunk of the tree. It is believed to have been restored by Donatello. The half of both arms are modern. A statue like this is in the Louvre Museum.

156. **Marsyas**. A statue similar to the preceding one, and restored by Verrocchio. The head, the arms and a part of the shoulders are restaurations. The original parts are in a kind of marble, the colour of which imitates that of the flesh.

157. **Pertinax**. A long bearded venerable old man, with rough hair, broad shoulders, and majestic look. He reigned not longer than three months.

158. **Manlia Scantilla**, the wife of Didius Julianus.

159. **Didius Julianus**. This bust represents him just as the best historians describe him. He was dissolute even in his old age: he became emperor simply by buying that dignity, which he soon lost with his life.

160. **Didia Clara**, the only daughter of Didius Julianus and Manlia Scantilla.

161. **Pescennius the Negro**. He competed for the imperial dignity with Septimius Severus, who soon conquered him, near Antiochia. — It is doubtful whether this bust is antique.

162. **Nereid** on a sea horse. This group is important on account of the subject which is very rarely treated.— The feet of the nymph and the two legs of the horse are modern.

163. **Septimius Severus**; a lively and fine head, which is a proof of the wonderful skill of some artists in that time. He reigned 17 years and 8 months.

164. **Julia Domna**; the wife of Septimius and mother

of Geta and Caracalla. She is represented in this bust, with all that beauty, grace and majesty which rendered her so famous in Roma and Syria.

165. **Septimius Severus.** Another bust.

166. **Julia Domna.** Another bust of the same empress, in the age in which she had lost something of her peculiar beauty, but not her noble and dignified look.

167. **Albinus,** who competed with Severus for the throne of Rome, and kept the title of Augustus for several years. This bust is in alabaster, and this peculiarity makes it particularly remarkable.

168. **Antony Caracalla.** This surname was given to him on account of his being used to wear a gallic dress just called Caracalla. This bust represents this emperor at the time when he had lost that courteous countenance and those graceful features, which had formerly rendered him so dear to the people and Senate. It is a fine work of art, and so much more remarkable, as it is rare to find one so good in an epoch which was called the last breath of the Roman Art, as it just preceded the decay which it had to suffer under the reign of Adrian. Caracalla reigned six years and two months.

169. **Discobolus.** A splendid specimen of the grand style of the antique Greek art. It was formerly believed to be one of Niobe's sons, but Visconti thinks it is an antique copy of the Discobolus from Miro. — The hands, a part of the right leg and the trunk on which the other leg is leaning, are new.

170. **Hygea,** the goddess of health and companion to Esculapius. She is feeding a serpent. Her drapery and the dressing of her hair are to be remarked. — The neck with a part of the head, a half of the left arm and a part of the right one are modern.

171. **Plautilla ;** the wife of Caracalla : in her prime. A bust.

172. A **Cippus,** with an inscription.

173. **Geta,** the brother of Caracalla, who stabbed him, in the arms of their own mother Julia Domna.

174. **Plautilla ;** another bust.

175. **Geta** ; another bust.

176. A **Cippus**, with an inscription.

177. **Apollo**. He is resting and has one of his feet on a tortoise. — The legs and the left arm are modern, and the head also is probably not antique.

178. **Jupiter**, with a thunderbolt in his right hand, as a sign of his power over men and gods. The figure is partly clad in a mantle, which gives it a character of great majesty. The right arm and the feet are modern.

179. Another **Cippus**, with inscription.

180. **Geta**. Another bust, representing him in his youth.

181. **Macrinus**, who conspired against Caracalla and was his successor. He reigned during one year and two months, with his son Diadumene.

182. **Macrinus**, another bust in which the beard is a little different from that of the other, just as it is in other portraits of this emperor as seen in some medals. .

183. **Diadumene**, in his childhood.

184. A **Cippus**, with an inscription.

185. A **Cippus**, with masks carved on two opposite sides. Such cippi were used as a sign in theatrical performances.

186. **A wounded soldier**, leaning on his left knee, while the right thigh is pierced by an arrow, a part of which is thrust in the wound. It represents a foreign soldier, as there is nothing Roman in the dress. The arms, a part of the neck, the shield and the feet are modern.

187. **Juno** : remarkable for a peculiar expression of majesty. — The arms and feet are modern.

188. **Macrinus**. Another bust.

189. **Cippus**, with an inscription.

190. **Marcus Aurelius Antoninus Heliogabalus**. He

was a very handsome youth but so dissolute and cruel
that he was considered the most disgraceful of the worst
tyrants who ever sat on the throne of Rome. He was
only 14 years old when he ascended the throne, and
was killed after three years and nine months of reign,
in 222 A. D.

191. **Diadumene**, in his childhood. A bust.

192. **Alexander Severus**, the son of Julia Mammea,
by whose counsels he demeaned himself so wisely on
the throne, and with whom he was assassinated by his
own soldiers in Germany. This bust well represents his
majestic look and natural kindness of disposition. He
is clad in a scaly cuirass.

193. A **Cippus**, with an inscription.

194. **Apollo.** He is nude and sitting, and holds a lyre,
which is very remarkable on account of its having five
cords. — The neck, arms and right foot as well as the
serpent are modern.

195. **Leda.** This statue has great artistic value, but
unluckily some stains in the marble hinder one from
admiring all the beauty of the work. The face is very
expressive and the forms of the breast are beautiful: the
drapery is of the best Greek style. — The right arm
and the feet are modern. — It was given to Francis I
de' Medici from Cardinal Lezio.

196. **Julia Aquilea Severa**, a Vestal whom Heliogabalus married declaring it right that the wife of a priest
of the Sun should be a Vestal. This bust represents her
before she had left her primitive state.

197. A **Cippus**, with an inscription.

198. **Alexander Severus.** This bust is superior to the
other (N. 192) in artistic value. His dress is that which
was called *laticlavium*. The busts of this emperor are
rare: even the Museum in Rome had but one, which
had been dug out at Ortricoli.

199. **Julia Mesa**; the sister of Julia Septimius Severus' wife, who contributed to raise her grandchild

Heliogabalus to the throne by means of much craftiness. This bust represents her in rather old age.

200. A **Cippus**, with an inscription.

201. **Maximinus**. He was a barbarian by birth and very daring and uncommonly strong. He was eight feet and two inches tall. He reigned two years, with his son.

202. **Apollo**. A standing statue. The arms, the lower part of the legs, the lyre and the drapery are modern. The few antique parts are very beautiful.

203. A **Cippus**, with inscription.

204. **Esculapius**. A statue similar to that which is in the Public Gallery in Rome (See *Museo Chiaramonti*, 2d vol., tab. IX, page 25). The sandals are to be remarked on account of their peculiar fashion and good state of preservation. — The right arm with the wand and serpent are modern.

205. **Olimpus**. A sitting statue similar to that which is in the group of Pan with Olympus (N. 51). The pipes of his instrument are sixteen in number. — The left arm, the right hand and the point of the right foot are modern.

206. A **Cippus**, with inscription.

207. **The forepart of a pedestal**, with a Greek inscription.

208. **Bacchus**, in a group with Ampelus or Acratos. He holds a cup with his right hand and rests the other on the head of the little Ampelus, who is sitting on an urn, embracing Bacchus' right leg. On the ground are some masks of satyrs and bunches of grapes. — The torso and part of the legs of the principal figure are the only antique parts of this group: all the rest is modern but very cleverly made.

209. **Esculapius**. This statue has a remarkable expression of a noble character. His left arm is leaning on a knotty stick, about which a snake is twined. This statue was probably once grouped with another, and

very likely with Hygea; as the trace of a hand, which seems to belong to the figure of a woman is visible on the left shoulder. The modern parts of this statue are the right arm, the left hand, the feet and the stick with the snake.

210. **Maximus**; the son of Maximinus, who reigned during two years with his father, and was killed at the siege of Aquilea (238 A. D.).

211. **Maximus.** Another bust of the same.

212. **Marcus Aurelius**: a statue. The figure is nude and represents the emperor in his youth, with a globe in his hand. It was perhaps made for a temple and seems to belong to the best epoch of antique Roman art. — The right arm, the hand with the globe, the legs and part of the drapery are modern.

213. **Gordianus** the African or the Father. No other bust of this emperor is known. He was raised to the throne in spite of himself, and did not reign longer than ten months.

214. A **Cippus**, with an inscription.

215. **Julia Mammea**; the mother of Alexander Severus: a beautiful, elegant, and courageous princess. This bust has little value as a work of art.

216. A **Cippus**, with an inscription.

217. **Salominus**: a child; the eldest son of Gallienus. He is crowned with laurel. He is named *Valerianus* in the medals. The artistic value of this work is superior to all which the best artists produced in Rome at that time.

218. A **Cippus**, with an inscription.

219. **Pupienus.** He was elected to the throne on account of his virtues, but he was assassinated by the Prætorian guards.

220. A **Cippus**, with an inscription.

221. A **Cippus**, with an inscription.

222. **Pupienus**: another bust.

223. **Leda.** A statue smaller than life. — The head, the arms, the swan and part of the drapery are modern.

224. **Apollo:** a statue, similar to that which is in the first corridor (N. 119). The figure is nude, a sea bird is at its feet. The half of both arm, the feet and a part of the drapery are modern.

225. **Gordianus Pius;** the third emperor who had this name. He was elected by the prætorian legionaries and was killed by the order of Philippus at Zaite on the Euphrates. His reign lasted six years.

226. **Tranquilla;** the daughter of Misitheus and wife of Gordianus: a very goodnatured woman. Her busts are rare.

227. A **Cippus,** with an inscription.

228. **Gallienus,** this bust is much better executed than might be expected in an epoch in which art had already begun to decay, as it then did still more under Clorius and Galerius. He reigned seven years with his father Valerianus, during which had rebelled against his authority.

229. **Melpomene or Clio:** a statue by Atticianus, a Greek sculptor not much renowned, who lived in the third or fourth century. His name is written on the base. The head, left arm, right hand and a part of the lyre are modern.

230. **An ancient breast plate,** in a Roman fashion, in marble. It is a military trophy, and is certainly Roman, as Greeks did not allow such monuments of individual glory to be made in any solid materials like marble or stone, so that no Greek trophy is ever to be found. — It was brought frome Rome in 1788.

231. **Trajan Decius,** who died in the year 249 of the present era. His busts are very rare. His features reveal much of that bravery and kindness, which rendered him dear to his subjects and soldiers. He reigned two years with his son Etruscus or Herennius.

232. **Salonina,** the wife of Gallienus. She honoured the throne by the best virtues proper to her sex.

233. **Probus**: famous on account of his uprightness and his victories. He would perhaps have restored the empire, which was then falling into ruin, had he not been killed a military sedition.

234. **Gallienus**: another bust.

235. **Carino,** the son of Caro and Magna Urbica. He became execrable to everybody in consequence of his tyranny over the Gauls. He was killed by a tribune in the second year of his reign.

236. **An altar** dedicated to the Lares of Augustus. On its front there are three figures, and a chicken. The figure in the middle bears a Lituus (the wand of augurs) in its right hand; the one at its left side holds a plate (*patera*) in one hand, and a vase with some fruits in the other. On the right side of the altar are two crowned figures, one of which carries a drinking horn (*potorium cornu*) and a *patera*, and the other a drinking horn also, and a pail. On the opposite side is a winged Victory standing by a trophy; on the back of the altar is a wreath of oak between two olive branches, a *perfericulus* (a kind of vase to pour libations on *pateras*) and a *patera*.

237. **Quintillius**; the brother of Claud II. A bust. He possessed many of the best qualities of an onest and worthy man, but wery few of those which made one worthy of sitting on a throne and ruling others. His reign lasted but twenty days.

241. **Night,** a statue standing, larger than life, with mantle in black basalte. Come to the Gallery in 1874 from Poggio Imperiale Villa.

238. **Sleep.** A winged nude boy in black marble. He holds two poppies and the horn of dreams. It is placed on a funeral cippus bearing an inscription which dedicates it to *C. Telegennus*. On the back of the cippus the door of Hades is figured, above which is a *lituus*, a *perfericulus* and a *patera*.

239. **Philip the Elder**; the son of a chief of robbers, who usurped the throne and reigned five years with his son Philip the younger. This bust is rare as there

are very few of this emperor and is also interesting as a specimen of what the art produced in an epoch in which it had already degenerated. Its artistic value is however small.

234 *bis*. **Charity,** a white marble statue.

235 *bis*. **Vestale,** a statue as above. All two come from Poggio Imperiale Villa in 1874.

240. **Constantine the Great:** a bust. A work of little value in itself, but good in comparison of the generality of artistic productions in its time. Its style resembles that of some medals. Busts of this emperor are very rare. The Museo Capitolino has none in its collection, as it also wants others which are to be found in this.

285. **Laocoon.** This magnificent group, work of Baccio Bandinelli a Florentine sculptor of the XVII Century, is copied from the Greek original, masterpiece of Polidorus Ottenodorus and Agesandrus. It represents Laocoon's punishment, being it opposed to the gods' will to introduce the famous wood horse in the Troyan city.

The Hall of Niobe.

Peter Leopold had this hall constructed in 1779, in order to collect here the splendid antique statues of Niobe and the Niobidi, which some years before (1772), he had ordered to be transported to Florence from the garden of the Medici Villa at Rome where they had been not very wisely placed.

The whole group is believed to have been composed of sixteen statues, the pedagogue included, but the number of Niobe's children is doubtful. Homer speak of twelve, but according to other poets or historians they should, be 3, 5, 10, 14 or even 20. In our collection there are fourteen, but two of them are so similar that they seem to represent the same personage, and two others probably do not belong to the group.

Niobe, the wife of Amphion and daughter of Tantalus, according to Ovid and Apollodorus, used to boast

of the number and beauty of her children and dispised her sister Latona who had only two, Apollo and Diana. Latona felt deeply offended and revenged herself by instigating her two children against the *Niobidi*. Apollo killed the sons and Diana the daughters; and the unhappy Niobe (as Homer relates) was then petrified by the cruel sorrow she experienced.

Ovid supposes the massacre to have happened in the hippodrome by the walls of Athens, and according to other poets Niobe's metamorphosis took place on the Sipyle, a mountain in Lybia, while her children were killed in Thebes.

These splendid statues were dug out in Rome close to the gate of S. Paolo in 1583. Cardinal Ferdinand de' Medici purchased them for the sum of 7938 francs, and placed this famous group in his palace in Rome (*Villa Medici* now *Accademia di Francia*).

Some of the heads of these statues have often been cast in plaster and carefully copied and studied, and casts of the whole family were requested by several Academie in Europe. Winckelmann, in describing these statues says that Niobe's daughters were struck by Diana's arrows, and their attitude, in fact, represents that anxiety and bewilderment which is caused by the fear of a death, which is imminent and inevitable. The prelate Fabbroni has written and published a monograph on this group, and had good drawings of these statues engraved and published in his book. Montfaucon has also published in his first volume (p. 107) an engraving by Perrier, representing this group as it was set in the Villa Medici at Rome, where the children formed a circle of which the mother stood in the middle.

It is also to be remarked that in the Museum at Rome there are two statues, which certainly belonged to another group similar to this. One of these to which the head and arms are wanting is exactly like the Niobide N. 246 of our group. It was once in the Quirinal palace, among the monuments collected by cardinal d'Este, in the Villa Adriana. A head of Niobe is in England, another head of one of the daughters is in the gallery at Munich, which is a proof of the old celebrity of these statues.

As to the way in which they were grouped many different opinions have been given, but nothing is known with certainty. The most reliable is that of Mr. Charles Robert Cockerell, a very clever English architect, who spent a long time in Greece to study the remains of the antique monuments of that classic country, which was formerly the cradle of the arts and sciences. According to his opinion these statues were destined to decorate the front of a temple. Returning from Greece in 1816 and being in Florence, he studied all these statues with great care, and made the drawing that is now exhibited in this hall, and in which he only put the fourteen figures of our collection.

Their different sizes and the progressive diminution of their height, as well as their various attitudes and the harmony, in short, resulting to the whole group from placing them as Mr. Cockerell did in his drawing, all seems to be a proof of what the clever English artist has conjectured. This opinion has also a good support in some words of Pliny about a group of Niobe's family, which existed at Rome in his time, taken from a temple of Apollo Sosienus, and which was a work of Phidias and Praxiteles.

The *Arduino* and Monsignor Fabbroni, then quote an antique Greek epigram which attributes this group to Praxiteles.

These statues in fact, since their discovery, were always reputed to be monuments of the greatest importance, particularly on account of their extraordinary value as works of art, and if they are not all equally excellent there are few of them which might not be considered worthy of being attributed to the most celebrated artists of Greece.

The learned Royal Antiquary Cav. Zannoni, in his praiseworthy work, edited in 1819 « *Galleria di Firenze illustrata,* » speaks of these statues with much erudition, and what he says is perhaps all that it was ever possible to discover on this subject.

241. Niobe. A colossal statue representing Niobe in the act of praying the gods that her youngest daughter who has found refuge in her bosom, may be saved. She

is clothed in a long thin robe, and the daughter is dressed with that kind of garment which the Greeks used to call χιταγ. — The right hand of the mother and the left foot of the girl are modern.

242. **A young woman.** The original place of this statue was perhaps by that of the dying brother (N. 244) as its eyes are just cast down with an expression of deep compassion and noble sorrow. The arms, a port of the dress and mantle, and the right foot are modern.

243. **A young woman.** The artistic value of this statue is inferior to that of all the rest in this group. The head is perhaps not original or it has at least been spoiled in some attempts at restoring it. — The hands, the feet and a part of the drapery are modern.

244. **The dying son.** He is entirely nude and lying on his mantle. The attitude is noble and expressive; the mouth is half open, the breast swelling and the terrible aspect of approaching death is manifest in every part of the body. — The right arm and foot are modern.

245. **The wounded son.** Half nude and kneeling, the left hand pressing the wounded side. It is doubtful whether this statue belongs to the Niobe family: it was once considered to be a Narcissus. — The left hand and foot are modern.

246. **A young Niobide.** A girl in the act of flying away. Her beautiful head expresses amazement and sorrow. She tries to defend herself by raising and spreading the edge of her dress. — The left hand and foot are modern.

247. **The pedagogue.** A bearded old man clad in that military costume which was then called *paludamentum*. He seems to be in the act of running, to the Hippodrome to defend his pupils. Some archæologists have supposed him to be Amphion their father: it is Winkelmann who thought this statue to represent the *pedagogue* or tutor of the young Niobidi. — The arms are modern, and very likely the head also. — In the Louvre Museum there is a statue like this grouped with one like that of the youngest Niobide (N. 256).

248. **A young Niob**ide. A standing statue, of a youth, half nude, in an attitude of terror. He is lifting his mantle or *clamis* so, as to make a shelter of it for his head, while he is flying from the danger by which he is threatened. This statue is the best in the group: the expression of the head is marvellous; the forms of the whole body are beautiful and noble; the foot which is trampling upon the ground is wonderfully modelled. — A half of the right and the whole of the left arm and a half of the right leg are modern.

249. **A young daughter.** A work of not great artistic value. The neck and arms are modern.

250. **A young Niob**ide. Half nude, in the act of lifting his *clamys* as a shelter in his flight. The movement of a flying person and the expression of fright are remarkable in this figure. —- The arms, the right leg and a part of the mantle are modern.

251. **A young woman.** This statue is thought not to belong to this group, but to represent a Psyche, as it is just similar to one of this subject, which is in the *Museo Capitolino*. The wings have probably been cut off. — The arms, and several parts of the drapery are modern.

252. **A young Niob**ide. A nude statue, similar in its movement to N. 255. A piece of marble which covers the left leg seems to.indicate that this statue is made to be looked at from the opposite side. — The right arm is modern: the neck and some other parts are restored.

253. **A young Niob**ide: quite nude. There is a wound in the side on which the right hand rests. The head is turned upward with an expression of pain and resentment. The right leg is shrinking in the contraction of the muscles caused by the smarting of the wound. This figure is one of the finest in the group and is also very well preserved, as the point of the nose is the only part restored.

254. **A young Niob**ide. Similar to N. 253, or rather

a copy of it, with a slight modification in its movement, and less skill in the modelling of some details.

255. **A young Niobide.** Similar N. 252. — The right hand, the nose and the mouth are modern.

256. **The youngest of Niobe's sons.** In the act of flying, and turning his head back with an expression of pain and dismay. The body is partly covered by a *clamys*, waving in the wind. — The right arm and left hand are modern.

257. **One of Niobe's daughters.** The expression of the head, the style of the drapery and other characteristics of the figure are so similar to those of the group of the mother with the youngest daughter, which stands next to it that one might easily attribute it to the same author. The arms are modern.

The following *busts* complete the decoration of this hall.

258. **A bust of a man.** The head is very beautiful and particularly remarkable for the peculiar shape of the skull. It was once believed to be a portrait of Fabius Maximus.

259. **Jupiter,** a colossal bust. Majesty, power and benevolence are expressed at the same time in the features of this splendid head. In the *Museo Pio Clementino* there is a bust similar to this.

260. **Neptune.** A colossal head.

261. **Pompey.** A modern bust with the head in porphyry; admirable considering the difficulty of carving this kind of granite.

Hall of Inscriptions and Sculptures.

The Greek and Latin inscriptions collected in Florence when Mr. Gori transcribed them in his book, are now almost doubled and have been divided by Mr. Lanzi

into classes, following the. example of the collections existing in Rome and Verona.

The 1st class contains the inscriptions dedicated to the Gods and their Ministers;

the 2d to the Cæsars;
the 3d }
the 4th } to the Consuls and Magistrates of Rome;
the 5th to Public Shows and Amusements;
the 6th to Warriors;
the 7th to the Manes of the Dead;
the 8th to Marriages;
the 9th to Freedmen;
the 10th to the Tombs of the Christians;
the 11th Epigraphs;
the 12th different inscriptions.

Two more classes of Latin and Greek inscriptions on various subjects have been added later, which are not numbered.

262. **Bacchus and Ampelos.** This group is larger than life and is a specimen of the best antique Greek style. Bacchus is gently leaning on Ampelos' left shoulder, while the young Faun, with a malicious smile, shows him a goblet, which he holds in his right hand. The hooked stick and the flageolet are hanging from the trunk of a tree; the flageolet has ten pipes, which number is uncommon, but may be the fault of the sculptor.

A similar group in the Museum at Rome differs only in one particular from this, which consists in Bacchus being bare-footed, while this one wears hunting sandals. The head of the god has a remarkable expression of nobility and is wonderfully executed. The had is in one piece with the rest of the statue and very well preserved, and has not been reset as was once erroneously asserted. It was dug out at Rome by the Porta Maggiore, and bought by Ferdinand II of the Medici.

This group is placed on an antique Egyptian monument representing a *Pompa Isiaca* (Pomp of Isis). It is a round altar of granite adorned with a bas-relief. Lanzi thinks it belongs to an epoch preceeding the century of Adrian. An engraving representing this

altar is published in Father Kircker's *Edipo Egiziano*,
v. 3, p. 426, and also by Montfaucon; v. 4, table 286;
and Mr. Zannoni has given a splendid description of
it, with five drawings in his *Galleria di Firenze*.

263. **Mercury.** Life size. A splendid antique statue,
in a state of perfect preservation. It is perhaps the *pa-
cific Mercury*, as it is often represented in some an-
tique medals. Many copies of this statue are to be
found in various museums. The half of both its arms
is modern.

264. **A Priestess.** As large as life and particularly
remarkable for its fine drapery, which gives a noble
aspect to the whole figure. The head and left hand are
modern.

This statue is placed on a Cippus, bearing an inscrip-
tion: P. Ferrarius, Hermes; which was found in the
environs of Pisa. There are also figures of various *toi-
lette* utensils, and the measure of the Roman foot; the
longest ever known, corresponding to 1881 $^1/_{15}$ of the
Parisien foot (ancient measure).

265. **Venus genitrix.** A statue in the best Greek style
with noble and grand proportions. Her body is almost
entirely clad in a very light garment, which adorns
her beautiful form without hiding it. — The right arm,
and the left hand are modern. The *tibia* in the restored
hand has been added by the restorer, who probably
mistook the subject of the statue.

266. **Venus Urania**. One of the finest statues in this
gallery. — She is represented in the act of dressing a
lock of her hair with the right hand, while the left is
holding a cloth which covers her from the waist down
to the feet. Her head is crowned by a diadem coloured
red and gold, on which hollow spaces are visible, a
proof of its having been formerly enriched with precious
stones. Both the arms are modern.

It was discovered at Bologna, by the Granduke
Ferdinand II in 1657.

The base of this statue is a splendid cippus of the
best Greek style, adorned with bas-reliefs representing

three bacchantes and Agave bearing the head of Pentheus.

267. **Carneades.** A bust in good style and perfect state of preservation.

268. **Ovid.** A bust, much restored; and its authenticity is doubtful.

269. **A horned and bearded head,** placed on a cippus dedicated to *Hateria Superba* when one year, six months and 25 days old; who is represented upon it in bas-relief, with a dove held in her left hand and another at her feet. A dog is also standing near her to which she presents a bunch of grapes. Two genii hover above the scene with garlands in their hands.

270. **Head** supposed to be the portrait of Marius.

271. **A bearded head,** adorned with a garland.

. . . **Homer,** in black stone (*Lapis suillius*).

292. **Silenus** (smaller than life), drunk and lying on the ground, with his eyes half shut as if unable to keep them open. One of his hands is resting on some bunches of grapes, and the other is trying to raise a goblet to his lips. His feet have the true *soccos*, which were used by the ancient comedians.

This statue is placed on a sarcophagus on which are carved some figures of boxing *genii*.

273. **Unknown head,** of mediocre artistic value.

274. **Scipio.** This bust is a clever work and very rare, as few portraits of this personage have been preserved to the present time.

275. **A head of an old man,** in black stone (*Lapis suillius*). It was once supposed to be a portrait of Euripides.

Underneath is a sepulchral cippus dedicated to Julius Theopompus, as appears from a Greek inscription, which is under a bas-relief representing Cupid and Psyche.

276. **Cippus,** upon which is placed a beautiful head of a goat, in a very rare black stone, stained with white spots. — It was brought from Rome, in 1788.

277. **Sappho.** A bust.

278. **Alcibiades.** A bust.

279. **Sophocles,** the Greek tragic poet. A bust.

280. **Aristophanes.** A bust, with a Greek inscription.

282. **A large bas-relief,** fastened on the wall, supposed to represent the emperor Gallienus going to the chase. He carries a long spear (*venabulum*) ad is followed by his horse led by a soldier. The work is rough, and seems to have been made to decorate a frieze.

Around are also fixed on the wall several beautiful portraits, among which, worthy of particular remark are those of Pompey, Seneca, Demostenes, Homer and Plato. The last one (a dimin. figure) is the most precious, and very rare, as it bears the name inscribed in Greek. It was sent from Greece to Lorenzo il Magnifico by Jerome Rossi of Pistoia.

285. **Bacchante;** a bust. The head alone, which is in basalt, is antique. The rest is in oriental alabaster and various kinds of coloured marble.

It is placed on the fragment of a column, which bears an inscription.

286. **The head of an old man.**

287. **Solon;** a bust, bearing an antique inscription, which makes it very precious, by affording a sure proof of its authenticity.

288. **An unknown man;** a bust. The head and neck are in basalt, the tunic is in white marble, and the mantle in gray marble.

281. **Nero.** A small statue, carved in a kind of dark basalt. The head is modern.

283. **A small statue,** in white marble. The figure is standing, the elbow leaning on a kind of column. Beneath is a sarcophagus with genii who bear the emblems of Mars.

289. **A figure seated,** in a consular dress. — The head is modern.

334. **A tired traveller**; a very expressive figure in alto-rilievo, in perfect state of preservation.

293. **Head of an old man**, in perfect preservation.

294. **Socrates.** A skifully worked head; but the nose has been restored.

295. **A Philosopher.**

296. **Anacreon**; a bust.

284. **Eon,** the Persian Divinity; a strong and monstruous figure, with snakes twined upon it.

298. **Erma,** with the head of an old man, worked with skill.

299. **Mark Anthony**; a colossal bust, not very well preserved but rare.

300. **Demosthenes**; the head alone: very expressive.

301. **Aratus**, a bust.

302. **Cicero,** a bust larger than life. The head alone is ancient and wonderfully well preserved, and certainly belongs to the best epoch of Roman art. All the rest is a restoration. — This bust was purchased by Ferdinand II of the Medicis, from the Ludovisi family in 1669.

303. **An urn for the ashes of the** dead; in marble, adorned with beautiful carvings, and bearing a Greek inscription, in which the name of Agaton is read.

304. **A Philosopher.**

305. **Hyppocrates,** a bust. The face is remarkably well worked and expressive.

There are fourteen other busts placed above in this room, but most of them are unknown.

Around the hall are also some cinerarian urns, and under them there are six sarcophagi.

Cabinet of the Hermaphrodite.

306. Hermaphrodite, lying upon a lion's skin; a splendid statue similar to one in the Paris Museum belonging to the Borghesi collection. The lower part of this statue has been so cleverly restored that it perfectly agrees with the upper portion which is antique and is considered a master piece of Greek sculpture. The part restored is also in parian marble. — It was purchased by the Grand Duke Ferdinand II of the Medicis from the Ludovisi family, in 1669.

307. **Fragment of a torso,** a splendid piece of work, so much more admirable as it is in basalt, which is very hard and not easily carved.

319. **A Philosopher.**

308. **Ganimede.** The old fragment of this statue, which Stephen Colonna of the princes of Palestrina presented to Cosmus I was so much admired by Benvenuto Cellini, that he undertook to restore it. The head, both the arms and feet and the eagle are his work, in which he did not at all endeavour to imitate the antique, but only pleased himself with the application of his own talent and skill. — The head is particularly remarkable for the same fineness of execution, which make Cellini's works in metal so admirable.

311. **Pan and an Hermaphrodite.** A group of small figures. — That of Pan is almost entirely new, but the restoration has been executed with great skill, and in perfect correspondence with the antique parts of the fragment.

347. **Bust of Seneca.** It was discovered in the storerooms of the Gallery, in 1864.

309. **A Philosopher.**

310. **The infant Hercules strangling the serpents.** The extraordinary vigour and strength of the future hero is wonderfully represented in this figure of a child,

312. **An unknown female bust** of beautiful form and wonderfully executed. It was once believed to be the portrait of Berenice, the mistress of Titus. A royal band girdles her hair, which is dressed in several rows of curls, hanging all round the head and down to the shoulders; a style of hairdressing unusual in the Roman princesses. It is an old Jewish fashion and was used by Mad.ᵉ La Vallière et Mad.ᵉ Montespan. The curls were probably all false.

BAS-RELIEFS.

The following six bas-reliefs are fragments of the figured decoration of the ARA PACIS AUGUSTÆ.

8. The papish portrait of Augustus.

9. The family of the Clauds.

10. The goddess Tellus.

11. The sacerdotal corporation of the Flamini.

12. The accompaniment of the Senators.

13. Fragment of ornamental decoration.

14. **The sacrifice of a bull.** Julius Firmicus is the only writer who makes any mention of such sacrifices, which seem no to have been performed in the remotest epochs of Paganism. The figures in the present bas-relief are crowned with laurel, the one behind representing the sacrificer. The medal in the middle, was perhaps intended to bear an inscription indicating the subject of the bas-relief, as is seen in other similar monuments.

15. **Decoration of good style.** It is divided in two parts, being deficient of the piece of connection.

325. **A model of a Temple.**

which may be pronounced one of the best works of antique art. An antique bronze statue quite similar to this is kept in the Museum of Naples.

317. **A child with a goose**; a very cleverly worked group, probably intended to adorn a fountain.

316. **Antinous**; a splendid monumental bust, in perfect preservation. It was purchased at Rome in 1671, by Cardinal Leopold de' Medici, for the price of 77 scudi (462 fr.).

290. **Ceres.** A pretty seating statue.

313. **A child holding a goose,** similar to N. 317.

314. **Juno;** a colossal bust; in the best monumental style.

315. **A colossal torso of a Faun.** Till 1778 this fragment was the chief ornament of the Gaddi Gallery in Florence. It is now considered one of the finest specimens of antique Greek art, and is not less famous than the celebrated torso, called *di Belvedere,* in the Vatican Museum. Its style is similar to that of the Laocoon.

318. **Alexander dying;** a very beautiful colossal head, considered one of the most marvellous productions of antique classic art.

321. **Unknown bust;** very expressive, and very well preserved.

323. **Cupid ad Psyche,** a very pleasant group which was discovered on the Monte Celio at Rome, in 1666. A group like this but a little larger is seen in the Museo Capitolino.

324. **Fragment of a statue** in Parrian marble, supposed to represent Bacchus from the goat skin by which it is partly covered. It belongs to the best epoch of Greek art.

326. **A bas-relief** representing the interior of a clothier's shop, made to serve for a sign.

327. **Three pretty female figures.** Fragment of bas-relief.

328. **Jupiter Ammon** ; a colossal head in bas-relief.

329. **An Emperor sacrificing** ; a well preserved bas-relief.

330. **A Genius,** bearing Jupiter's thunder-bolts.

331. **Two women and a bull**; a bas-relief in a good Greek style.

332. **A pretty** child bearing a vase on his shoulders.

333. **A dying Bacchante** ; a bas-relief. See an illustration of this, by the Abbé Zannoni (*Illustrazione del vaso Cornisiano*).

336. **Three Bacchantes** ; a bas-relief.

337. **A bas-relief,** the subject of which is similar to that of N. 326.

In the Hall of the Portraits of Painters.

338. **A statue of Cardinal Leopold de' Medici.** the original founder of this famous collection of portraits.

339. **The Medicean Vase,** placed in the middle of the hall.
On this famous urn, generally known under the name of *Vaso Mediceo* a splendid bas-relief of nine figures is sculptured, which represents the Sacrifice of Iphigenia. The young victim is sitting at the foot of an altar before a simulacrum of Diana, and holds a small branch in her hand, with an expression of deep sorrow and resignation. Two *galeati* (young men with helmets) stand by her. The one who looks into her face is supposed to be Achilles. He is partly nude but wrapped in a mantle, and wears a helmet on his head and a girdle round his waist, on which the forefinger of his

right hand is fixed. The other is Diomede, naked, all but the shoulders and arms, from which a mantle falls in majestic folds.

Montfaucon thinks the figure behind that of Achilles to be Ulysses; Lanzi takes it for Agamemnon, and Zannoni describes it as a figures of Menelaos, since Ulysses is generally represented with the *pileus* on his head, and Agamemnon ought to be in mourning. This figure in fact is very like that of Menelaos in the famous group in the *Museo Clementino* (See Visconti, v. IV, Tab. 18) and the calm expressed in it, is quite suitable to that prince, for whom the innocent girl was rather sacrificed than for Diana. Agamemnon is very likely represented in the figure behind these.

The following figures are probably other captains of the Greek army. Another figure of a naked youth, who seems to walking rapidly, with a short mantle waving down from his shoulders, is supposed to represent the herald Talthybius.

On the upper part of the vase, two vine branches are sculptured in very low relief: the lower part is adorned with leaves and flowers of acanthus.

The use of this vase and of other similar ones has been very well described by Visconti in his illustrations ot the Borghesi Gallery, where he quotes the account that Homer gives of ancient banquets. The guests, says he, used to sit at a little distance one from the other; a small table being placed before each of them.

A huge vase stood in a corner of the hall, in which wine was kept mixed with water, from which mixture (*crasis*) the vase was called *crater*. By the means of small vessels the wine was then drawn from it to be distributed to the guest by the cup bearer. These craters were usually made of solid material and also marble, like this one, which was discovered at Tivoli in the Villa Adriana, and is one of the most important monuments of antiquity, certainly belonging to the best epoch of Greek art.

In the second saloon of the Flemish and German School.

340. Upon an oriental alabaster table are two small busts, Vitellius and Adrian.

In the saloon of the Italian School.

341. Upon another oriental alabaster table: Sleep; a splendid marble figure, representing a naked child sleeping: a very remarkable piece of antique scupture. Two busts of Seneca on the two sides.

In the Tribune.

342. **The Venus of the Medicis.** Of all the statues of Venus which Rome anciently possessed, and which are mentioned by Pliny, this is undoubtedly to be numbered among the finest, as none so perfect has ever been dug out from the ruins of that wonderful city, which has afforded so rich a harvest of ancient art treasures. One might say of this statue of Venus that it is among the other statues of that goddess what that goddess herself is among the other goddesses. Writers of different nations have contributed to its celebrity, which has been continually groving with the ages. The right arm and the lower half of the left are modern, and cleverly done, though far from the perfection of the original.

The Venus is probably not inferior to that of Praxiteles, which was in the temple of Guidus and of which Ovid wrote that her divine majesty alone forbade her to move.

It was found in Adrian's villa at Tivoli, and transported to Florence under Cosimo III, about the year 1677 with the *Arrotino* (the knife-whetter) (346) and the group of the two Wrestlers (343).

Cleomenes the son of Apollodoro the Athenian, was the author of this masterpiece, according to an inscription in the base, which is evidently modern, but may be supposed to have been faithfully copied from the antique one, when the base was restored, as the name of one of the most famous artists of Greece, like that of Phydias, Polycletus, Scopa or Praxiteles would have been chosen if one had intended to attribute a false author to this statue, while that of Clecmenes would be almost unknown, if this statue had not been discovered.

Its height is 4 feet, 7 inches and 8 lines.

343. **The Wrestlers.** This group is considered to be one of the best specimens of ancient Greek sculpture. One of the two athletes has thrown the other to the ground, and is still threatening his conquered antogonist. In each muscle and vein the violent efforts of the wresling are wonderfully represented. The winner seems to rejoice in his victory, while the other, forced down by the vigorous arms of his fortunate rival bears the expression of impotent wrath. He is still striving to get up again, but his conqueror prevents his stirring by strongly grasping and pressing both his arms. The head of this figure is supposed not to be antique and seems at least to have been retouched but in all the other parts of the group some pieces which are evidently new are small and of little importance. — It was brought from Rome, with the Niobe, in 1677.

344. **The Dancing Faun.** This statue undoubtedly belongs to the best epoch of ancient sculpture. The figure is entirely nude, and is executed with a remarkable knowledge of anatomy: every part of the body bears the features proper to the satyrs, and a kind of convulsive briskness seems to agitate each muscle. It is generally assigned to Praxiteles, but no reliable argument can be adduced to sustain this opinion, except the extraordinary artistic value of the work itself. The figure is dancing and playing rattles (*crotola*) and the *scabillum* or *crepetia*, tied at the right foot, a kind of musical instrument in the shape of small bellows, which

gave a sharp note when pressed. Maffei considers this statue as one of the most admirable works of antiquity, but the head and both arms are new, and add a great value to this statue, as they are sculptured by Michelangelo, who made them with such wonderful skill, so perfectly imitating the ancient style that the whole figure seems to be the work of a single artist.

345. **The little Apollo** (*L'Apollino*); so named to distinguish it from the other celebrated Apollo called *di Belvedere,* in Rome ; which is bigger than this, and is as noble and grand as this is graceful and fine. It was brought from Rome in 1780, and is similar to the little Apollo in the Albani Gallery. The style is so analogous to that of the Venus de' Medici, that it is supposed to be also a work of Cleomenes. All parts of this statue are ancient.

Its height is 4 feet, 6 inches.

346. **The Arrotino** (*The Whetter*) or **Lo Spione** (*The Spy*), a magnificent and celebrated statue, found at Rome in the XIV century and brought to Florence in 1677. The figure is nude and represents a man bent on a stone, on which he is whetting a hooked knife, which he holds by his right hand, and presses by two fingers of the left, while his head is turned upwards with an expression of keen attention.

This statue has long been supposed to represent Cincinnatus, or Manlius Capitolinus, or Milicius, or Accius Nevius, and also the slave who discovered the plot of Brutus' sons in favour of Tarquin, or the one who revealed the conspiracy of Catilin against the Roman republic. The most learned archæologists now however agree in thinking the subject of this figure to be the Scythian man to whom Apollo gave the order of skinning Marsyas. His attitude, in fact, is just that of a person listening to an order and acting in conformity of it ; and his face bears much of the characteristic features of the Scythian nation. Winkelmann then describes a carved stone formerly belonging to Mr. Stoch's collection and now passed into that of the Emperor of Germany, in which the Scythian is just represented

in this attitude before the figure of Marsyas. A bas-relief also exists in the Borghesi Gallery, and another one at S. Paolo near Rome, both representing Maryas' death, as whell as several old medals, in all which the Scythian is represented in the same way. This opinion is finally supported by clear arguments by the Abbé Zannoni, in his celebrated work intitled: " *Illustrazione della Galleria.*"

This statue in also a splendid master-piece, in a perfect state of preservation.

Cabinet of Gems.

This fine cabinet, built in the form of a tribune, is decorated with four columns in oriental alabaster, and four in *verde antico,* about seven feet high. The six glass-cases contain upwards of 400 pieces of workman-ship in *pietre fini,* rock crystal, lapislazzuli etc., statuet-tes in jasper and calcedonius; busts, vases, cups etc., all enriched with enamel, and the most precious stones and gems.

All these works were executed in Florence in the time of the Medicis, and their material value, although so rich is in many of them surpassed by their artistic worth.

Eight columns of Sienese agate and eight of rock crystal; eight statues of the apostles in *pietra dura,* by *Orazio Mochi,* a Florentine; some bas-reliefs, busts, vases, also in *pietra dura,* were executed to decorate the altar intended to adorn the splendid Medicean chapel in *S. Lorenzo.*

Case I (to the right).

A vase in lapislazzuli of 12 inches in diameter, in one piece.

Three small busts of women in jacinth, one of which is enriched with white enamel.

Two small bas-reliefs in gold on jasper, attributed to *Gian*

Bologna, but now thought to be a work of *Michael Mazza-firri*, a Florentine goldsmith.

A small vase in agate, with enamelled gold handless, in Cellini's style.

Case II.

On the lower stage.

Two vases in sardonyx, very precioux for their size and the beauty of the grain. The name of *Lorenzo de' Medici*, is engraved on both. Their value is inestimable.

A casket in rock crystal, with the life of Christ in 24 divisions, engraved on the reverse side by *Valerio Belli*, of Vicenza, by order of Clement VII who gave it in 1533 to Francis I of France in the occasion of the marriage of Catherine de' Medici with that king's son, then called Henry II.

It is not known how it was brought back to Florence. The inventories of the Gallery bear it registered for the first time in 1635.

This casket is considered to be the rarest work in the collection.

On the middle stage:

Cosimo II kneeling before an altar. A full length, in bas-relief, ornamented with precious stones; executed in the manufactory of works in *pietra dura*, in 1619.

A cup of rock crystal, with a gold enamelled cover, on which are the initials of Diana of Poitiers Cellini's style.

On the higher stage:

Two vases of rock crystal, one of which is ornamented with admirable engravings, and the other has purposely been left unengraved, not to spoil the extraordinary pureness of its natural transparency.

Three bas-reliefs in gold, attributed to *Gian Bologna* or rather to *Mazzafirri*.

Two small statues representing two of the Apostles, in *pietra dura*.

Case III.

A triangular cup in emerald, in one piece.

A statue in *pietra dura*.

Several vases in rock-crystal, agate, and different kinds of jasper.

Case IV.

A lapislazzuli vase ornamented with pearls, and remark-able for the regularity of its white spots.

A red jasper cup ornamented with diamonds, which a small statue of a warrior in enamelled gold on its cover.

A variegated jasper vase, ornamented with pearls.

A Venus and Cupid in prophyry, the work of *Pietro Maria Serbaldi da Pescia.*

Case V.

A Grison jasper cup ornamented with pearls, representing a Hydra, with the figure of Hercules in gold; by *Michael Mazzafirri* of Florence.

A small vase in acqua marina.

Another vase in emerald.

A head in turquoise, of an extraordinary size. The eyes are two diamonds.

A large vase in blood-red jasper.

A large cup in rock crystal, engraved; with the handles in enamelled gold.

A view of the *Piazza della Signoria,* in *pietra dura,* with bas-reliefs in gold, by *Gaspero Mola.*

A bowl in the form of a bottle, of Spanish coralline, ornamented with pearls and cameos (High, to the left).

A cats-eye or star-stone, of extraordinary size, surmounted by a pearl.

Two small statues of St. Peter and St. Paul, in *pietra dura.*

Case VI.

A vase in lapislazzuli, remarkable for its uncommon size and the elegance of its shape as well as for its enamelled gold ornaments.

A cup in rock crystal, with a gold handle enamelled. A splendid work, attributed to *Benvenuto Cellini.* It is now believed to be the work of *Masseroni* of Milan.

A bowl in the form of a sea shell in blood-red jasper.

A small oval cup, made out of a single garnet.

A bust of Tiberius, in turquoise. The gold ornaments are attributed to *Cellini.*

Small statue of an apostle, in *pietra dura.*

In the centre of the room.

A small casket in rock crystal, surmounted by an uncommonly big pearl, in the form of a litle dog.

Cabinet of Cameos
engraved stones, nielli, etc.

This collection of cameos, engraved stones, etc., consists chiefly of the numerous and precious objects of this kind that the Palatine princess Anna Maria de' Medici bequeathed to Florence, and that her ancestors had gathered with such munificence and good taste.

It is disposed in 12 compartments. The first, second, third and fourth compartments contain old cameos; the fifth and the sixth contain modern cameos of the XVth century. Antique cut stones are in the 7th, 8th, 9th and 10th glass-cases; modern ones of the XVth century are kept in the 11th and 12th.

We shall only mention the more notable objects.

Compartment I.

N. 3. Large cameo, in onyx, representing **Antoninus Pius** in the act of sacrificing to Hope, while the Genius of the Empire is throwing some incense on the altar. The extraordinary size of this cameo makes it very rare, although it has been wrought by a mediocre artist.

7. Cameo in onyx, representing a winged **Cupid** playing on a lyre, and sitting on the back of a lion. The name of the author (*Protarcos*) in written under the figures ΠΡΩΤΑΡΧΟΣ ΕΠΟΙΕΙ.

13. **Apollo in repose.** A pretty little figure in gold, on onyx. A very rare work, once belonging to the *Piccolomini* museum. — See Maffei: *Illustrazioni delle gemme figurate*, vol. III, p. 96.

II.

33. **Iphigenia** recognising her brother Orestes and his friend Pylades. A cameo in onyx.

40. **Fragment of a two wheeled car,** in onyx; restored in gold by *Cellini*.

51. **Head of Dodonean Jupiter,** in onyx. One of the most interesting works in the collection.

68. **Bust of a Bacchante.** A splendid carving in onyx.

III.

86. **The head of Augustus,** under the form of Apollo. A remarkable cameo in onyx.

87. **Head of Augustus;** veiled and crowned with oak. A splendid fragment, in onyx.

109. **Head of Vespasian;** almost full face. A splendid carving in high-relief in onyx.

114. **The head of Livia;** veiled and crowned with fruits, in onyx.

IV.

148. **A wounded stag;** in onyx.

156. **The fall of Phaeton.** A copy of an antique bas-relief. A splendid composition.

V.

Modern cameos.

178. **The Body of Our Saviour,** supported by an angel. Mantegna school. A large onyx.

180. On one side: **The flight into Egypt,** on the other side: **The Massacre of the Innocents.** A double cameo, in blood-red jasper.

VI.

Portraits.

221. **Cosimo the Elder.**

222. **Lorenzo il Magnifico.**

223. **Alessandro de' Medici** (by *Dominici di Polo de' Vetri*).

227. **Catharine de' Medici.**

228. **Francis I,** King of France.

232. **Leo X.**

236. **Philip II.** This cameo is thought to be the work of *Jacopo da Trezzo,* a celebrated Lombard engraver, in the service of the King of Spain.

.... **Bianca Cappello.**

VII.

Antique cut stones.

28. **The apparition of Apollo.** Onyx. A wonderfully delicate engraving.

44. **Hercules;** in green jade. It was the last seal of the Florentine republic, used at the time of Cosmus the Elder.

54. **Hercules in Olympus,** with his bride Hebe. A work in amethyst, by *Teucros.*

66. **A Bacchanal.** A drunk Silenus, on his donkey. Onyx.

76. **Tritons;** in amethyst.

VIII.

358. **Bust of Pallas,** in sardonyx.

117. **Two priests of Mars** (Salii) bearing their *Anciles* on which are same Etruscan letters.

151. **Head of a young Hercules,** cut in cornelian. A splendid work by *Onesas.*

127. **The car of the sun,** surrounded by the Zodiac. On the other side: The car of the moon, sorrounded by a serpent, the symbol of Eternity.

IX.

185. **The head of Pluto,** or rather of **Jupiter Panthean.** A fragment in onyx. A work belonging to the best epoch of this art.

190. A bust in sardonyx; thought to represent **Leander.**

203. **Head of Augustus,** in sapphire.

208. **Cajus and Lucius,** sons of Agrippa; in cornelian. On the reverse: **Faustulus** with the twins.

219. **Head of Galba,** in cornelian.

220. **Head of Vitellius,** in green jasper.

228. **Bust of Adrian,** in cornelian.

233. **Bust of Lucius Verus,** in cornelian.

237. **Bust of Crispina,** the wife of Commodus: in red jasper.

239. **Bust of Julia Domna,** the wife of Septimius Severus; in acqua marina.

X.

This compartment contains a collection of portraits of Greek philosophers and other personages, all admirably executed. The following ones are particularly to be remarked:

265. **Head of a veiled woman,** in cornelian.

267. **Head of a woman,** resembling Faustina the younger: in green jasper.

130. **Mask of a Satyr,** in lapislazzuli.

XI.

In this compartment there are some modern copies of the ring bearing a Sphynx (N. 2458) which was used by Augustus as a seal and which was found in his tomb, at Corea, near Rome. This precious ring once belonged to the Riccardi museum, and was lately possessed by Mrs. Margaret Fiaschi-Frosini, who gave it to the Gallery in 1859. — For the description of this ring see *The Genealogy of the Count Guidi,* by Scipione Ammirato; *Firenze illustrata,* by Leopoldo Del Migliore and *The life of Richard Romulus Riccardi,* by Lami.

XII.

Engraved stones of the XV and XVI century.

371. **Portrait of Savonarola,** in cornelian. A splendid work of *Giovanni delle Corniole.*

372. **Bust of Pope Paul II,** in cornelian; once belonging to *Lorenzo il Magnifico.*

373. **Bust of Leo X,** in jade; a work of *Pier Maria Serbaldi da Pescia,* or perhaps of his rival *Michele di Paolo Foggini,* called *Michelino.* .

· 374. **Portrait of the same;** a seal in phorphyry.

334. **A marriage allegory,** in calcedony; attributed to *Valerio Vicentino.*

386. **Ring** ornamented with a head, in sapphire. A modern imitation of antique style.

Then follow eight glass-cases containing about 87 ancient cameos, 7 carvings in gold, 20 Etruscan scarabees and 403 ancient and modern engraved stones, all bequea-

thed to the Gallery by *Sir William Currie,* in 1863,
In this collection the *head of a nymph* engraved by
Dioscoride is worthy of particular observation.

On the wall opposite the window is a mask of *Dante,*
a plaster cast taken after his death. This mask was
bequeathed to the Gallery by the Marquis Charles Tor-
rigiani, in 1865.

On each side of this is a small case in the form of
a tripod: containing a number of ancient Roman jewels,
also the seal of the Medicis, bearing the word: COSMUS
R. P. FLOR. DUX. ET EJUS CONSILIARII: a work
of Dominic di Polo (1532).

PART THE SECOND

Frescoes on the ceilings of the Corridors.

The frescoes on the ceiling of the first corridor were executed by *Alessandro Allori*, *Gio. Maria Butteri*, *Giovanni Bizzelli* and *Alessandro Pieroni*, although they are commonly attributed to *Bernardino Poccetti* who is simply the author of the ornamental figures on the angles of the vault of the Tribune. The subjects are all mythological or allegorical; the style is that which Vitruvius describes (book VII, chap. V) and Raphael revived, and is now called *alla Raffaella*. The date MDLXXXI which is seen in the twentieth compartment of the first corridor, probably indicates the epoch in which the decoration of the vault was begun.

The frescoes of the 2d and 3d corridor were executed by *Cosimo Ulivelli*, *Angelo Gori*, *Jacopo Chiavistelli*, *Giuseppe Tonelli* and *Giuseppe Masini*, in the second half of the XVII century, on subjects suggested by Count Ferdinand Del Maestro and Laurence Panciatichi. The fire which invaded a part of the third corridor in 1762, completely effaced the decoration of the last twelve divisions of the vault, which were then remade by *Traballesi*.

The subjects treated in the frescoes of the first corridor are quite fantastical and grottesque, we shall

therefore only mention those of the second and third ones, which are as follows:

2d Corridor.

1. St. Charles Borromeo and St. Philip.
2. The foundation of the order of St. Stephen.
3. Etruria.
4. A personification of Sanctity, with a glory of several Florentin Saints.
5. Piety.
6. The General Council of Florence under Pope Eugene IV in 1439.
7. St. Dominic and St. Francis.
8. The principal virtues of the grand-dukes Cosmus I, Francis I, Ferdinand I and Cosmus II.

3d Corridor.

1. Florence.
2. Some Medicean princes, who reigned before Cosmus I.
3. Portraits of other personages of the Medici family.
4. Portraits of some notable Florentine men, who were liberal to their own town.
5. Fiesole, destroyed by the Florentines in 1010.
6. Portraits of some notable Florentine men, who were liberal to foreigners.
7. Portraits of Florentine men, who ruled on stranger countries.
8. Exploits of Florentine heroes, by sea.
9. Pisa, conquered by Florence in 1406.
10. Exploits of Florentine heroes, by land.
11. Fortune, as a favourer of the Florentine glories.
12. Hospitality of Florence to strangers.
13. Pistoia, famous on account of its civil discords between the Cancellieri and Panciatichi parties, and submitted to Florence in 1382.
14. Civil Prudence.
15. Magnificence in public and private buildings.
16. Erudition.
17. Arezzo: one of the old Etruscan towns; brought into the power of Florence in 1384.
18. Celebrated Florentine ambassadors.

19. Secretaires of the Florentine Republic.
20. Matematicks.
21. Volterra: one of the old Etruscan towns. It was subdued to the dominion of Florence in 1254.
22. Love of Country.
23. Love of Literature.
24. Theology.
25. The town of Borgo S. Lorenzo.
26. Jurisprudence and Legislation.
27. Montepulciano. Submitted to Florence in 1390.
28. Philosophy.
29. Cortona: an ancient Etruscan town. It fell under the domination of Arezzo in 1490, and was sold to Florence by king Ladislaus.
30. Politicks.
31. Musick.
32. Medicine.
33. The town of Colle. Submitted to Florence in 1349.
34. The Florentine Academies, foundend in different times.
35. Tuscan Eloquence.
36. Tuscan History.
37. The town of S. Miniato, founded by Desiderius king of the Lombards. and conquered by the Florentines in 1370.
38. Poetry.
39. Sculpture.
40. Architecture.
41. Prato: bought by the Florentine republic in 1350.
42. The Art of Painting.
43. Agriculture.
44. Leghorn. It was sold by the Genoese to Florence in 1421 and ows its prosperity to the decline of its rival Pisa.

Corridors.

Length of the first corridor	Meters	149,08
» of the second	»	39,47
» of the third.	»	147,57
Breadth of each corridor	»	6,40

Sala delle Copie.

In questa Sala gentilmente concessa dal R. Ministero della Pubblica Istruzione, non si trovano che le sole Copie eseguite dagli Originali, vidimate e autenticate da apposita Commissione. — Queste Copie non sono da confondersi con varie Ricopie che a prezzi minori si trovano in commercio.

Salle des Copies.

Dans cette Salle gracieusement concédée par le R. Ministère de l'Instruction Publique, on ne trouve que des Copies peintes d'après les Originaux et authentiquement reconnues par une Commission spéciale. — Il ne faut pas confondre ces Copies avec quelques Réproductions des Copies que l'on rencontre dans le commerce à un prix inférieur.

Copies-Exhibition-Room.

This room has been kindly granted by the R. Minister of Public Instruction for the exhibition of Copies taken from the originals and authentically admitted by a special Commission. — These Copies are not to be confounded with several re-copies sold at a lower price.

Saal der Copien.

In diesem Saale, der vom R. Ministerius des Unterrichts angewiesen worden ist, befinden sich nur Originalcopien, welche als solche von besonderer Comission beglaudigt worden sind. — Nicht zu verwechseln mit verschiedenen Recopien die sich oft zu geringen Preisen im Handel befinden.

PAINTINGS [1]

First Corridor.

1. UNKNOWN. — Greek-byzantine school. X Cent.

The Virgin and Child seated between two angels. Above the Magis, and on either sides the Apostles, half length, with their particular emblems.

Purchased in January 1889 from Mr. David Ricci at the price of 400 frs. and recognised as an old byzantine work of great value.

2. UNKNOWN. — Italian school. XII Cent. Byzantine style.

Madonna and Child. The Virgin seated on a throne formed with some cushions covered by a rich cloth. She wears a brown mantel and presses her divine Child to her breast, who is raising his little hand in the act of benediction. Two half length angels are hovering above; the back-ground is gilded and surrounded by a beautiful wreath of pink leaves.

The crusades had a great influence on Art, on account of the precious records that many of the christian warriors or pilgrims used to bring home from the oriental cities they happened to visit. It was just in

(1) Comm. Prof. Gaetano Milanesi has kindly afforded many notices about the names and some dates of the birth and death of the artists mentioned in this catalogue.

that time that those quaint brown images of the Virgin
attributed to St. Luca, who was then tradictionally
believed to be the most ancient of all Christian pain-
ters, were introduced into Europe, and so enthusiasti-
cally admired by our artists that from the eleventh
century to the beginning of the thirteenth Art was
plunged in darkness and barbarity, never succeeding
in extricating itself from the servile and crude imi-
tation of these primitive models.

3. UNKNOWN. — Italian school. XII Cent.

The Crucifixion. The feet of the crucified Lord are
nailed on separately to the cross; the head is a little
bent upon the breast; the eyes are open and staring;
the hair is long and falls from the middle of the fore-
head upon the shoulders. A golden girdle is round
the waist of the Saviour, from which a rich cloth, or-
namented with gold embroideries hangs down to the
knees. Above the head is a scroll bearing the words
in golden letters : *Jhs Nazarenus rex Judeorum.*

Both ends of the horizontal arm of the cross bear
the figures of the *Maries* (The left end having been
sawed off only one figures is preserved on this side).

Under these, along both sides of the Saviour are six
representations of small figures on golden ground viz :

1st Jesus Christ washing the feet of the Apostles.
2d Judas kissing his divine master.
3d The flagellation.
4th The deposition.
. 5th The entombment.
6th The resurrection.

The Crucifixion was one of the most favourite subiects
of Christian artists of the first period, and the Saviour
was then always represented alive on the cross, with
his feet nailed separately, the eyes open, the look either
calm or stern, following the commun belief that our
Lord was still alive when Longinus pierced his breast
with the spear. This error had been generally accepted
in Germany in the XIIth century through some insinua-
tions of a certain Peter John who was also supported

by the clergy. It was later spread in Italy and would probably have lasted for a long time, had not Clement V condemned it.

The influence that such disapproval of Peter John's opinion had on the way of representing the Crucifixion was not without a certain importance in the progress of art. The feet of our Lord continue to be separately nailed on the cross in the pictures of the first half of the XIIIth century according to the tradition which was still common with us at that time; but the crucified Saviour is then generally represented dead; the eyes are closed; the body is no more stiff, but bent under its own weight: the face is lined with deep wrinkles and bears the expression of long and dreary sufferings.

All this was certainly far from that scientific exactness of representation, which the study of anathomy later afforded to Art; it was yet evidently a step towards naturalism, a first attempt to animate artistic fictions by the expression of feeling and thoughts.

4. UNKNOWN. — Italian school. XIII Cent.

The Crucifixion. The feet of the Saviour are separately nailed on the cross; the eyes are closed in a convulsion which is visible in some almost grottesque contractions of the brow; the head is a little turned and bent; the nose is long and narrow; the mouth is broad and surmounted by a thin mustach; a short beard covers the chin. The back-ground is gilded; eight small compositions of diminutive figures are beneath the horizontal bar of the cross, representing the following subjects:

1st Christ arrested.
2^d *Ecce Homo.*
3^d The flagellation.
4th Jesus on the cross.
5th The deposition.
6th Christ buried.
7th The resurrection.
8th The eucharistic bread.

(The extremities and arms of the cross have been sawed off).

5. GUIDO DA SIENA (*Guido di Graziano*, called). Born 1278, died 1302.

The Virgin and Child.

A painter named Guido di Graziano was in Siena at the same time that one was in Florence, and did not only leave several splendid works, but was also the father of a family of artists, by whom art was honoured for more than half a century, so that it may be said that the Siennese school really received its first impulse from them.

This painting is a recent acquisition made by the hon. Thechnical Committee of the Florentine Galleries and Museums, after the recommandation of one of its members, Cav. Prof. Cristiano Banti, who was charged to examine the work and succeeded in proving its authenticity before his colleagues, who consequently consented to purchase it, as an object of art, which would fill up a void in the series of the antique specimens of primitive painting in our gallery.

Purchased from Mr. Murray.

6. PUCCIO CAPANNA, of Firenze. Flourished about 1349.

The Crucifixion.

7. UNKNOWN. — Tuscan school, XIV Cent.

The Virgin and Child, attended by St. Peter and St. Paul. — On the pedestal are three compositions, representing : *Christ in the sepulcre, The martyrdom of St. Catherine,* and *The martyrdom of another Saint.* — On wood. Diminutive fig.

8. GIOTTO (?). Born in 1266, at *Bondone* in the community of Vespignano in Mugello. Died in 1337.

Christ in the garden. On the pedestal two compositions in diminutive figures represent : *Christ betrayed by Judas,* and *Christ stripped for the crucifixion.* — On wood. Half life size figures.

9. UNKNOWN. — Tuscan school. XIV Cent.

The Virgin with the infant Jesus, St. John and St. Zenobius. The eternal above. On a golden background, in a gothic golden frame.

Taken from the Register-House of Florence.

10. UNKNOWN. — Tuscan school. XIV Cent.

St. Bartholemew, sitting on a chair and holding a knife in his left hand. Four angels are around him, two of which are playing on violins and kneeling. Above are three small panels in which our Saviour (half length) in the act of benediction, and two Prophets are represented.

It was brought to this Gallery from the suppressed Chamber of Commerce in 1782.

11. UNKNOWN. — Tuscan school. XIV Cent.

The Virgin sitting and holding the infant Saviour, and figures of angels around her, bearing pots, with lilies. St. John and St. Zenobius kneeling at her feet. — On wood; diminutive figures.

12. GIOTTO'S SCHOOL.

The Crucifixion, with small compositions on the passion of our Lord.

13. GIOTTO'S SCHOOL.

The Crucifixion. On golden back-ground. In the lower part of the painting is the Virgin, with St. John and St. Mary Magdalene.

14. ORGAGNA'S SCHOOL.

St. John the Evangelist, sitting on a chair, the right hand raised and an open book in the left. Above is a half length Christ with Seraphim and Angels. Under the feet ot the saint are three figures representing Pride, Avarice and Vanity. — On wood. Life size.

15. LORENZETTI Pietro di Lorenzo, of Siena. His works are known from 1327 to 1350.

The Holy Virgin and Child, and four angels on each side. — The name of the author is inscribed with the date 1340. — On wood. Half life size fig.

This painting was given to the Gallery by the Adv. Cellesi, in 1799.

16. LORENZETTI Pietro di Lorenzo, of Siena.

The Hermits of the Thebaid; representing episodes in the life of some penitents in the Thebaid desert.

This subject has been treated by the same artist in

the Camposanto at Pisa, but with a different composition. — On wood. Dim. fig.

17. GIOTTO'S SCHOOL.

A blessed soul taken up into Paradise, in the presence of some friends and the priest standing on the temple door. — On wood. Diminutive fig.

26. DADDI Bernardo. A florentine painter, died 1348.

An altar piece divided in three parts : in the middle is the Virgin with the infant Jesus, to the right hand St. Matthew the apostle and to the left St. Nicholas bishop. Under the gradino, the words : ANO . DNI . MCCCXXVIII FR. NICHOLAUS DE MAZINGHIS DE CANPI, ME FIERI . FECIT . P . REMEDIO . ANIME . MATRIS. ET FRATUM (*sic*) . BERNARDUS . DE . FLORENTIA ˙ . ME PINXIT. — On wood. Half life size fig.
From the Convent of Ognissanti in Florence.

20. UNKNOWN. — Tuscan school. XIV Cent.

The front side of an altar with an image· of *St. Cecilia*, surrounded by eight compositions, representing some events in her life, in small figures.
This painting was taken from the church of St. Cecilia to that of St. Stephen, and in 1841 it was brought to this Gallery. — On wood. Dim. fig.
Vasari erroneously attributes it to Cimabue.

21. UNKNOWN. — Tuscan school. XIV Cent.

The Virgin and Child attended by St. Michael and St. Matthew. Taken from the church af S. Angiolo di Nebbiano.

23. MARTINI Simone and MEMMI Lippo of Siena. — Simone born in 1285, died 1344. — Lippo born ..., died 1357.

The Annunciation. — This painting with the two ones which bear the numbers 8 and 10, formed one piece formerly, and hung in the Cathedral at Siena. It was then taken to St. Ansano church in Castelvecchio, and in 1799 it was brought to this Gallery. — Inscribed : SIMON MARTINI ET LIPPUS MEMMI DE SENIS ME PINXERUNT ANNO DOMINI MCCCXXXIII. — On wood. Half life size figures.

19. TADDEO GADDI'S SCHOOL.

A half length *Madonna,* holding the infant Jesus.
In the pinnacle the Saviour and two prophets : in
the gradino Pity and around her the Virgin, the Magda-
lene and six figures of other saints all diminutive and
half length. — On wood.

22. UNKNOWN. — Tuscan school. XIV Cent.

The Virgin and Child. Above *the Annunciation,* and
below, two coats of arms and the words : ODI LAUTRA
PARTE, from which it is supposed to have belonged
to the suppressed Tribunal of Justice. — On wood.

27. GIOTTINO (?)

This precious work of the XIVth century was erro-
neously attributed by Vasari to a certain Tommaso di
Stefano called *Giottino,* a Florentine painter.
Since two painters lived at the same time in Flo-
rence, one of whom was called *Maso* son of *Banco,*
inscribed among the artists before 1343 and in the as-
sociation of St. Luke (Compagnia di S. Luca) in 1350,
and the other *Giotto di Maestro Stefano* called *Giottino*
in order to distinguish him from his famous namesake,
Vasari confused the two names, creating out of these
two one imaginary artists whom he called Tommaso
di Stefano called Giottino. What Vasari affirms about
the author of this painting being then undoubtedly
erroneous, the best modern critics have long endeavoured
to find out whether it belonged to Maso di Banco or
Giotto di Maestro Stefano ; and although they did not
succeed in giving a sure answer to this question, it
is yet most probable, as Prof.[r] Milanesi and some others
remark, that this painting is the work of Maso di
Banco, whom Philip Villani, Sacchetti and Ghiberti
mention, and whom an unpublised document of that
time calls *a great master.* — On wood.

28. GADDI Angelo, of Florence, son and pupil to Taddeo. Born
about 1333, died 1396.

The Annunciation. Three small compositions are on
the pedestal: *the Nativity ; the Epiphany ; the Presen-
tation in the temple.* — On wood. Half life size fig.

29. NICCOLÒ DI PIERO GERINI, florentine painter. Inscribed among the artists on September 15th 1368, died in 1415.

The Saviour in the act of crowning his holy Mother. Underneath are some patron saints of Florence. In the gradino are seen the coats of arms of the Florentine Mint, which ordered this painting from Nicholas Gerini, who was helped in his work by master Simon, until Jacob of Lino another Florentine painter, completed in 1373.

Niccolò di Piero Gerini had been entirely forgotten among our painters and his name was only brought to light in 1820, when Latini engraved the representations of our Lord's passion in the assembly hall (*capitolo*) of St. Francis, where Niccolò had signed his name with the year in which he executed those frescoes.

This painting was taken to this Gallery from the suppressed office of the old Florentine Mint, on the 21st July 1863.

30. ANGELO GADDI'S SCHOOL.

St. Thomas touching the Saviour's breast. Above two prophets. — On wood.

From the Superintendence of the Chamber of Communities.

31. IACOPO DEL CASENTINO. Flourished in the half of the XIV Cent.

The Coronation of the Virgin. A triptyc : St. Francis and St. John the Baptist, St. Ivo and St. Dominic in the side panels. In the pinnacles *the Annunciation* in two separate figures, the Virgin on one side, the angel on the other and *Our Lord delivering souls from Limbo.* — On wood. Half life size fig.

33. UNKNOWN. — Tuscan school. XIV Cent.

A Saint giving alms to two beggars.

36. ORGAGNA (Andrea di Cione), a florentine painter, sculptor and architect. B. 1308, d. 1368.

The Annunciation. — On wood. Half life size.

32. MILANO (Giovanni da), pupil of Taddeo Gaddi. XIV Cent.

A picture in ten compartments, in gothic style. In each of the five compartments above are two saints : the compartments below which are smaller, contain

each a number of diminutive figures of saints, divided in choirs. In the first to the right is the choir of the *Prophets*, in the second are the *Patriarchs*, in the 3^d the *Apostles*, in the 4th the *Martyrs*, in the 5th the *Virgins*.

This precious work had been recognised by Baron Rumhor as the one mentioned by Vasari, which *Giovanni da Milano* executed for the church of Ognissanti in Florence, where it was still in fact when it was purchased by the Government in 1860 to place it in this Gallery. — On wood. Dim. fig.

35. UNKNOWN. — Florentine school. XIV Cent.

St. Martin, on a white horse in the act of cutting his own cloak in two parts with his sword and giving it to a beggar who is standing before him. On gold back-ground. Two chalices in bas-relief on the frame represent the coat of arms of the Taver keepers. — On wood. Dim. fig.

34. UNKNOWN. — XV Cent.

The Virgin sitting and holding the infant Jesus in the act of benediction. Six angels in adoration are around his head. — On wood. With golden ornaments.

Taken from the monastery of Santa Verdiana.

40. LORENZO MONACO, of Florence. B. 1370, d. 1425.

The Virgin and St. John both kneeling and holding the body of our Saviour. Above are the scenes of the passion, below two coats of arms and an inscription with the date 1404. A lunette in distemper. — On wood. Life size. — Bought from Mr. William Spence, on the 5th of July 1882.

37. SPINELLO ARETINO. Born 1333 circa, died 1410.

The Calvary. In the foreground is the Virgin fainting in the arms of the Maries. At the foot of the cross are St. Mary Magdalene and St. John kneeling: to the right is a group of soldiers throwing dice for the Saviour's vesture. — On wood. Dim. fig.

This painting was purchased in 1870.

38. UNKNOWN. — Tuscan school. XIV Cent.

The Holy Virgin and Child.

From the convent of St. Lucy in Via San Gallo in Florence.

39. LORENZO MONACO.

The Adoration of the Wise Men. This picture is very valuable on account of its composition, colouring and finish. *The Annunciation* and two *Prophets* which are seen above were not originally painted to adorn this picture, and are not equally antique. — On wood. Dim. fig.

41. THE SAME.

Triptyc. In the middle is the Virgin sitting on a throne with the divine Infant standing on her lap in the act of blessing. Behind the throne stand two angels in adoration. Right and left St. John the Baptist, St. Bartholemew, St. Taddeus and St. Benedict. In the three other compartments is the holy Saviour, the Angelical Messenger and the Virgin. Under the Madonna the words : « Ave gratia plena Dominus tecum. An. D. DCCCCX. » — On wood. Life size.

This painting was formerly in the subterranean oratory of the church of Monte Oliveto near Florence.

42. UNKNOWN. — XIV Cent.

The Virgin with the divine Infant enthroned. At her sides are two Saints. — On wood.

Purchased from Cavaliere Giuseppe Toscanelli for the price of L. 2750, and then believed to be a work of Cennini as the name of this author is written on the very painting, which signature is however now considered to be false.

43. STROZZI Zanobi, of the noble Strozzi family. A pupil of Fra Angelico. Born in Florence, on Nov. 17th 1412, died on Dec. 6th 1468.

Portrait of Giovanni Bicci de' Medici, in a red mantle. — On wood.

Vasari says : « In the Duke's storeroom were the portraits of Giovanni di Bicci de' Medici and Bartolommeo Valore, in one painting. » Now the commentators of Vasari affirm this portrait to be just that of Giovanni di Bicci de' Medici, which has been separated from the other in order to add, to the series of the portraits of the Medicis, that of this old countryman, who is the stock of the two branches of that princely family. It is also to be remarked that all other por-

traits of Giovanni di Bicci have been evidently copied from this one.

44. STROZZI Zanobi.

St. Lawrence, leaning on the gridiron, and holding a flag in his right hand and a book with a palm in the other. Above the figure of the saint, in a circular compartment is a half length figure of our Saviour. Two episodes of St. Lawrence's life are represented underneath on the base of the frame. — On wood. Life size.

45. BICCI di Lorenzo. Born 1350, died 1427.

St. Cosmus and St. Damian : two standing figures in full length. Above in the compartment, a half length *the Eternal ;* in the base of the frame two compositions representing episodes in the lives of these saints in diminutive figures.

This picture, which is perhaps the only authentic one, that is known, of this artist, was executed in 1429 for Anthony Ghezzi della Casa, and hung then long at a pillar in the cathedral, untill it was taken to this Gallery in 1844. — On wood. Life size.

46. UNKNOWN. — Tuscan school. XV Cent.

The Holy Virgin enthroned, and her divine Child on her arm, in the act of benediction; attended by St. John and St. Philip. Above two angels upholding a crown. — On wood.

Transferred from the suppressed Chamber of Commerce.

48. UNKNOWN. — XV Cent.

The Virgin sitting and holding the infant Saviour. On the right side stand St. John and St. Francis; to the left are the Magdalene and St. Paul.

Above is the Crucifix and to the left and right are St. Peter and St. Paul. — On wood.

49. UNKNOWN. — Tuscan school. XV Cent.

St. Catherine. — On wood.

Brought from the convent called de' Barbetti in Florence, on July 1867.

50. UNKNOWN. — Tuscan school. XV Cent.

St. Francis. — On wood.

Brought from the convent called de' Barbetti in Florence, on July 1867.

51. UNKNOWN. — Tuscan school. XV Cent.

The Holy Virgin with Child, attended by St. Anthony, St. John, St Peter and St. Sthephen. — On wood. Dimin. fig.

52. UCCELLO Paolo, of Florence. Born 1397, died 1475.

A combat between horsemen. According to Vasari, this is one of the four pictures, which Paolo Uccello executed by commission from the Bartolini family of Via Valfonda, and which, being much damaged by time, were restored by Julian Bugiardini. A painting similar to this is in the National Gallery in London (N.ʳ 583) and represents the Battle of St. Egidio in 1416, where Braccio da Montone makes Malatesta, the Lord of Rimini, a prisoner. Vasari says that several of the figures in these paintings are intended for some renowned Captain of Fortune of that time. In the right hand corner one reads: PAULI UCELI OPUS. — On wood. Half life size fig.

53. BICCI (Neri di), of Florence. Born 1419, died 1491.

The Annunciation, and the Eternal hovering above. Neri di Bicci in his Commentary mentions this painting, which he made in 1458 for the Compagnia di St. Andrea a Mosciano. as may be read in the inscription at the foot of the painting itself. — On wood. Half life size fig.

3437. VERROCCHIO'S SCHOOL.

The Virgin with the divine Son.

61. UNKNOWN. — XV Cent.

The Holy Virgin and Child: the infant St. John and two angels.

This painting has been judged to be the work of Fra' Damiante. — A tabernacle.

56. BALDOVINETTI Alessio, of Florence. Born 1422, died 1499.

The Annunciation. This paintings, which was origi-

nally made for the church of S. Giorgio sulla Costa, was believed to be lost, when it was rediscovered in the adjoining Monastery. It was brought to the Gallery in 1868. — On wood. Life size.

57. UNKNOWN. — Tuscan school. XV Cent.

The preaching and martyrdom of St. Peter the Martyr. To the left the saint is preaching to a crowd of listeners, through which a demon in the form of a black horse is rushing, in order to disturb their pious attention. To the right the saint is seen whom a soldier is striking on the head with his sword.

This painting is in the old inventories attributed to Dello ; a Florentine painter. — On wood. Dim. fig.

54. BICCI (Neri di).

The Holy Virgin. A two third length figure, sitting and turned to the left, with joined hands, and the divine child on her knees, with a pomegranate in his hands. Two angels hovering on each side are upholding a curtain. — On wood. Life size.

58. UNKNOWN. — Tuscan school. XV Cent.

The Epiphany. This painting is also attributed to Dello as the N. 57. — On wood. Dim. fig.

60. BALDOVINETTI Alessio.

The Holy Virgin seated and holding the infant Saviour ; attended by several saints. On her right St. John the Baptist, St. Cosmus, St. Damian, and St. Francis kneeling : on the left St. Laurenz, a hermit, another saint, and St. Dominic kneeling.

This picture hung formerly in the chapel of the royal villa of Cafaggiolo, and was brought to this Gallery in 1796. — On wood. Half life size fig.

62. UNKNOWN. — Tuscan school. XV Cent.

The game of the owl. Some young people playing at the game volgarly called *la civetta* (the owl) on an small square, by the gate of a town. The architecture of the buildings and the dresses of the people are Florentine.

Purchased on the 17th March 1781, from a certain

88 PAINTINGS

J. Perini, at the price of 20 Zequins. — On wood.
Dim. fig.

63. ROSSELLI Cosimo, of Florence. Born 1439, died 1507.

The Coronation of the Virgin. — On wood. Dimin.
figures.

66. BOTTICELLI'S SCHOOL.

*The banquet of Ahasuerus to the Lords of his king-
dom.* On the left under a bower is a laid table where
Ahasuerus is sitting in the midst of his princes, with
three musicians in the back-ground.

Some Lords come towards the table, two of whom
approaching it, kneel down. On the right Ahasuerus
followed by four Lords is represented walking along
a portico, where a fountain stands. An old man of
quality is kneeling at his feet; on the foreground of
this scene there is a deer. — On wood. Dim. fig.

This painting with the two following ones (67 and 68)
decorated the sides of an old trunk and were purchased
on the 6th of June 1781 from a certain Giuseppe Mo-
rellini, carpenter, at the price of six zequins.

See the register of the year 1781, volume XIV, to
be found in the archives of the Royal Gallery.

67. THE SAME.

The banquet of the queen Vasthi, wife of Ahasuerus.
On the right Vasthi in sitting at the table in the midst
of five ladies of honour while the eunuchs are coming
to her with the order to go to Ahasuerus. On the left
the arrest of Haman. — On wood. Small figures. —
See note to N. 66.

65. ROSSELLI Cosimo, of Florence. Born 1439, died 1507.

The Adoration of the Wise Men. This picture con-
tains several portraits, among which, according to Va-
sari, is that of Donato Acciajoli. Although Lanzi in
his *History of Painting* mentions this picture as exist-
ing in this Gallery yet it remained hidden and ignored,
until 1857, among the paintings which were kept,
excluded from the sight of the public, in the Corridor,
then shut and unfrequented, which unites the Palazzo
Vecchio to the Pitti Palace, and now the Ufizi and

the Pitti Galleries. Vasari attributes this work to Pe-
sello, but senator Morelli, in his book : *Le opere dei
Maestri Italiani nelle Gallerie di Monaco, Dresda, Ber-
lino;* Bologna, 1886, p. 353, thinks it to be rather the
work of *Cosimo Rosselli.* — On wood. Half life size fig.

68. BOTTICELLI'S SCHOOL.

Exaltation of Mordecai. He is seen of the left, dressed
in royal vestments, riding on a horse richly harnessed,
and preceded by Haman ; on his way he is met by two
children and two men who, stretching out their hands,
applaud him. On the back-ground, beyond a terrace
Haman is seen hanged. On the right, Ahasuerus, with
Esther at his side, walking under a portico They are
advancing towards a door, close to which Haman is
sleeping. In the foreground the king and queen are
talking with Mordecai who is sitting. — On vood.
Small figures. — See note to N. 66.

59. ROSSELLI Cosimo, of Florence. B. 1439, d. 1507.

· *The Virgin sitting and holding the infant Jesus on
her lap;* behind her, and at her side, stand two angels
in adoration with clasped hands. — On wood.
From the Royal Mint of Florence. September 1863.

79. BOTTICELLI?

The Virgin and Child with architectural back-ground,
A three thirds lenght figures. — On wood.

69. POLLAIOLO (Pietro del), of Florence. Born 1441, died 1489 ?

Hope. The figure of a woman seated in a bench, and
turned to the left, having her hands clasped on her
breast and looking towards heaven. — On wood.
Life size.
Vasari in his biography of this artist says : « Se-
veral allegorical figures of virtues were painted in the
market place of Florence all seated on bencher like
those on which judges sit. » Those of Pollaiolo are :
Faith, Hope, Charity, Justice, Temperance and Pru-
dence, which last is seen in the 3^d hall of the Tuscan
School, N. 1306, where the figure of Strenth by Botti-
celli is also placed, N. 1299.

70. POLLAIOLO (Pietro del).

Justice. A woman sitting in a bench like the preceding one, and holding a sword in her right hand. — On wood. Life size. — See note to N. 69.

71. THE SAME.

Temperance. A woman standing on a bench and holding with her right hand a golden vase from which she pours out water in a golden cup placed on her left knee. — On wood. Life size: — Se note to N. 69. .

72. THE SAME.

Faith. A woman also sitting in a bench, holds up in her right hand a chalice covered with a patine and in the other hand a crucifix in metal ornamented with precious stones. — On wood. Life size — See note to N. 69.

73. THE SAME.

Charity. A woman bearing a royal crown on her head is sitting on a bench and suckling a naked babe which she is pressing to her breast with her left arm while holding up a light with the right one. — On wood. Life size. — See note to N. 69.

64. ROSSELLI Cosimo.

The Madonna and Child. On each side of the chair is an angel. St. Anthony and St. Nicholas. — On wood.

84. PIERO DI COSIMO.

The Nuptial of Perseus disturbed by Phineas. Perseus is represented in the act of petrifying Phineas and his companions, by holding Medusa's head before their eyes — On wood. Dim. fig.

75. UNKNOWN. — Tuscan school. XV Cent.

A half length *Madonna* in a tabernacle, with the Child, in the act of stretching his arms up to her neck. Architecture in the back-ground. — On wood. Life size.

80. DOMENICO GHIRLANDAIO'S SCHOOL.

The Holy Virgin on a chair, with her Divine Child standing on her knee, and attended by S. Blasius, St. Francis and St. Anthony.

This painting was originally on wood, but it was

transferred to canvas by signor Botti of Venice, in order to secure it from further decay.

74. SIGNORELLI Luca, of Cortona. Born 1441, died 1532; a pupil of Pier della Francesca.

The Virgin holding her divine son on her lap, and four figures of shepherds behind. Above are two prophets painted in chiaro-scuro.

This picture was ordered by Lorenzo de' Medici. — On wood. Half life size.

3418. THE SAME.

Allegory.

This painting was purchased in 1895 by the Royal Ministery of Public Instruction.

81. PIERO di Lorenzo, called *Piero di Cosimo* (Rosselli). Born 1462, died 1521.

The Virgin Mary standing on a pedestal, attended by four·Saints : St. Margaret and St. Catherine kneeling before her : all looking up to the Holy Ghost.

Placed in this Gallery in 1804. — On wood. Life size.

83. THE SAME.

Andromeda delivered from the monster by Perseus. This is perhaps one of the pictures ordered by Francis del Pugliese and mentioned by Vasari, Vol. VII, p. 119. In the inventory of the Gallery of 1589, p. 30, this work is said to have been drawn by Leonardo da Vinci and coloured by Piero Rosselli. — On wood.

90. UNKNOWN. — Tuscan school. XVI Cent.

The Holy Virgin above, in an oval glory of little angels : Underneath are four saints. — On wood.

Taken from the Monastery of S. Vivaldo near Città di Castello.

82. PIERO DI COSIMO.

A sacrifice to Jupiter, to deliver Andromeda. — On wood. Dim. fig.

89. UNKNOWN. — Tuscan school. XV Cent.

The Holy Virgin suckling her Divine Child, with the infant St. John standing on her left. — The style of

this painting is very similar to that of Rodolfo del Ghirlandaio. — A round painting on wood.

Taken in 1889 from the R. Office of the Avvocatura Erariale, in Florence.

91. GERINO d'Antonio Gerini, of Pistoia.

A large painting, representing *the Virgin enthroned and Child,* attended by saints. St. Jacop, St. Cosmus, and St. Mary Magdalene on the right; St. Catharine, St. Peter and St. Dominic on the left. On the throne of the Virgin are the words: GERINUS ANTONII DE PISTORIO PINXIT MDXXIX.

This picture was in the convent of the nuns of Sala at Pistoia. — On wood. Life size fig.

Second Corridor.

93. ANDREA DEL SARTO, of Florence, B. 1486, d. 1531.

The Saviour appearing to the Magdalene, under the figure of a gardener. — On wood.

92. UNKNOWN. — Tuscan school. XV Cent.

The Holy Virgin and the infant Saviour with the child St. John in the act of offering a rose to his divine companion. — A nound painting, on wood. Half life size fig.

86. UNKNOWN. — Tuscan school. XV Cent.

The Holy Virgin and Child.

Taken from the office of the R. Court of Appeal. — On wood.

87. VERDI Francesco d'Ubertino, called *il Bachiacca.* B. 1494, died 1557.

The Crucifixion. — This painting was brought to this Gallery, from the convent of Santa Maria Maddalena de'Pazzi in 1867. — On wood. Life size.

55. UNKNOWN. — Tuscan school. XV Cent.

The last judgement. Above is Christ in the act of blessing and on his left the Virgin praying for mercy

to her divine Son, surrounded by the Apostles. Beneath are two allegorical choirs of angels: the angels of the Passion and Resurrection, and under these are the blessed and the wicked with demons tormenting and dragging them down to hell.

On the reverse of this painting is the figure of an angel playing a flageolet, and two coats of arms. — A polygonous panel.

Taken from the convent of Annalena, in Florence.

78. BOTTICELLI'S SCHOOL.

A half length *Madonna,* bearing her divine Son on her arms. — On wood.

Third Corridor.

78. LUTI Benedetto, of Florence. Born 1666, died 1724.

Moses delivered from the waters. — On canvas. Life size.

3430. UNKNOWN.

Portrait of a child. — On canvas. Life size.

3412. ANDREA'S SCHOOL.

Portrait of a gentlewoman. — On canvas. Life size.

634. FLEMISH SCHOOL.

Jesus presented to the people. — On wood. Dim. fig.

80. MANSUETI Giovanni, of Venezia. B. 1450 (circa), died 1500.

Jesus among the Doctors, with a remarkable architectural back-ground. — On canvas. D. fig.

The composition of this painting is rich with a great variety of figures in strange oriental dresses. On the lower edge of the canvas one reads: JOHANNES DE MANSUETIS FACEBAT.

It was bequeathed to this Gallery by Cav. Niccolò Puccini, in 1852.

3402. SUSTERMANS Just. Born in Antwerp in 1597, died in Florence on april 24th 1681.

A young warrior. — On canvas. Life size.

1190. SUSTERMANS Just, of Antwerp. Born 1557, died in Florence on april 21st 1631.

Portrait of Francesco dei Medici, in an oriental dress. — On canvas. Life size.

3455. THE SAME.

Portrait of a young buffoon. — On canvas. Life size.

150. UNKNOWN. — (School of Van-Dyck).

The Virgin with the infant Jesus, St. Mary Magdalene, David, and other saints. — Brough from Vienna in 1793. On canvas. Life size.

796. FLEMISH SCHOOL.

A wedding dance.

1391. SUSTERMANS Just.

Portrait of an unknown man. — On canvas. Life size.

1188. THE SAME.

Portrait of an unknown man. — On canvas. Life size.

3456. UNKNOWN.

Portrait of Ferdinando II. — On canvas. Life size.

1207. UNKNOWN.

Portrait of Bianca Cappello.

152. G. HONTHORST, called *Gherardo delle Notti.*

A Gipsy telling an young woman's fortune, and other figures. A little more than half length. — Life size. On canvas.

3413. PIERO DI COSIMO.

Portrait of an unknown man.

3414. UNKNOWN.

Portrait of Catherine Sforza. — On canvas.

3453. SUSTERMANS Just.

Portrait of an unknown woman. — On canvas. Life size.

88. MANGLAND Adrian, of Lyon. Born 1695, died 1760.

View of a sea port. — On canvas.

91. MICHELI Andrea, called *Andrea Vicentino*. Born 1539, died 1614.

The queen of Sheba offering her jewels to Salomon. — On canvas. Life size.

90. MANGLARD Adrian.

A sea port. — On canvas.

3429. FLEMISH SCHOOL.

Portrait of a gentlewoman.

3403. POURBUS Francis, of Antwerp. B. 1570, d. 1622.

Louis XIII of France. — On canvas. Life size.

95. UNKNOWN. — School of Paolo Veronese.

Resurrection of Lazarus. — On canvas. Life size.

79. HEMBRECKER Teodoro, of Harlem. Born 1624, died 1694.

A masquerade in a village. — On canvas. Dim. fig.

3404. POURBUS Francis.

Louis XIII of France. — On canvas. Life size.

3425. BRONZINO Angelo, of Florence. B. 1502, d. 1572.

Cosimo I dei Medici. — On wood. Life size.

3408. CASTIGLIONI Gio. Benedetto, of Genova. B. 1616, d. 1670.

Beasts behind an army. — On canvas. Dim. fig.

3405. EMPOLI (Iacopo Chimenti, of Florence, called l'). Born 1551, d. 1640.

Portrait of Gio. Batta. Gambetti. — On wood. Life size.

82. BATONI Pompeo, of Lucca. Born 1708, died 1787.

Achilles in female attire at the court of Lycomedes; recognised by Ulysses, who surprises him while, among various jewels and other feminine ornaments, he choses a sword, which Ulysses himself had just put there for that purpose. — On canvas. Half life size fig.

Both this painting and N.ʳ 81 were purchased from the Bonfisi house in Lucca, in 1836.

81. THE SAME.

The education of Achilles, by the centaur Chiron. — On canvas. Half life size fig.

107. FYTT John, of Antwerp. Born 1609, died 1661.

Some poultry scared by the presence of a falcon perched on the branch of a tree. — On canvas. Life size fig.

106. UNKNOWN. — Canaletto's school.

St. Mark's square at Venice. — On canvas.

3424. SUSTERMANS Just.

Vittoria della Rovere Grand-duchess of Tuscany. — On canvas. Life size.

3426. THE SAME.

Ferdinand II Grand-duke of Tuscany. — On canvas. Life size.

96. DA PONTE Francesco, called *il Bassano.*

The supper at Emmaus. — On canvas. D. fig.

97. THE SAME.

Christ in the house of Lazarus. — On canvas. Half life size fig.

3395. DA PONTE Iacopo, also called *il Bassano.* Born at Bassano in 1510, died 1592.

The announcement to the shepherds. — On canvas. Dim. fig.

3397. SUSTERMANS Just.

Portrait of an unknown young man. — On canvas. Life size.

114. ROOS Philip, of Frankfort, called *Rosa da Tivoli.* Born 1655, died 1705.

Sheep and cattle, in the environs of Rome. — On canvas.

3398. SUSTERMANS Just.

Portrait of an unknown young woman. — On canvas. Life size.

3428. POURBUS Francis (the young), of Antwerp. Born 1570, died 1622.

Portrait of a gentlewoman.

3396. SUTERMANS Just.

Portrait of an unknown young man. — On canvas. Life size.

132. TIERCE Jean Baptiste. A French artist of the XVIII Century.

The fall of the Teverone, at Tivoli, called *Le Cascatelle.* Subscribed « J. B. TIERCE F. 1782. » — On canvas. Life size.

3401. SUSTERMANS Just.

Portrait of an unknown man dressed with armature traversed with a red sharp. — On canvas. Life size.

3447. POURBUS Francis (the young), of Antwerp. Born 1570, died 1622.

Louis XIII of France. — On canvas. Life size.

1106. LANFRANCO Giovanni, of Parma. B. 1586, m. 1647.

St. Peter. — On canvas. Life size.

3415. POURBUS Francis.

Louis XIII king of France. — On canvas. Life size.

101. SUSTERMANS Just (the young).

St. Mary Magdalene penitent. The features resemble those of Vittoria della Rovere, wife to Ferdinand II de' Medici. — On canvas. Life size.

3410. POURBUS Francis, of Antwerp. B. 1570, d. 1622.

Portrait of a young Princess. — On canvas. Life size.

3406. SUSTERMANS Just.

Portrait of a young man. — On canvas. Life size.

127. BOUGET Didier, of Chantilly. — XVIII Cent.

A landscape, executed with remarkable fineness of detail. A mountain in the distance seems intended for the Monte Mario. — Subscribed: « D. BOUGET, Rome 1792. » — On canvas.

3411. POURBUS Francis.

Portrait of a young Princess. — On canvas. Life size.

207. DOLCI Carlo, of Florence. Born 1610, died 1687.

Santa Galla Placidia. — On canvas. Life size.

129. RESCHI Pandolfo.

A landscape, with figures, representing the building of a nunnery. — On canvas. Dim. fig.

120. UNKNOWN.

Our Saviour ascending Mount Calvary. — On canvas. Dim. fig.

148. HONTHORST Gerard, called *Gherardo delle Notti.* Born at Utrecht in 1592. The epoch of his death is uncertain: it is believed to be either in 1666 or in 1680.

A supper, by candle light. — Half lenght, life size figures. On canvas.

133. COSTA Francesco, of Genoa. Born 1672, died 1740.

A view of ruins on the sea shore, with figures representing *the rape of Europa.* — On canvas. D. fig.

3410. DOUVEN cav. J. Francis, of Roermont (Ruremonda). B. 1656, died 1727.

Portrait of John William Palatine Elector. — On canvans. Life size.

112. BONONE (or Bononi) Carlo, of Ferrara. B. 1569, d. 1632.

St. Peter delivered from prison. — On canvas. Life size.

634. DA PONTE Francesco, called *il Bassano.*

The Ark of Noah. — On canvas. Dim fig.

122. THE SAME.

The Ark of Noah floating on the waters. — On canvas. Dim. fig.

134. RESCHI Pandolfo, of Danzink. Born 1643, died at S. Jacopo Sopr'Arno, on august 17th 1699.

A landscape, with soldiers assailing a nun, on a bridge. — On canvas. Dim. fig.

137. MANNOZZI Giovanni, called *Giovanni da S. Giovanni.*

The wine joke of Pievano Arlotto. — Affresco. Half life size fig.

146. MIREVELT Michæl.

Portrait of a man. He is dressed in dark and holds the gloves in his left hand. — On wood. Life size.

145. FAES Peter.

Portrait of Lord Ossory, general in the English army. — On canvas. Half lenght. Life size.

3400. SUSTERMANS Just. Born in Antwerp in 1597, died in Florence on april 24th 1681.

St. Marguerite. She is seating and holds a book and a palm in the left hand, in the right she holds a cross. At her feet is a monster. — On canvas. Life size.

3429. BRONZINO Angelo.

Portrait of a gentlewoman. — On wood. Life size.

3431. THE SAME.

Portrait of a gentlewoman. — On wood. Life size.

143. FLEMISH SCHOOL.

Portrait of a gentlewoman. She is standing, dressed in dark, and holds a book in her left hand. — On wood. Life size.

142. FAES Peter, called *il Cavalier Lely.* Born at Soest in Westphalia in 1618, died at London in 1680.

Portrait of Robert Prince Palatine, English general. A half length figure. — On canvas. Life size.

3393. ROSA Salvatore.

A landscape. Given to the Gallery by the chev. Arthur de Noè Walker in 1893. — On canvas.

3432. BRONZINO Angelo.

Portrait of a gentlewoman. — On wood. Life size.

3433. THE SAME.

Portrait of a gentlewoman. — On wood. Life size.

3430. SUSTERMANS Just.

Portrait of a young man. — On canvas. Life size.

93. BONIFAZIO Veronese. Born 1491, died 1553.

Holy family. — On canvas. Half life size fig.

3407. ALLORI Cristofano, of Florence. B. 1577, d. 1621.

The Magdalene. — On canvas. Life size.

715. UNKNOWN — XV Cent.

A landscape.

3394. RENI Guido. B. at Calavenzano, near Bologna, in 1575, died 1642.

The Virgin of the Snow, and two Saintes. — On canvas. Life size.

Given to the Gallery by chev. Arthur de Noè Walker in 1893.

720. UNKNOWN. — XVII Cent.

A landscape.

40. BRILL Paul.

A landscape. — On canvas.

3409. CARDI Lodovico, called *il Cigoli.* ·

The Magdalene. — On canvas. — Half life size.

128. CASTELLI (or Castello) Valerio, of Genova. Born 1625, died 1659.

The rape of the Sabines. — On canvas. Half life size fig.

1253. PIERI Stefano, of Florence.

The sacrifice of Abraham. — On canvas. Life size.

33. UNKNOWN. — School of Andrea del Sarto.

The Holy Virgin with the infant Saviour and St. John. A copy of the celebrated fresco, which formerly existed in a shrine near Porta a Pinti; and was destroyed in 1530.

Original Drawings
of ancient great Masters.

The Florentine Gallery already possessed one of the rarest collections of original drawings by the greatest Masters (about 40,000) when in 1866 the distinguished sculptor Prof. Emilio Santarelli, added the splendid present of his own collection, consisting of not less than 12,461 pieces.

We cannot certainly give here a detailed and general catalogue of such a considerable number of works, and

must therefore confine ourselves to affording a few historical notice concerning these unrivalled drawings.

George Vasari in his biographies of the Artists (*Vite d'Artefici*) often speaks of an album he possessed, in which he had gathered several drawings of the most celebrated Italian Artists of his time. He also mentions a similar collection made by Vincenzo Borghini. Of this no notice has reached us; but as to that of Vasari it is almost certain that the greatest part of the drawings were purchased by Cardinal Leopold de' Medici, and were the nucleus of the present collection.

Several drawings, by Gaddi, Michelozzi and Hugford, were then added and in 1709 they were all taken from Palazzo Pitti to this Gallery, where however a few of them were shown to the public, and not before 1854.

In 1866 a new selection of the best pieces of the collection was brought out and ranged with the others in the corridor which runs over the Ponte Vecchio, and finally in 1882 they were provisionally taken into these rooms where their preservation is better secured.

In 1891 another great part of drawings has been exhibited in the first and second corridor, in manner that all drawings have been definitively and rationally classificated.

They are subdueed in two great categories: the first, who is in the three halls, comprends the drawings of masters of all schools, from the XIII Century till the first half of the XVI; the second, who is sistemated in the two mentioned corridors, is formed by the drawings of the second half of the XVI Century till the end of the XVII.

We give here simply the names of the principal artists to whom the most remarkable of these drawings belong, in order to give an idea of the extraordinary importance of this famous collection.

XIV Century.

Taddeo and Angelo Gaddi — Lorenzo di Bicci — Lorenzo Ghiberti — Pisanello — Simone Martini.

XV Century.

Beato Angelico — Andrea del Castagna — Paolo Uccello — Luca della Robbia — Masaccio — Benozzo Gozzoli — Fra Filippo Lippi — Antonio and Piero del Pollaiuolo — Andrea del Verrocchio — Luca Signorelli — P. Perugino — Domenico Ghirlandaio — Lorenzo di Credi — Leonardo da Vinci — Botticelli — F. Squarcione — Gentile and Giovanni Bellini — Andrea Mantegna — Carpaccio — Liberale da Veróna — Giorgione — Schongauer — Israel Van Meckeln.

XVI Century.

Raffaello — Michelangiolo — Fra Bartolommeo — M. Albertinelli — Andrea del Sarto — Baldassarre Peruzzi — Beccafumi — Il Sodoma — Giulio Romano — Tiziano — Sebastiano del Piombo — Il Pordenone — Giovanni da Udine — Tintoretto — Paolo Veronese — Correggio — B. Cellini — Pierino del Vaga — Baroccio — Alberto Durer — Holbein — Luke of Leyden — Rubens — Van Dyck.

XVII Century.

Guido Reni — Domenichino — Albano — Lo Spagnoletto — Guercino — Salvator Rosa — Borgognone — Luca Giordano — Callot — Poussin — Murillo — Velasquez.

Sketch and Pastel Rooms
& the Collection of small Portraits.

The first of these two rooms originally contained the collection of paintings presented by the Marquis Paolo Feroni and since transferred to the *Cenacolo di Foligno* in Via Faenza; in the second were exhibited the bronzes, now removed to the National Museum in this city.

At present the halls contain all the drawings which were on view in one of the rooms of the Gallery of Ancient and Modern Art, many of them by Fra Bartolommeo, Baroccio, Allori, Raphael, Andrea and Poccetti, together with architectural and ornamental designs placed in frames around two of the columns, and a number of sketches taken from the store-rooms, including many by S. Rosa, Baroccio, Zuccheri, Parmigianino, Bassano, Tintoretto, Pinelli, Beccafumi, Vasari, Manetti, Sorri and Cigoli. In the second hall is be seen a collection of life-size portraits in pastel, many being by Giovanna Fratellini and some by Volterrano, a collection of small portraits of the highest interest and exceptional delicacy, and a number of miniatures among which are examples by Giulio Clovio and Stefaneschi.

Hall of Niobe.

139. SUSTERMANS Just, of Antwerp. Born 1557, died in Florence on april 21st 1681.

The Florentine Senate swearing fidelity to Ferdinand II. (Authentic portraits). — On canvas. Life size.

140. RUBENS Peter Paul, of Cologne. Born 1577, died in Antwerp 1640.

Henry IV at the battle of Ivry. A wonderful composition and splendid execution although the painting is not finished. Both this picture and the other on the opposite wall (N.ʳ 147) were executed to adorn the Luxembourg palace, in the celebrated series of paintings intended to represent all the principal episodes of the life of Henry IV, and Maria de' Medici. — They were both brought from the Pitti Gallery in 1773. — On canvas. Figures larger than life.

147. THE SAME.

Entry of Henry IV into Paris, after his victory at Ivry. The execution of this painting is less imperfect than that of N.ʳ 140, but it is probably not entirely by Rubens. — The figures are above life size. On canvas.

Hall of Baroccio.

154. BRONZINO Angelo.

A portrait of Lucretia dei Pucci, wife to Bartho-lemew Panciatichi. (See N.ʳ 159). — A half length, on wood. Life size.

211. SALAINO (or Salai) Andrea, of Milan, pupil of Leonardo da Vinci.

The Holy Virgin and St. Anna, caressing the infant Jesus, who is plaing with a lamb.

This painting is a diminutive copy of the celebrated one by Leonardo da Vinci existing in the Louvre Museum, N.ʳ 481. — It was brought to this Gallery ·in 1743. — On wood.

156. SODOMA (Bazzi Gio. Antonio, of Vercelli, called *il*). Born 1477, died at Siena 1549.

Seizure of Christ by the soldiers. — Half length, life size figures. — On wood.

157. HONTHORST, called *Gherardo delle Notti.*

The Virgin, the infant Jesus, St. Joseph and two angels. A glory issuing from the figure of the holy Child, lights the whole scene, with an admirable effect. — On canvas. Life size.

This painting was taken from the Poggio Imperiale Villa, in 1796.

158. BRONZINO Angelo, of Florence. B. 1502, d. 1572.

Descent from the Cross; the holy Virgin receiving our Lord's body in her arms; St. John and several other personages. Some angels hover above the scene, bearing some emblems of the Passion. — On wood. Life size.

159. THE SAME.

Portrait of Bartholemew Panciatichi. — On wood. Life size. — See N.ʳ 154.

181· LANFRANCO (or Lanfranchi) Giovanni.

St. Peter, weeping. — Half length. On wood. Life size.

161. UNKNOWN.

Portrait of a man. (Half length). — On canvas.
Life size.

199. UNKNOWN. — Flemish school.

Portrait of the sculptor Francavilla. — Half length.
Life size. On wood.

3448. POURBUS Francis.

Portrait of a young Princess.

163. SUSTERMANS Just.

Portrait of Galileo Galilei; the bust. — On canvas.

164. POURBUS Francis.

Portrait of the sculptor Francavilla. The head alone.
— On canvas. Life size.
Brought to this Gallery in 1798.

165. DOLCI Carlo, of Florence. Born on may 25th 1616, died
on january 17th 1687.

The Virgin, the infant Jesus and St. Solomea, in the
clouds, in the act of appearing to St. Louis Bishop
of Toulouse, who is kneeling before the altar. A large
painting made by commission of the Canon Bocchineri,
for the church of St. Francis in Prato. — On canvas.
Life size.

172. BRONZINO Angelo.

Portrait of Eleonora da Toledo, the wife of Co-
smus I, at whose right hand stands her son Ferdinand I.
— Two thirds lenght. — On wood. Life size.

183. CARLONE Andrea, of Genoa. Born 1639, died 1697.

St. Mary Magdalene. — A nudity half length. .Life
size. On canvas.

173. FRANCESCHINI Marc'Antonio, of Bologna. Born 1648,
died 1729.

Omnia vincit amor. Cupid in the act of throwing an
arrow, and treading upon various emblematical objects.
— On canvas. Life size.

169. BAROCCIO (Fiori Federigo, called *il*) of Urbino. Born 1528, died 1612.

The Holy Virgin begging the Saviour to bless some pious noblemen, who are giving alms.

This great composition so rich of fine figures, is known under the name of *Madonna del Popolo*, and was executed for the *Fraternità* of Arezzo, whence it was brought to this Gallery in 1787. It bears the name of the author, and the date 1579. — On wood. Life size.

763. SUSTERMANS Just.

The portrait of princess Claudia, the daughter of Ferdinand I de' Medici, and wife of the Archduke Leopold of Austria. — Taken from the Royal Pitti Palace in 1861.

166. SOGLIANI Gio. Antonio, of Florence. Born 1492, d. 1514.

The Virgin, Child and St. John. — On wood. Life size.

168. ARETUSI Cesare, of Bologna. Born, died 1612.

Portrait of John Aigemann; whose name is written on the painting itself: *Johannes Aigemanus, Alemanus, anno aetatis LXXXIII, 1611.* — On wood. Life size.

174. LANFRANCHI (or Lanfranco) Cav. Giovanni di Stefano, of Parma. Born 1581, died 1647.

St. Mary Magdalene, laying one hand on a skull. — On canvas. Half life size.

175. PIPPI Giulio, called *Giulio Romano*. Born at Rome 1499, died 1546.

Portrait of Cardinal Accolti, of Arezzo. — A dimin. fig. On wood.

176. DONDUCCI Gio. Andrea, of Bologna, called *Mastelletta*. Born 1575, died 1655.

Charity. — On wood. D. fig.

177. BELLINI Giovanni, of Venice. Born 1427, died 1516.

Portrait of an old man. — On wood. D. fig.

178. ALLORI Alessandro, of Florence. Born in 1535, died on september 23d 1607.

The Samaritan. — On canvas. D. fig.

179. ALLORI Alessandro.

The marriage 'feast at Cana. A rich composition of many figures, which was made for the church of Sant'Agata in Florence. — On wood. Life size.

180. RUBENS.

Portrait of Helen Forman, the painter's second wife. — On wood. Life size.

162. RENI Guido, of Bologna. Born 1575, died 1642.

The Cumean Sybil, holding a sheet of paper on which is written: *Nascetur de Virgine.* — One third lenght. Life size. On canvas.

205. ALLORI Alessandro.

A portrait, supposed to be that of Torquato Tasso. Purchased in 1868. — On canvas. Life size.

206 *bis.* MARATTA (or Maratti) Carlo, of Camerino in the Marca d'Ancona. Born 1625, died in Rome 1713.

Head of the Saviour; in profile. — On wood. Life size.

206. BAROCCIO (Federigo Fiori).

Portrait of a young woman. — On canvas. Life size.

185. DOUVEN cav. J. Francis.

Portrait of Elisabeth Haurey, the daughter of Haurey, Baron of Hendrovich. — Full length. On canvas.

184. AMERIGHI (or Morigi) Michelangelo, of Caravaggio near Milan, called *il Caravaggio.* Born 1569, died at Porto Ercole in 1619.

Christ among the Doctors. — Half lengths. Life size. On canvas.

186. DOLCI Carlo.

St. Mary Magdalene, holding the vessel of balm between her arms, crossed on her breast. — On canvas. Half length. Life size.

192. SUSTERMANS Just.

Portrait of a man dressed after the Swiss fashion. Half length. Life size.

198. BRONZINO Angelo.

Portrait of a young woman. — Half length. Life size. On wood.

187. GUERCINO (Barbieri Gio. Francesco, called *il*). Born at Cento in 1591, died 1666.

Head of St. Peter. — Brought into the Gallery in 1862, from the Villa del Poggio Imperiale. — On canvas. Life size.

190. HONTHORST G., called *Gherardo delle Notti.*

The adoration of the Shepherds, with the Virgin and St. Joseph and hovering Angels. — On wood. Life size.

This splendid painting was formerly in St. Felicita church in Florence, and was brought into the Gallery in 1836, by concession of the Guicciardini family, to whom it belonged.

191. SALVI Gio. Battista, called *Sassoferrato,* after the name of his native town. Born 1605, died 1685.

The Virgin in sorrow. — Half length. On canvas. Life size. Belonging to this Gallery since 1792.

3427. SUSTERMANS Just.

Portrait of a young woman. — Half length. On canvas. Life size.

193. ALLORI Alessandro.

Portrait of Julian de' Medici, Duke of Nemours. Half length. Supposed to be a copy from Raphael. — On wood. Life size.

160. CAMBIASO Luca, of Genoa. Born 1527, died 1585.

The Virgin, holding the infant Saviour. — On canvas. Half length.

195. CARAVAGGIO.

The Pharisee showing the piece of money to Christ. — The same size of N.ᵣ 184.

196. VAN-DYCK Anthony. Born in Antwerp in 1599, died at Blackfriars near London 1641.

Portrait of the Princess Margaret of Lorraine, the wife of Prince Gaston of France. — Full length. Life size. On canvas.

144. VAN-DYCK Anthony, of Antwerp. Born 1599, died 164!.

A portrait supposed to represent the mother of Sustermans. — On canvas. Life size.

189. BECCAFUMI Domenico, of Siena, called *il Mecherino*. Born 1486, died 1551.

Holy Family, painted on a round board. — Half lengths. Half life size. Brought to the Gallery in 1795.

200. UNKNOWN.

The portrait of an old man, and a statuette, representing the Venus of the Medicis. — On canvas. Life size.

182. MAZZUOLI Francesco, of Parma, called *il Parmigiano*. Born 1594, died at Casalmaggiore on august 24th 1640.

Portrait of a Turkish Slave, holding a feather fan in her left hand, and wearing a turban on her head.

188. DEL SARTO Andrea, of Florence. Born 1487, died on january 22d 1531.

Portrait of a woman in a blue dress, holding an open book. — On wood. Half length. Life size.

201. UNKNOWN.

A young man. — On canvas. Life size.

202. UNKNOWN.

The Virgin and Child. — Half length. Life size. — On canvas. — Brought to this Gallery in 1862.

194. FRANCESCHINI Baldassarre, of Volterra, called *il Volterrano*. Born 1611, died 1689. ·

St. Peter. Half length. — On canvas. Life size.

3399. RENI Guido.

Susanne, surprised by the two old men.

This painting was given to the Gallery by chev. Arthur de Noè Walker in 1895.

204. LUINI (or Lovini) Aurelio, the son of the celebrated Bernardino. Born at Luino on the Lago Maggiore in 1530, died 1590.

The Virgin with the infant Jesus, St. Anna, St. Margaret, St. Mary Magdalene etc. — On wood. Life size.
This painting was brought into this Gallery in 1793.

213. BUGIARDINI Giuliano, of Florence, Born 1475, died 1554.

The Virgin suckling her divine Son. A full length. — On wood. Life size.

208. BAROCCIO (Federigo Fiori).

St. Francis, receiving the stigmata. — On canvas. Life size.

Brought to the Gallery in 1798.

1113. RENI Guido.

The Holy Virgin in full face, looking up with her arms crossed on her breast. — A half length. — On canvas. Life size.

210. VELASQUEZ DE SILVA Don Diego, of Seville. Born in 1599, died 1660.

Portrait of Philip IV King of Spain, on horse back. Three allegorical figures hovering above, are probably the work of another hand, as well as that of the attendant bearing the helmet, who stands in the lower corner of the painting, behind the principal figure.

The tuscan celebrated sculptor Pietro Tacca is said to have modelled his equestrial statue of Philip IV, from this painting. — On canvas. Life size.

3451. BUGIARDINI Giuliano.

The Virgin with the Infant Jesus and little St. John. The Virgin kneeling, is holding by an arm the Holy Child standing on a rock and looking at little St. John who is kneeling near Her.

On the back-ground of the painting there is to be read: — Julianus Florentinus faciebat 1520. — On wood. Dim. fig.

212. BAROCCIO.

Christ and the Magdalene. Brought into this Gallery in 1798. — On canvas. Half life size fig.

155. UNKNOWN. — Tuscan school.

Portrait of the benedectine monk Theophilus Folengo, better known under the name of *Merlino Coccai,* on account of his celebrated burlesque poem. — A half length, life size figure, painted on wood.

216. RUBENS Peter Paul.

A bacchanal. Silenus in the middle of the painting, laying his right foot on the back of a tiger; left and right of him are two children; a Faun and a Bacchante stand behind bearing bunches of grapes. — Life size figures. On canvas.
This painting was brought from Vienna, in 1793.

217. SEGHERS Gerard, of Antwerp. Born 1589, died 1651.

The Conception. A large allegorical composition. The Holy Virgin bearing the Divine Child on her arms, lays her feet on three chained demons. Adam and Eve driven from Eden are seen at a distance. — On canvas. Life size.

167. BRONZINO Angelo.

Portrait of a woman, in a black dress, holding a cameo in her right hand. A statuette, behind the figure, on a table. — On wood. Life size.

171. CARACCI Annibale, of Bologna. Born 1560, died 1609.

A man laughing and holding a monkey on his shoulders. A half length. — On wood. Life size. — Bought in 1793.

170. THE SAME.

Portrait of a monk. (The bust). — On canvas. Life size.

219. ROSSI Francesco, called *Cecchin Salviati,* of Florence.

Christ bearing his cross. Half length. — Life size. Brought from the Poggio Imperiale Villa in 1862.

214. LIPPI Lorenzo. Born 1606, died 1664.

St. Catharine. Half length. An oval painting, on canvas. — Life size.
Discovered in the store-rooms of this Gallery in 1861.

218. LIPPI Lorenzo.

St. Agatha. — The same shape and size of N. 214. On canvas. Life size.

221. CARDI Lodovico, of Cigoli near Florence, called *il Cigoli.*
Born 1559, died 1613.

St. Francis. — Half lenght. On canvas. · Life size.

220. SNYDERS (or Sneiders) Francis, of Antwerp. Born 1579,
died 1657.

The Boar Hunt. The boar is assailed by two hun-
ters armed with pitch forks, and by a set of hounds,
some of which have been repulsed and wounded.

This painting is in a perfect state of preservation,
and is one of the best works of this celebrated painter
of animals. It was brought from Vienna in 1821. —
On canvas. Life size.

222. ALBANO Francesco, of Bologna. Born 1578, died 1660.

The infant Jesus in the midst of Angels who offer
him the instruments of the Passion. A circular pain-
ting. — On canvas. D. fig.

223. FONTANA Lavinia. Born at Bologna in 1552, died 1614.

Portrait of Father Panigarola, of Milan, a celebrated
preacher. — On canvas. Life size.

224. STROZZI Bernardo, called *il Cappuccino Genovese.* Born
at Genoa in 1581, died at Venice in 1644.

The Pharisee showing the piece of money to our
Saviour.

———————

Four splendid tables of Florentine Mosaic in *pietre
dure* are also in this room. They were executed in the
old celebrated Florentine manufactury of mosaics (Via
degli Alfani, in Florence). The one standing in the middle
of the room is the finest. It was begun in 1613 by
Jacopo Autelli, after the designs of *Ligozzi, Poccetti*
and *Del Bianco;* 22 artificers worked upon it during
25 years, and it costed 40,000 zequins. (About 448,000
francs).

Portraits
of ancient and modern painters
painted by themselves

First and second Hall.

This precious and unique collection of portraits of celebrated painters, painted by themselves, is principally owed to Cardinal Leopoldo de' Medici.

He began by purchasing a great number of those which were in the Academy of S. Luca in Rome, and then he invited all the most famous painters of his time to send their portraits, still continuing to collect as many of the ancient ones as he succeeded in finding.

Cosimo III de' Medici gathered them all in this room, about the year 1681, and had the statue of his uncle, the Cardinal Leopoldo, erected here in a nich, as a monument of his munificence. This statue is by Gio. Battista Foggini, and the latin inscription on the base is by Henry Newton, who was then in Florence, as an ambassador from the English court to the Grand-Duke.

This collection was then much enriched by Pietro Leopoldo of Lorraine who purchased a good number of such portraits from the Abbé Pazzi, and is still growing year by year, with those of the contemporary artists, whose celebrity makes them worthy of being admitted into this Pantheon.

The order adopted in arranging these portraits is as follows:

On the right wall and half of that opposite the entrance door are the portraits of the native painters of south Italy; on the other half of that wall and on the left one are the portraits of painters from north Italy; and finally on the same side as the door the portraits of old foreign artists are collected.

The second hall chiefly contains the most recent portraits, many of which represent artists still living, either foreign or italian.

The most remarkable among the ancient ones, are those of *Raffaello, Leonardo, Perugino, Andrea del Sarto, Masaccio* (1), *Michelangiolo, Guido Romano*, the founders of the Tuscan and Roman School, and *Parmigianino, Giorgione, Tiziano, Paolo Veronese, Tintoretto, Bassano, Palma, Morone*, etc.: the chief masters of the Lombard and Venetian School. The Bolognese School is also represented by its principal masters, as *Domenichino, Guercino*, the two *Caracci, Primiticcio, Guido Reni, Albano*, etc.

Among the foreign old painters those worthiest of mention are: *Albert Durer, Luke of Leyden, Holbein, Rubens, Van-Dyck, Rembrandt, Gerard Dow, Substermans, Bourguignon, Vivien, Liotard, Nanteuil*, etc.

The most interesting among the modern portraits of this collection are those of: *Raphael Mengs, Batoni, Appiani, Reynolds, Angelica Hauffmann, Mme Lebrun, Overbeck, Gagneraux, Ingres, Benvenuti, Sabatelli, Bezzuoli, Hayez, Malatesta*, that of the celebrated sculptor *Canova*, also painted by himself, and those of *Zorn, Lehman, Hamon, Cabanel, Amerling, Hebert, Millay, Watson, Laurent, Canevari, Ussi, Ciseri, Mussini, Cassioli, Heyden, Leighton, Millais, Nani*, etc., many of whom are still living.

Alphabetical Catalogue of the Portraits of Painters, painted by themselves.

624. **Acqua** (Dell') Caesar.
458. **Agar** James, of Paris. b. 1640, d. 1716.
.... **Americo** Pietro, of Brazil (still living).
240. **Aikmann** William, of England, b. 1682, d. 1731.
443 **Aivasovski** John.
441. **Albano** Francis, of Bologna, b. 1578, d. 1660.
331. **Alberti** Cherubino, of Borgo San Sepolcro in Tuscany, b. 1553, d. 1615.

(1) This portrait is now however believed to be that of Filippino Lippi. — See Vasari, Ed. Le Monnier, 1848; *Vita di Masaccio*, Commentario, T. III, pag. 167.

332. **Alberti** Giovanni, of Borgo San Sepolcro, b. 1558, d. 1601.
269. **Allori** Alessandro, of Firenze, b 1535, d. 1607.
263. **Allori** Cristoforo, of Firenze, b. October 17th 1577, b. 1621.
299. **Aloisi** Baldassarre, of Bologna, b. 1577, d. 1638.
379. **Amerighi** Michelangelo, of Caravaggio in Lombardy, called *Il Caravaggio*, b. 1569, d 1609
513. **Amerling** Frederic, born in Vienna in 1803.
659. **Amistani** Luigi.
685. **Amor** Salvatore, of Danzica.
342. **Angelis** (De) Filippo, of Napoli, b. 1600, d 1660.
400. **Anguissola** Sofonisba, of Cremona, born about the year 1530, died 1620.
561. **Appiani** Andrea, of Milano, b. 1754, d. 1817.
639. **Arienti** Carlo.
656. **Arizzarra** Teresa.
568. **Arland** James, a French artist. The portrait has been painted in 1778.
295. **Arpino** (See Cesari).
625. **Bache** Otto, Danimark (still living).
667. **Bacherelli** Vincenzo (1765).
404. **Baciccio** (See Gaulli).
926. **Baker** (De) Francis, a Flemish artist. Date of the portrait 1721,
329. **Balassi** Mario, of Firenze, b. 1604, d. 1667.
351. **Baldacci** Maria Maddalena, of Firenze, d. 1782.
490. **Baldrighi** Giuseppe, of Pavia, b. 1723, d. 1802.
405. **Balestra** Antonio, of Verona, b. 1666, d. 1740.
306 **Bandinelli** Baccio, Florentin painter and sculptor, b. 1493, d. 1559.
706. **Barabino** Niccolò (of Genova) b. 1832, d. 1891. Unfinished on account of the Painter.
356. **Barbarelli** Giorgio, called *Giorgione*, of Castelfranco, near Treviso, b. 1478, d. 1511.
312. **Barbatelli** Bernardo, called *Bernardino Poccetti*, of Firenze, b 1542, d. 1612.
396. **Barbieri** John Francis, of Cento, called *Il Guercino*, b. 1591, d. 1666.
326. **Barocci** Federigo (called *Baroccio* or *Fiori d'Urbino*). b. 1528, d. 1612.
395. **Bassano** (See Ponte).
534. **Batoni** Pompeo, of Lucca, b. 1708, d. 1787.
282. **Bazzi** Giovanni Antonio, of Vercelli, called *Il Sodoma*, b. 1477, d. 1549.
310. **Beccafumi** Domenico, of Siena, called *Il Mecherino*, d. 1486, d. 1551.

231. **Bel** (Le) Jean-Baptista, a Flemish painter. XVIIth century.
354. **Bellino** Giovanni, of Venezia, b. 1427, d. 1516.
418. **Bellotti** Pietro, of Volzano, b. 1627, d. 1270.
427. **Bellucci** Antonio, of Venezia, b 1648, d. 1726.
717. **Benczur** Giulio, of Nyiregyhara (Ungary).
386. **Benefial** Marco, of Roma, b. 1684,° d. 1764.
704. **Benwel** Mary, of England, date 1779.
548. **Benvenuti** Pietro, of Arezzo, b. 1769, d. 1844.
272. **Bernini** Giovan Lorenzo, of Napoli, b. 1598, d. 1680.
631. **Bertrand** James (still living).
294. **Berrettini** Pietro, of Cortona, b. 1596, d. 1669.
664. **Bettini** Antonio, of Firenze, 1772.
522. **Bezzuoli** Giuseppe, of Firenze, b. 1784. d. 1855.
503. **Bimbi** Bartolommeo, of Firenze, b. 1648, d. 1725.
532. **Biscarra** Giovanni, of Torino, d. 1851.
720. **Bisschop** Christophan, of Holland (still living).
248. **Bizzelli** Giovanni, of Firenze, b. 1556, d. 1612.
610. **Bles** David, Hollandes (still living).
446. **Bloemart** Abraham, of Dordrecht, b. 1567, d. 1647.
590. **Bloch** Carl, Danimark (still living).
628. **Boare,** of England.
364. **Boccaccini** Camillo, of Cremona, b. 1460? d. 1518?
321. **Bocciardi** Clemente, of Genova, b. 1620, d. 1658.
708. **Boldini** John (still living).
410. **Bombelli** Sebastiano, of Udine, b. 1635, d. 1685.
253. **Bonito** Cav. Giuseppe, of Napoli, 1789.
594. **Bonnat** Leon, a French painter (still living).
350. **Borgianni** Orazio, a Roman painter, 1630.
264. **Boscoli** Andrea, of Firenze, b. 1553, d. 1606.
559. **Bossi** Giuseppe, of Milano, b. 1776, d. 1815.
491. **Bottani** Giuseppe, of Cremona, b. 1717, d. 1784.
297. **Botti** Francesco, of Firenze, XVIIth century.
508. **Botti** Scifoni Ida, of Roma, b. 1812, d. 1844
557. **Bouchardon** Edmond, a French painter, born about 1698, d. 1762.
721. **Bouguereau** William, of France (still living).
537. **Brach** (See Vander Brach).
434. **Breckberg** Job, of Harlem, also called *Berkheyden,* b. 1637, d. 1698.
341. **Briglia** Giovan Francesco, of Firenze, b. 1737.
575. **Breton** Jules, of France (still living)
679. **Brioschi** Vincenzo, of Firenze.
511. **Brokedon** William, of England. Date of the portrait 1822.
485. **Brun** (Le) Charles, of Paris, b. 1619, d. 1690. (Signed: C. LE BRVN Dʳ PEINTRE DU ROY TRES CHRESTIEN).

549. **Brun** (Le) M^me Vigée, Elisabeth Louise, of Paris, b. 1755, d. 1842.
412. **Brusacorci** Domenico (See Riccio).
285. **Buonaccorsi** Pietro, called *Pierin del Vaga,* of Firenze, b. 1499, d. 1547.
290. **Buonarroti** Michelangiolo b 1475, d. 1564 (This portrait is not painted by Michæl-Angel but it belongs to his school).
271. **Buontalenti** Bernardo, of Firenze, b 1536, d. 1608.
530. **Burino** Antonio, of Bologna, b. 1656, d. 1727.
613. **Cabanel** Alex., of Paris (still living).
427. **Caccianiga** Francis, of Milano, b. 1700, d. 1781.
398. **Cairo** Francis, of Milano, b. 1598, d. 1674.
385. **Caliari** Paolo, called *Paolo Veronese,* b. 1528, d. 1588.
512. **Callot** Jaques, of Nancy, b. 1594, d. 1635.
387. **Cambiaso** Luca, of Genova, b. 1527, d. 1585.
487. **Campiglia** Gio. Domenico, of Lucca, b. 1692 (date of the portrait 1712).
424. **Campi** Galeazzo, of Cremona, b. 1475, d. 1586.
566. **Canevari** Gio. Battista, born a Genova, 1791 (date of the portrait 1864) still living.
573. **Canova** Antonio, of Possagno near Treviso ; a sculptor and painter, b. 1757, d. 1822 (date of the portr. 1792).
374. **Caracci** Annibal, of Bologna, b. 1560, d. 1609.
380. Another portrait of the same.
450. Another portrait of the same.
348. **Caracci** Agostino, of Bologna, b. 1558, d. 1601.
891. The same.
368. **Caracci** Antony, of Bologna, b. 1583, d. 1618.
262. **Caracci** Francis, of Bologna, b. 1559, d. 1622.
397. **Caracci** Ludovic, of Bologna, b. 1555, d. 1619.
379. **Caravaggio** (See Amerighi).
298. **Cardi** Ludovico, called *Il Cigoli,* from the name of his native place near Firenze. Born on september 12th 1559, d. 1613.
363. **Carriera** Rosalba, of Venezia, b. 1675, d. 1757.
674. **Casini** Giovanni, of Firenze (1748).
338. **Casolani** Alexander, of Siena, b. 1552, d. 1606. (Together are the portraits of Lucretia Piccolomini, Ventura Salimbeni and Francis Vanni).
353. **Cassana** Gio. Francesco, of Genova, b. 1611, d. 1691.
883. **Cassana** G. Agostino, id., b. 1658, d. 1720.
414. **Cassana** Niccolò, born at Venezia in 1659, d. 1713.
617. **Cassioli** Cav. Prof. Amos, of Siena, d. 1892.
477. **Castiglione** G. Benedetto, of Genova, b. 1616, d. 1670.
573. **Cavalieri** Ferdinando, of Torino, b. 1795 (date of the portrait 1829.

367. **Cavedone** Jacob, of Sassuolo in Lombardy, b. 1577, d. 1660.
654. **Cerroti** Violante.
295. **Cesari** Cav Giuseppe, of Arpino, b. 1560, d. 1640.
583. **Chenavard** Paul, of France (still living).
243. **Chiari** Giuseppe, of Roma, b. 1654, d. 1727.
344. **Chiavistelli** Jacopo, of Firenze, b. 1621, d. 1698.
274. **Chimenti** Jacopo, of Empoli, called *L'Empoli,* b. 1551, d. 1640.
695. **Ciabilli** Giovanni, of Firenze, d. 1740.
366. **Cignani** Carlo, of Bologna, b. 1628, d. 1719.
298. **Cigoli** (See Cardi).
668. **Cinqui** Giovanni.
543. **Cipriani** Gio. Battista, of Pistoia, b. 1732, d. 1785.
612. **Ciseri** Prof. Antonio, d. 1890.
619. **Clarke** James Hooh, of England.
719. **Cluysenaar** Alfred, of Bruxelles (still living).
518. **Colignon** Joseph, of Firenze (date of the portrait 1840).
635. **Colonna,** Duchessa of Castiglione.
429. **Colonna** Michelangelo, of Como, b. 1600, d. 1687.
256. **Comodi** Andrew, of Firenze, b. 1560, d. 1638.
554. **Conca** Sebastiano, of Gaeta, b. 1676, d. 1764,
527. **Costantin** John Antony, of Genève; painted in 1824, (enamel on porcelaine).
428. **Contarini** John, of Venezia, b. 1549, d. 1605.
493. **Conti** Francis, of Firenze, painted in 1760.
317. **Coppi** Jacob, of Firenze, called *Di Meglio,* b. 1523, d. 1591.
628. **Corot** (J. B. Camille), born on july 29th, died on febr. 22d 1875.
690. **Corvi** Dominic, of Rome, 1786.
528. **Costoli** Aristodemo, a Florentine sculptor and painter, b 1803, d. on july 22d. 1871.
630. **Couder** L. C. Aug., of Paris, painted in 1870 at the age of 81.
643. **Counis** William, of Geneva, b. 1785, d. 1859.
698. **Counis** Elisa, of Firenze, b 1812. d. 1848.
478. **Courtois** or Cortesi Jacob, of Sainte-Hippolythe (Franche-Comté) called *Il Borgognone,* b. 1628, d. 1679.
542. **Coypel** Anthony, of Paris, b. 1661, d. 1722
419. **Crespi** Daniel, of Milano, b. 1580 circa, d. 1630.
394. **Crespi** Joseph Maria, of Bologna, b. 1665, d. 1747.
281. **Cresti** Dominic, of Passignano near Firenze, called *Il Passignano,* b. 1560, d. 1638.
301. **Curradi** Cav. Francis, of Firenze. born in 1570, d. 1661.
308. **Dandini** Peter, of Firenze, b. 1646, d. 1702.
713. **David** James, of Paris.

627. **Deveria** Eugene, of Paris, b. 1805.
660. **De Cam** James, of Feltre, 1791.
668. **De Clain** Pasquale, painted 1778.
641. **De Sanctis** Guglielmo, of Roma, still living.
683. **Diotti** Joseph, of Casal Maggiore, painted in 1821.
262. **Dolci** Charles, of Firenze, born on may 25th 1616, d. 1681.
402. **Domenichino** (See Zampieri).
889. **Dossi** Dosso, of Ferrara, b. 1479, d. 1542.
437. **Douwen** John Francis, of Ruremond, b. 1656, d, 1727.
449. **Dou** or Dov Gerard, of Leyden, b. 1613, d. 1680. Signed : G. DOV, 1680.
439. **Durer** Albert, of Nuremberg, b. 1471, d. 1528. It bears the usual cypher of the author with the date 1498, and a german inscription attesting that he painted his own portrait at the age of 26. (Baldinucci, t. IV, pag. 116).
228. **Dyck** (Van) Anthony, born in Antwerp in 1509, d. 1641.
433. **Elzheimer** Adam, of Frankfort, b. 1574, d. 1620.
274. **Empoli** (See Chimenti).
388. **Facini** or Faccini Peter, of Bologna, b. 1560, d. 1602.
700. **Fagnani** Joseph, born at Napoli 1819, died at New-York, 1873.
438. **Fanti** Vincent, of Vienna, painted in 1750.
718. **Fantin Latour** Henry, of Grenoble (still living).
606. **Farina** Achilles, (still living).
411. **Favray** or Fauray Anthony, of France, born in 1706, died in 1789 circa.
484. **Fedi** Anthony, of Firenze, b. 1771, d. 1843.
541. **Feltre** (Morto da) b. 1485, d. about the year 1519.
502. **Ferrari** Luke, of Reggio, p. 1652.
302. **Ferretti** Gio. Domenico, of Firenze, b. 1692.
276. **Ferri** Cyrus, of Roma, b. 1634, d. 1689.
335. **Ferri** Gesualdo, of S. Miniato.
519. **Fidani** Orazio, of Firenze, painted in 1656.
326. **Fiori** (See Barocci).
520. **Flandrin** Hyppolytus, born at Lyon 1809, d. 1864.
361. **Fontana** Lavinia, of Bologna, b. 1552, d. 1614.
369. **Forabosco** Jerome, of Venezia who lived in 1660.
586. **Français** Francesco Luigi, b. 1814.
304. **Franceschini** Baldassarre, of Volterra, called *Il Volterrano,* b. 1611, d. 1689.
413. **Franceschini** Marc-Anthony, of Bologna, born 1648, dead in 1729.
241. **Franck** or Fraucken Francis, junior, of Antwerp, b. 1581, d. 1642.

273. **Franchi** Anthony, of Lucca, b. 1634, d. 1709.
564. **Frascheri** Giuseppe, of Savona (still living).
533. **Fratellini** Marmocchini Cortesi Giovanna, of Firenze, b. in 1666, d. 1731.
665. **Fratellini** Rosalba.
318. **Furini** Francesco, of Firenze, called *Il Furino*, b. 1600 circa, d. 1640.
257. **Gabbiani** Anton Domenico, of Firenze, b. 1652, d. 1722. (Signed : ADG. 1686.
677. **Gabbiani** Gio. Domenico.
470. **Gagneraux** Benedict, of Dijon, b. 1763, d. 1795. (Given to tho Gallery by the painter M. Sabatino Levi).
399. **Galanino** (See Aloisi).
319. **Galantini** Father Hyppolitus, of Genova, b. 1627, d. 1706.
311. **Galletti** Father Filippo Maria, of Firenze, b. 1664, d. 1742.
261. **Gambaccini** Francis, of Roma.
642. **Gauffens** Goffredo, of Belgique, (still living).
404. **Gaulli** Gio Battista. of Genova, called *Baciccio*, b. 1639, d. 1709.
582. **Gebhardt** von E., of Prussie.
430 **Gennari** Benedict, of Cento, b. 1633, d. 1715.
583. **Ghenavard** Paul, of Alsazien (still living).
507. **Gherardini** Alexander, of Firenze, b. 1655, d. 1723.
506. **Gherardini** Thomas, of Firenze. b. 1715, d. 1797.
296. **Ghezzi** Pier Leone, of Roma, b 1674, d. 1755.
275. **Giordano** Luca, of Napoli, called *Luca fa' presto*, b. 1632, d. 1705.
356. **Giorgione** (See Barbarelli).
712. **Giron** Charles (still living).
595. **Gordigiani** Cav. Prof. Michele (still living).
653. **Gouttebrun** Lewis, of Germany, painted in 1782.
688. **Grassi** Joseph, 1762.
657. **Grati** Gio. Battista, 1756.
502. **Greys** (De) Father Benedict, of Livorno. A pen and ink drawing : 1758.
515. **Grisoni** Joseph, of Firenze, d. 1769.
684. **Grund** Gio. Giacomo, of Anspach, 1791.
687. **Gualdi** Antonio, of Guastalla, b. 1796, d. 1865.
396. **Guercino** (See Barbieri).
300. **Hamilton.**
518. **Hamon** John Louis, b. a Plouha (France) in 1821, d. 1874.
568. **Harlow** George Henry, of England. Paint 1818, d. 1820.
523. **Hayez** Francis, of Venezia, painted in 1683.
705. **Healy** G. P. A., born at Boston in 1813 (still living).

453. **Healst** (Van der) Bartholemew, b. at Harlem? in 1613? d. at Amsterdam in 1670.
707. **Hellquist** Charles Gustave, of Awedin (still living).
618. **Henner** Jean, of Alsazien (still living)
611. **Herbert** Ernest, of Paris (still living).
604. **Heyden** Otto, b. 1820 in Pomerania (Prussia), still living.
538. **Heyter** George, of England, b. 1793.
680. **Hickels** Joseph, of Boemia, F. 1769:
498. **Hoare** Prince, of England. painted in 1870.
232. **Holbein** John, junior, born at Augsbourg, in 1497, died at London in 1543. Inscribed: JOANNES HOL-PENIVS BASILEENSIS SVI IPSIUS EFFIGIATOR AE. XLV.
441. **Honthorst** Gerard, of Utrecht, called *Gherardo delle Notti*, b. 1592, d. 1660.
531. **Ingres** John August, of Paris, b. 1783; signed: I. A. D. INGRES PICTOR GALLICUS SE IPSIUS P.xt ANNO ÆTATIS LXXV. MDCCCXLVIII.
629. **Isola** Giuseppe, of Genova (still living).
238. **Jordaens** James, of Antwerp, b. 1593, d. 1678.
469. **Jouvenet** Francis, b. at Rouen 1665 circa, d. at Paris in 1749.
471. **Kauffmann** Angelica, b. at Bregentz in Switzerland in 1741, d. at Roma in 1807.
640. **Keller** Ferdinando, of Baden (still living).
692. **Kiprensky** Oreste, of St. Petersbourg, painted 1820.
220. **Klockner** or **Kloheer** David, of Hambourg, b. 1629, d. 1698.
516. **Kneller** Godfrey, of Lubeck, b. 1648, d. 1726.
418. **Koninck** or **Koning** Philip, b. at Amsterdam in 1619, d. 1689.
224. **Kranac** or **Cranach** Luke, of Cranach, b. 1472, d. 1553.
605. **Kroyer** Peter Severin, still living.
581. **Kunelaki** Nicholas.
234. **Laer** Peter, called *Il Bamboccio*, b. near Naarden (in Holland) in 1613, d. 1675 circa.
600. **Laighton** Prof. Fried., president of the Royal Academy in London.
552. **Lami** Vincent (still living).
569. **Landi** Gaspar, of Piacenza, b. 1756, d 1830
409. **Lanfranco** John, of Parma, b, 1581, d. 1647.
245. **Lapi** Nicholas, of Firenze, b. 1661, .d. 1732.
473. **Largillière** (De) Nicolas, of Paris, b. 1661, d. 1746.
621. **Laurent** Paul, painted in 1876 (still living)
423. **Legnani** Stefano Maria, of Milano, called *Il Legna-nino*, b. 1660, d. 1715.

578. **Lehmann** Henry, of Paris, b. 1814 (still living).
447. **Leisman** John Anthony, of Salisbourg, b. 1604, d. 1698.
230. **Lely** Peter, of Westphalia, b. 1617, d. 1680.
590. **Lenepveu** I. E., a French artist, still living, painted in 1877.
375. **Liberi** Cav. Pietro, of Parma, b. 1605, d. 1687.
373. **Licinio** or Regillo Gio Antonio, of Pordenone, b. 1484, d 1540.
246. **Ligozzi** Jacopo, of Verona, b. 1543, d. 1627.
535. **Liotard** Ernest, of Geneve, painted, 1744.
286. **Lippi** Filippino, of Firenze, b 1457, d. 1504.
283. **Lippi** Lorenzo, of Firenze, b. 1606, d. 1664.
229 **Loth** Charles, of Munchen, b. 1611, d. 1698.
577. **Löwenthal** Emil, of Prussia (still living).
444. **Luca d' Olanda,** of Leyden, b. 1494, d. 1533. - Senator Morelli thinks it to be an old copy of a portrait of Bernardino de Conti of Pavia (pag. 423).
250. **Luti** Benedict, of Firenze, b. 1666, d. 1724.
702. **Macpherson** Joseph, 1778.
320. **Maganza** Gio. Battista (junior), of Vicenza, b. 1577, d. 1717. Signed : GIO. BATTISTA MAGANZA.
563. **Malatesta** Adeodato, of Modena, painted in 1846.
570. **Mancinelli** Giuseppe, of Napoli (still living).
355. **Manetti** Rutilio, of Siena, b. 1572, d. 1639.
305. **Mannozzi** Giovanni, of San Giovanni (Val d' Arno), called *Giovanni da San Giovanni,* b. 1590, d. 1636.
323. **Manzuoli** Tommaso, of Firenze, b 1536. d. oct. 2d 1571.
266 **Maratta** Carlo, b. at Camerino near Ancona in 1625, d. 1713.
313 **Marinari** Onorio, of Firenze, b. 1627, d. 1715.
602. **Markò** Prof. Carlo, of Lenthschan, b. 1793, d. 1860.
533. **Marmocchini Cortesi** (See Fratellini).
672. **Maro** Giuseppe, of Torino, f. 1750.
483. **Maron** Anthony, of Vienna, painted 1787; b. 1733, d 1808.
562. **Marteau,** of France, painted 1726.
253 **Marucelli** Gio. Stefano, of Firenze, b. 1586, d. 1646.
681. **Mary** Antonietta, Princess of Baviera.
651. **Masini** Antonio.
673 **Masini** Giuseppe, of Firenze, d. 1736.
499. **Mazzanti** Cav. Lodovico, of Orvieto, 1760.
662. **Mazzi** Taddeo
381. **Mazzucchelli** Pier Francesco, of Lombardy, called *Il Morazzone,* b. 1571, d. 1626.
386. **Mazzuoli** or Mazzuola Francesco, of Parma, called *Il Parmigianino,* b. 1503, d. 1540.

415. **Mazzuoli** Giuseppe, of Ferrara, d. 1586. Signed : GIU. MAZZUOLI SÈ DIPINSE, 15..4.
349. **Medici** Piero, of Firenze, b. 1586, d 1648.
466. **Medina** Chev. Jean Baptiste, of Bruxelles, born 1660, d. in 1711.
236. **Mehus** Lyvius, of Oudenarde, b. 1630, d. 1691.
.... **Menageot** Francis, of France, b. 1744, painted in 1797, d. 1816.
555. **Mengs** Chev. Antoine Raphaël, of Aussig, in Bohemia, b. 1728, d. 1816.
634. **Mensi** Francesco, of Genova, 1873.
509. **Messini** Ferdinando, of Firenze, d. 1750.
303. **Meucci** Vincenzo, of Firenze, b. 1694, d. 1770.
443. **Meylens** or Mayden Martin, of Stokolm, b. 1696, d. 1770.
237. **Metsys** Quentin, b. at Louvain in 1466, d at Antwerp in 1530. A portrait of his wife, bearing the date 1520, is seen on the reverse ef this painting.
316 The same, in a diminutive size.
496. **Middleton** Goodsall, of England (still living).
222. **Miel** John, of Antwerp, b. 1599, d. 1665
455. **Mieris** (Van) Francis, of Leyden, b. 1689, d. 1763. Purchased by Cosmus III de' Medici.
588. **Millais,** of England (still living).
382. **Mola** Pier Francesco, b. at Coldrè near Como in 1612, d at Rome in 1668.
504. **Monari** Cristofano, of Reggio, painted 1717.
346. **Monti** Francesco, of Bologna, b 1685, d. 1768.
462. **Moro** Anthony, of Utrecht, b. 1512, d. 1581. Bearing the signature : *Ant. Morus Philippi Hisp. Reg. Pictor sua ipse depictus manu 1558.*
239. **Moor** Charles, of Leyden, b. 1656, d. 1738.
255. **Morandi** Gio. Maria, of Firenze, b. 1622, d. 1717.
523. **More** Jacob, of England, 1773
658. **Morghen** Giovanni Elia, painted 1730.
259. **Moro** (Del), of Firenze, d. 1725.
360. **Moroni** Gio. Battista, of Albino, called *Morone,* b. about 1510, d. 1578.
538. **Morto** (See Feltre da).
252. **Muller** or Muller or also Molyn Peter, of Harlem, called *Il Cav. Tempesta,* b, 1637, d. 1701.
465 **Murray** Thomas, of Scotland, b. 1666, d. 1724.
347. **Musscher** Michæl, of Rotterdam, b. 1646, d. 1705. Signed: *M. H. V. Musscher se Ipsum Pinxit. Ætat 46. 1692.*
534. **Mussini** Cesare, of Firenze, painted in 1873, d. 1879.
539. **Mussini** Luigi, of Firenze, (still living).

609. **Nani** Cav. Prof. Napoleone, President of the *Accademia dei Pittori e degli Scultori,* at Verona, (still living).
536. **Nanteuil** Robert, of Reims, b. 1630, d. 1678.
492. **Nannetti** Nicola, of Firenze, b 1675, d. 1749.
500. **Nasini** Antonio, of Siena, painted in 1716.
468. **Natoire** Charles, of France, b. 1700, d. 1777.
521. **Nebbia** Cesare, of Orvieto, d. 1611.
457. **Neer** (Aart Van Der), b. at Amsterdam in 1619, d. 1683.
646. **Nef** Timoleone.
494. **Nortchote** James, of Plymouth, painted in 1778.
598. **Novy** (Count de) of France (still living).
574. **Nuzzi** Marius, called *Mario dei Fiori,* of Penna, near Fermo, b. 1603, d. 1673.
715. **Orchardson** W. Q. (still living).
343. **Ortolani Damon** Gio. Battista, of Roma, painted in 1879.
518. **Overbeck** Frederic, of Lubech, b. 1790.
284. **Pagani** Gregorio, of Firenze, b. 1550, d 1605.
505. **Paggi** Gio. Battista, of Genova, b. 1559, d. 1627.
420. **Paglia** Francis, of Brescia, b. 1636, d. about 1770.
592. **Pagliano** Eleuterio, of Milano, paint. 1891 (st. living).
545 **Paladini** Arcangiola, of Pistoia, b. 1599, d. 1662.
565. **Palagi** Pelagio, of Bologna, b. 1775, d 1860.
614. **Palizzi** Filippo, of Napoli (still living)
372. **Palma** Jacob (junior), of Venezia, b. 1544, d. 1628.
689. **Panti** Romolo, of Pistoia, d. 1703.
322. **Paolini** Pietro, of Lucca, d. 1632.
385. **Paolo Veronese** (See Callari).
386. **Parmigiani** (See Mazzuoli).
421. **Parodi** Dominic, of Genova, b, 1688, d. 1740.
622. **Parrodin** E., of France (still living)
576. **Pasini** Alberto, of Napoli (still living)
324. **Passeri** Giuseppe, of Roma, b. 1634, d. 1714.
370. **Passerotti** Bartolommeo, of Bologna; who flourished about 1578.
406. **Passerotti** Ventura, of Bologna, b. 1533, d. 1593.
377. **Passerotti** Tiburzio, of Bologna, d 1612.
281. **Passignano** (See Cresti).
516. **Patania** Giuseppe, of Palermo, b. 1780, d. 1852.
546. **Pazzi** Abate Antonio, of Firenze, b. 1706.
591. **Pedro** Amerigo, 1877.
357. **Pellegrini** Pellegrino (See Tibaldi).
416 **Pellegrini** Antonio, of Padua, b. 1675, d. 1741.
436. **Pencz** George, of Nuremberg, b. 1500, d. 1550.
529. **Perrounet Briggs** Henry, of England, d. 1844.
287. **Perugino** (See Vannucci).

660. **Pertichi** Pietro, painted 1730.
636. **Peterssen** Elif, of Kristiania (still living).
242. **Petrazzi** Astolfo, of Siena, b. 1579, d. 1653.
652. **Petrucci** Francesco, painted 1730.
524. **Piattoli** Anna, of Firenze, d. 1788
255 **Piattoli** Gaetano, of Firenze, d. 1774.
697. **Pierotti** Pierotto, of Castelnuovo in Garfagnana.
358. **Pignoni** Simone, of Firenze, b. 1614, d 1706.
661. **Pinacei** Giuseppe, of Siena, d. 1718.
289. **Pippi** Giulio, of Roma, called *Giulio Romano,* b. 1499, d. 1546
312. **Poccetti** (See Barbatelli).
603. **Podesti** Francesco, painted 1829.
481. **Poerson** (De) Charles, of Paris, b. 1652, d. 1725.
401. **Ponte** (Da) Iacopo, of Bassano, called *Il Bassano,* b. 1510, d. 1592.
407. **Ponte** (Da) Francesco. id. 1558, d. 1592.
395. **Ponte** (Da) Leandro, id , b 1558, d. 1623.
373. **Pordenone** (See Sacchiense)
550. **Porporati** Carlo, of Torino, b. 1740. d. 1790.
445. **Pourbus** Francis, of Antwerp, b. 1542, d. 1622. Signed: *Francesco Pourbus 1591 — Ætati suæ 49.*
623. **Poynter** J. Edward, of England (still living).
334. **Pozzo** Andrea, of Trento (a Jesuite), b. 1642, d. 1709.
699. **Preller** Frederic, of Weimar (still living).
352. **Pressler** John Justin, of Nuremberg. b. 1698, d. 1771.
267. **Preti** (De) Mattia, of Calabria, b. 1613, d. 1699.
551. **Preziado** Francis, of Seville, b. 1713, d. 1789.
431. **Primaticcio** Francesco, of Bologna, b. 1540, d. 1570.
392. **Procaccini** Giulio Cesare, of Bologna, b. about the year 1548, d. about 1626.
599. **Puvis** de Chavannes P., of France.
482. **Quadal** Marius, of Moravia, painted 1685.
288. **Raffaello** (See Sanzio).
260. **Ramenghi** Bartolommeo, called *Il Bagnacavallo,* b. 1484, d 1542.
636. **Rapisardi** Michael, of Palermo, b. 1822, d. 1886.
292. **Razzi** Gio. Antonio, of Vercelli (See Bazzi) or Sodoma.
314. **Redi** Tommaso, of Firenze, b. 1665, d. 1726.
451. **Rembrandt** Van Ryn, of Leyden. b. 1606, d. 1669.
452. The Same.
403. **Reni** Guido, of Bologna, b 1575, d. 1642.
333. **Resani** Arcangelo, of Roma, who flourished in 1718.
540. **Reynolds** Cav. Joshua, of England, b. 1723, d. 1792, painted in 1775.
244. **Ribera** Giuseppe, of Gallipoli, called *Lo Spagnoletto,* b. 1583, d. 1656.

601. **Ribbing** (De) Sopha, of Swede, painted in 1875 (still living).
432. **Ricci** or Rizzi Sebastiano, of Belluno, b. 1662, d. 1734.
345. **Ricciolini** Michelangelo, of Todi, b. 1654, d. 1715.
714. **Richmont** George.
607. **Richter** Gustavos, born at Berlino on august 3d 1823, died on april 3d 1884.
422. **Ridolfi** Claudio, of Verona, b. 1560, d. 1644. .
474. **Rigaud** Hyacinthe, of Perpignano, b 1659, d. 1743.
265. **Riminaldi** Orazio, of Pisa, b. 1598 d. 1631.
480 **Rivière** Francis, of Paris, d. 1725.
412. **Rizzo** Domenico, of Verona, called *Brusasorci*, b. 1494, d. 1567.
644. **Robert** Fleury, of France (still living).
111. **Robie** John, of Bruxelles (still living).
378. **Robusti** Iacopo, of Venezia, called *Il Tintoretto*, b. 1512, d. 1594.
365. **Robusti** Marietta, *Tintoretto's* daughter, born in 1560, d. 1590
247. **Roncalli** Cristofano, of Pomarance in Tuscany, b. 1552, d. 1626
293. **Rosa** Salvatore, of Napoli, b. 1615, d. 1673.
293bis. The same
225. **Rosa** or Ros John, of Antwerp, b. 1631, d. 1685.
595 **Rosen** (Von) George, of Stockholm, painted, in 1811.
649. **Rosi** Alessandro, of Firenze, d. 1700.
517. **Roslin** Alexander, of Stockholm, b. 1733?, died 1793. Painted in 1790.
278. **Rosselli** Matteo, of Firenze, b. 1578, d. 1650.
269. **Rossi** Francesco, of Firenze, called *Cecchino Salviati*, b. 1510, d. 1563.
547. **Rotari** Count Peter, of Verona, b. 1707, d. 1762.
228. **Rubens** Peter Paul, b. 1577, d. at Antwerp 1640.
233. The same.
514. **Rubio** Cav. Prof. Luigi (still living)
580 **Sabatelli** Giuseppe, of Firenze, b. 1810, d. 1848.
558. **Sabatelli** Luigi, of Firenze, 1772, d. 1850.
373 **Sacchiense** Gio. Antonio, called *Il Pordenone*, born in Friuli in 1483, d. 1540.
676. **Sagrestani** Gio. Cammillo, of Firenze, d. 1731.
587. **Salghetti Prioli** Francesco, of Zara, 1877.
315. **Salimbeni** Ventura, of Siena, b. 1557, d. 1613.
340. **Salvi** Gio. Battista, of Sasso Ferrato near Urbino, called *Il Sasso—Ferrato*, b. 1605, d. 1685.
268. **Salviati** (See Rossi Francesco).
467. **Sandrart** Joachim, of Francfort, b. 1606. d. 1683.
277. **Santi di Tito** (See Titi).

648. **Santi** Pietro.
288. **Sanzio** or Santi Raffaello, of Urbino, b. 1483, d. 1520. (See Pelli, *Saggio, etc*, t. I, p. 243).
280. **Sarto** (Del) Andrea (Andrea Vannucchi), of Firenze, b. 1487, d. 1531 (See Vasari, t. VIII, p. 287).
340. **Sasso-Ferrato** (See Salvi).
435. **Schalcken** Godfrey, of Dordrecht, b. 1643, d. 1706.
376. **Schiavone** Andrea, of Sebenico, b. 1522, d. 1582.
626. **Schmid** Prof. Charles Fred. Louis, of Stettin in Prussia, b. 1799.
235. **Schonjans** Anthony, of Antwerp, b. 1655, d. 1694.
461. **Schwartz** Christopher, of Ingolstadt, b. 1550, d. 1594.
716. **Schwartze** Terese, of Amsterdam.
327. **Scorza** Sinibaldo, of Genova, b. 1589, d. 1631.
459. **Servolini** Giuseppe, of Firenze.
605. **Severin** (See Kroyer) Peter, Danimarck (still living).
454. **Sevin** Claudius, of Bruxelles, d. 1776.
221. **Seybolt** Christian, of Althenaer, b. 1697, d. 1768.
339. **Sirani** Gio. Andrea, of Bologna, b. 1610, d. 1670.
328. **Siries** Violante, of Firenze, d. 1783.
282. **Sodoma** (See Bazzi).
551. **Sogni** Giuseppe, of Milano (still living).
417. **Sole** (Del) Giuseppe, of Bologna, b. 1654, d. 1719.
337. **Solimena** Francesco, of Nocera near Napoli, b. 1657, d. 1747.
678. **Sorbi** Giovanni, of Siena, painted 1733.
251. **Sorri** Pietro, of Siena, b. 1556, d. 1622.
390. **Spada** Leonello, of Bologna, b. 1576, d. 1622.
244. **Spagnoletto** (See Ribera).
475. **Sparvier** Peter, of France, b. 1660, d. 1731.
309. **Stefaneschi** Gio. Battista, a Florentin hermit, born in 1585, d. 1659.
219. **Storer** Christopher, of Constance, b. 1611, d. 1671.
579. **Stuckelberg** Ernest (Basiliensis), painted 1889.
218. **Sustermans** Just, of Antwerp, b. 1597, d. 1681.
423. **Taruffi** Emilio, of Bologna, b. 1633, d. 1669.
359. **Tavarone** Lazzaro, of Genova, b. 1556, d. 1641.
252. **Tempesta** (See Muller).
254. **Testa** Pietro, of Lucca, b. 1617, d. 1650.
408. **Tiarini** Alessandro, of Bologna, b. 1577, d. 1668.
357. **Tibaldi** Pellegrino, of Bologna, b. 1527, d. 1591.
378. **Tintoretto** (See Robusti).
300. **Titi** Tiberio, of Firenze, the son of *Santi di Tito*, b. 1573, d. 1627, painted in 1612.
277. **Tito** (Santi di), of Borgo S. Sepolcro, b. 1538, d. 1603.
330. The same.
384. **Tiziano** (See Vecellio).

495. **Torelli** Felice, of Verona, b. 1667, d. 1748.
691. **Torelli** Lucia, of Bologna, d. 1762.
489. **Trevisani** Angelo, of Venezia. He flourished in 1753.
393. **Trevisani** Francesco, of Treviso, b. 1656, d. 1746.
479. **Troy** (De) Francis, of Toulouse, b. 1645, d. 1730
478. **Troy** (De) John Francis, of Paris, b. 1679, d. 1752.
258. **Ulivelli** Cosimo, of Firenze, b. 1625, d. 1704.
597. **Ussi** Comm. Prof Stefano, of Firenze (still living).
285. **Vaga** (Del) See Buonaccorsi.
537. **Vander-Brach** Nicholas, of Messina, painted in 1756.
453. **Vander Helst** Bartolommeo, of Harlem, b. 1601,
 d. 1670.
457. **Vander Neer** Angelo Enrico, of Amsterdam, b 1649,
 d 1722
456. **Vander-Werff** Adrian, born near Rotterdam in 1659,
 d. 1722.
223. **Van-Dyck** Anthony, of Antwerp, b. 1599, d. 1641.
 (See Baldinucci, vol. XV, pag. 45).
675. **Van Kalcher** Giovanni
460. **Van Platen** Matthew, of Antwerp, called *Il Montagna,*
 b. about 1630, d. 1776.
227. **Spranger** Barthélemy, of Antwerp, b. 1546, d. 1627.
249. **Vannini** Ottavio, of Firenze, b. 1585, d. 1643.
280. **Vannucchi** (See Sarto).
287. **Vannucci** Pietro, of Perugia, called *Pietro Perugino,*
 b. 1446, d. 1526.

 The Chevalier Montalvo who rightly attributed this
 portrait to Perugino, then fall into the mistake of
 affirming it to represent the author, to which con-
 clusion he would certainly not have come, had be
 not neglected to read the following inscription,
 which is seen on the reverse of this painting:
 1494 D'LUGLIO PIETRO PERUGINO PINSE FRANC.° DE
 LOPE (delle Opere) *Francis delle Opere* was a flo-
 rentin artist, the brother of the celebrated *Giovanni
 delle Corniole.* He died at Venice in 1496. (Vasari;
 G. C. Sansoni, 1880, Vol. III, pag. 604).

608. **Vannutelli** Scipione, 1876.
694. **Vantini** Domenico, of Brescia, b. 1765, d. 1821.
668. **Varottari** Chiara, b. 1650.
291. **Vasari** Giorgio, of Arezzo, b. 1511, d. 1574.
371. **Vasillachi** Antonio, of Milo, called *L'Aliense,* born
 in 1556, d. 1629.
593. **Vautier** B., of France.
384. **Vecellio** Tiziano, of Cadore, in Friuli, b. 1477, d. 1576.
216. **Velasquez de Silva** Diego, of Seville, b. 1599, d. 1660.
217. The same.

426. **Veneziano** Antonio, b. 1319? d. 1383?
336. **Veracini** Agostino, of Firenze, b. 1689, d 1762.
307. **Vignali** Jacopo, of Prato Vecchio, province of Casentino (Tuscany), b. 1594, d. 1664.
292. **Vinci** (Da) Leonardo, born at Vinci near Empoli, province of Firenze, b. 1452, d. 1519.
497. **Vivien** Joseph, of Lyon. b. 1657, d. 1734.
567. **Vogel** Charles, of Vegelstein, b. about 1788.
582. **Vos** Gebhardt E.
440. **Vos** (De) Martino, of Antwerp, b. 1531, d. 1603.
463. **Vouet** Simone, of Paris, b. 1590, d. 1649.
476. **Vouet** Ferdinand, a Flemish, artist who flourished in 1660.
593. **Voutier** B., of Prussia (still living).
464. **Vump** Jean, a Flemish, artist who flourished in 1650.
460. **Waldstein** Marianna, Marchioness of Sancta–Crux, (a miniature) 1818.
585. **Watts,** English painter (still living).
456. **Werff** (See Van der Werff).
553. **Werhlein** Vinceslaus, of Torino, d. 1780. He is holding the portrait of Grand–Duke Peter Leopold I of Tuscany; signed : *Vinceslaus Werhlein,* 1771.
710. **Werner** (von Antony), of Berlin (still living).
571. **Winterhalter** Franz, b. 1806, d. 1878
633. **Yvon** Adolphe, b. 1817 at Eschviller (Moselle).
669. **Zaballi** Raimondo, b. 1794, d. 1842.
402. **Zampieri** Domenico, of Bologna, called *Il Domenichino,* b. 1581, d. 1641
488. **Zanchi** Antonio, of Este, b. 1639, d. 1722.
442. **Zoffani** John, of Germany, b. 1733, d. 1772.
551. **Zona** Antonio, of Venezia (still living), painted in 1865.
615 **Zorn** Andrea Leonardo, of More, Svezia (still living).
270. **Zuccheri** Federigo, of S. Angelo in Vado, near Urbino, b. 1536, d. 1609.
279. **Zuccheri** Taddeo, b. 1529, d. 1566.

Corridor leading
to the Hall of Lorenzo Monaco.

The two first traits of this corridor belongs to the Collection of Portraits of Painters painted by themselves, in the third trait are exhibited the following paintings :

1282. GRANACCI Francesco.

Joseph presenting his father and brothers to Pharaon.
— On wood. Dim. fig.

3387. ROSA Salvatore.

Job. In one angle is Job seating and nude and in
the other are many figures one of which in complete ar-
mature. — On canv. Life size.

1249. GRANACCI Francesco.

Joseph conduced in prison. A landscape in the back-
ground. — On wood. Dim. fig.

203. RENI Guido.

Bradamante in a military costume, standing by a
fountain, listening to the account of Ruggero's sad ad-
ventures made by Fiordespina. (Ariosto, *Orlando Fu-
rioso*, canto I). — On canvas. Half life size.

This painting, was in the *Casino Mediceo*, in Piazza
di S. Marco, and was brought to this Gallery in 1667.

637. BASSANO.

Dead Christ and the three Marys; a large painting,
with an admirable night effect. — On canvas. Life size.

597. TINTORETTO'S SCHOOL.

Entry of Christ into Jerusalem. — On canvas. Dim.
figures.

Hall of Lorenzo Monaco.

17. ANGELICO (Fra Giovanni), of Fiesole. Born near Vicchio
di Mugello in Toscany in 1387, died 1455.

A tabernacle with two doors. Within the tabernacle
is the Holy Virgin with the Infant Saviour standing on
her knee: twelve little angels playing on different in-
struments are painted all around. The figure of the Vir-
gin is above life size. The internal parts of the doors
bears the figures of St. John the Baptist and St. Mark:
on the exterior are St. Peter and again St. Mark.

This remarkable work was committed to Fra Ange-
lico on the 11th of July 1433, by the Association of the

flax-weavers (Arte de' Linaioli) for the price of 190 golden florins, and was brought to this Gallery in 1777.

The *gradino* contain three different subjects: *Preaching of St. Peter; Adoration of the Kings,* and *Martyrdom of St. Mark.* — On wood. Dim. fig.

1297. GHIRLANDAIO (Domenico Bigordi, called Domenico del), of Florence.

The Holy Virgin with the Infant Jesus, attended by four angels; St. Michael and St. Raphael, left and right of the throne, and St. Zenobius and St. Just kneeling before it. The background is richly decorated with architecture and landscape. — On wood. Life size.

This painting was made for the church of St. Just of the Jesuits, near Florence, and after the distruction of that church, during the famous siege in 1530, it was taken to the little church of St. John, called *La Calza,* by Porta Romana, also in Florence, and was finally purchased by the Government and brought to this Gallery in 1857.

1286. BOTTICELLI Alessandro.

The adoration of the Kings. A very fine work, particularly remarkable for its composition and perfect drawing, as well as for the sentiment which the whole painting expresses. The figures are probably the portraits of some illustrious personages of the time : those of Cosmus the Elder, Julian and John are well recognisable. — On wood. Half life size.

Vasari mentions this work as existing in the church of Santa Maria Novella; in the XVII century it was taken to the Villa del Poggio Imperiale, and was brought to this Gallery in 1796.

24. CREDI (Lorenzo di), of Florence. Born 1459, died 1537.

The Holy Virgin adoring the Divine Infant, with an angel. — On wood. Dimin. fig.

1305. DOMENICO VENEZIANO. Died on may 15th 1461.

The Holy Virgin enthroned, holding the Divine Infant on her lap. On her right are St. John the Baptist and St. Francis, on the left St. Nicholas and St. Lucy. On the lower edge of the picture an inscription as follow :
OPUS DOMINICI DE VENETIIS. HO MATER DEI

MISERERE MEI DATUM EST. — On wood. Half life size fig.

This splendid painting formely belonged to the church of Santa Lucia de' Magnoli, Via de' Bardi in Florence: and was taken to the Gallery in 1862.

1309. DON LORENZO MONACO, of Florence. Born about 1370, died 1422.

The coronation of the Virgin. A tryptic, admirable for the number and beauty of the different paintings it contains. The *Coronation of our Lady* amidst a glory of sixteen angels is painted in the middle panel; the two others bear ten figures of saints each. Several smaller figures are scattered among the various ornaments of the frame. On the pinnacles above the principal panels is *the Holy Trinity,* left and right of which are: *the Virgin announced and Gabriel.* The *gradino* contains six diminutive compositions, four of which represent some scenes from the life of St. Bernard, and the two others *The Birth of our Lord* and *The Adoration of the Mages.* Between the tryptic and the *gradino* there is an inscription in golden letters, with the following words: HEC · TABVLA · FACTA · EST · PRO ANIMA : ZENOBI · CECCHI · FRASCHE · ET · SVO-RUM · IN · RECOMPENSATIONE · VNIVS · ALTE-RIVS · TABVLE · PER · EVM · IN · HOC.... (LA)V-RENTII · IOHANNIS · ET · SVORUM · MONACI HVIVS · ORDINIS · QVI · EAM · DEPINXIT · ANNO DOMINI · MCCCCXIII . MENSE . FEBRVARII · TEM-PORE · DOMINI · MATHEI · PRIORIS · HVIVS MONASTERII.

This painting is one of the few works of this famous artist which could be preserved to our time. It was made in 1413 for the high altar in the church of the Monastery called *degli Angioli* to which *Don Lorenzo* belonged; but about the end of the sixteenth century it was removed from that place, and people then believed it lost, until it was found out again in 1830 in the Abbey of St. Peter at Cerreto near Certaldo, by the commentators of Vasari, in an artistic journey in Val d' Elsa. This splendid master-piece contains more than a hundred figures altogether. It was brought to this

Gallery in 1866, and restored under the direction of
Mr. Ector Franchi.

1302. GOZZOLI Benozzo, of Florence. Born 1420, died 1498.

Gradino. In the middle a *Pietà;* left and right:
St. John and *St. Mary Magdalene; St. Catherine's
bridal with the divine Child, St. Anthony,* and *Bene-
dectine saint.* — On wood. Dimin. fig.

It was taken to this Gallery from the convent cf Santa
Croce of Florence in 1847.

1310. GENTILE da Fabriano. Born at Fabriano, near Ancona,
in 1370, d. at Roma about the end of 1450.

St. Mary Magdalene, St. Nicholas of Bari, St. John
and *St. Georges.* An Ancona which formerly decorated
the high altar of the church of San Niccolo in Florence,
and was given to this Gallery by its owner, the mar-
quis Quaratesi in 1879. The middle panel containing
a Madonna is lost, and no one knows how or when.
The *gradino* which Vasari mentions is also wanting,
but a part of it is now possessed by the Puccini family
at Pistoia.

This painting before being mutilated bore an inscrip-
tion with the following words: OPVS GENTILIS DE
FABRIANO MCCCCXXV. MENSE MAI.

1224. GHIRLANDAIO (Domenico Bigordi, called Domenico
del), of Florence.

The Virgin Mary sitting in the open country with the
infant Jesus on her knees and St. Joseph on her left.

1296. VERDI Francesco di Urbino, called *il Bachiacca,*
pupil of Pietro Perugino. Born 1494, died on october
5th 1557.

Gradino with three scenes in the life of St. Acasius.
In the middle one Acasius is seen at the head of a
Roman legion, defeating the rebels by the help of some
angels; the left one represents the Saint and his com-
panions, instructed by Angels and baptized: in the third
scene St. Acasius is represented with his companions,
crucified on the mount Ararat. — On wood. Dim. fig.

This *gradino,* belonged to the altar of the Medici
chapel in San Lorenzo, and was purchased for this Gal-
lery in 1860.

39. BOTTICELLI (Alessandro Filippepi, of Florence, called). Born 1447, died 1510.

The birth of Venus. The goddes is standing on an open sea-shell in the middle of a calm sea. On the left side two winds are figured, flying over the waves and pushing the goddess towards the shore; to the right is the figure of a girl, representing Spring. — On canvas. Life size.

Brought to the Gallery from the rooms of the Royal Palace in 1815.

Venetian School.

(First Hall).

The greater part of the works gathered in the two following rooms belonged to the private collection of a florentine merchant, Paul del Sera, settled in Venice, which was bought by Cardinal Leopoldo de' Medici in 1654.

627. FRA SEBASTIANO DEL PIOMBO (Fra Bastiano di Lu· ciano or Luciani). Born at Venezia in 1485, died in Rome in 1547.

· *Portrait of a Warrior*, remarkable for its caracteristic features and lively expression. — On canvas. Life size.

572. PAOLO VERONESE (Caliari Paolo), of Verona. B. 1528, d. 1588.

St. Catharine, kneeling and chained, near the wheel, which was the instrument of her martyrdom. — On canvas. Half life size.

Taken from the Poggio Imperiale Villa in 1796.

573. MUZIANO Girolamo, born at Acquafredda, near Brescia, in 1528, d. at Roma in 1590.

Male portrait. — On canvas. Life size.

574. POLIDORO VENEZIANO. B. 1515, d. 1565.

The Virgin, Child and St. Francis. Full length. — On wood. Half life size.

575. LOTTO Lorenzo. Born at Venezia about 1476, d. at Loretta between 1555 and 1556.

The Holy Family, with St. Anna, St. Joahim and S. Jerome. Half length figures. — On wood. Half life size. — Signed: *Lorenzo Loto, 1534.*

576. TIZIANO.

Portrait of the sculptor Sansovino. A two thirds length figure, in a black dress, in the act of laying one hand on a marble head. — On wood. Life size.

602. CAMPAGNOLA Domenico, of Padova. B. 1484, d. 1564.

Portrait of a man. The bust only. — On canvas. Life size.

578. BORDONE Paris.

Portrait of a boy. The bust only. — On wood. Life size.

582. MORONI Giovan Battista, of Albino near Bergamo, called *Morone.* B. about 1523, d. 1578.

Portrait of an old man. — On canvas. Life size.

603. CALIARI Paolo, called *Paolo Veronese.*

A male portrait. The bust. — On canvas. Life size.

579. THE SAME.

The Annuntiation. A large painting, with a remarkable architectural back-ground. A sketch. — On canvas. Life size fig.

592. LUCIANI Sebastiano, called *Sebastiano del Piombo.*

Venus wailing among some nymphs for the death of Adonis. The goddes having been pricked by a thorn, the white rose in coloured by her blood. — A large painting. On canvas. Life size.

Taken from the store rooms of the Royal Palace in 1798.

583 *bis.* CARPACCIO Vittore. B. about 1450, d. after 1519.

The subject is unknown. It is probably the fragment of a Crucifixion. Eight figures, and a mountainous landscape in the back-ground. — Sold to the Gallery by Mad.ᴵˡᵉ Isabella Bianciardi-Pini, for the price of 11,500 francs. — On wood. Dimin. fig.

631. BELLINI Giovanni, of Venezia. B. 1426, d. 1516.

A Holy Allegory. The Virgin, attended by some

Saints, among which St. Joseph, St. Paul and St. Sebastian. — On wood. Dim. fig.

Taken from the Poggio Imperiale Villa in 1795.

584. CIMA Gio. Battista, of Conegliano in the province of Treviso. Born about 1460. — Some of his paintings are dated 1517.

The Holy Virgin with the Infant Jesus, St. Peter and a nun bearing a child in swaddling. — Half length figures. — Half life size. On wood.

Taken from the store-rooms of the Royal Palace in 1798.

584 bis. THE SAME.

The Holy Virgin sitting and holding the infant Jesus on her lap. Taken from the store-rooms of the Florentine R. Academy of Fine Arts in 1884. — On wood. Dim. fig.

588. SCHIAVONE Andrea, of Sebenico. B. 1522, d. 1582.

The Adoration of the shepherds. — On canvas. Half life size.

Taken from the store-rooms of the Royal Palace in 1798.

586. MORONE.

Portrait of a man, in a black dress, laying his left hand on the hilt of his sword, and by his right pointing to a fire in a vase upon a pedestal, on which are the words: « ET QUID VOLO - NISI UT ARDEAT, MDLXIII. Jo. Bap. Moronus p. » — On canvas. A full length. Life size.

Taken from the store rooms of the Royal Palace in 1797.

580. MICHELI Andrea, of Vicenza, called *il Vicentino.* B. 1539, d. 1614.

Salomon's feast. — On canvas. Life size.

648. TIZIANO.

Portrait of Catharine Cornaro, queen of Cyprus, representing St. Catharine of Alexandria, with the wheel, which was the instroment of her martyrdom. This painting was purchased by Cardinal Leopoldo de' Medici as a work of Paul Veronese. — On canvas. Life size.

1111. MANTEGNA Andrea, of Padova. Born 1431, d. on september 13th 1506.

A triptyck. The middle composition represents *the Adoration of the Kings;* to the right is *the Circumcision,* to the left *the Resurrection.* — This precious painting is said to have formely decorated the chapel of the Ducal Palace of Mantua, and to have then been bought from the Gonzagas by the Medicis, as it is found registered in the inventory of the objects inherited by Don Anthony de' Medici, Prince of Capistrano, son of the Grand-duke Francis I. It was placed in the Gallery in 1632. — An engraving of the middle painting (Epiphany) was begun by Mantegna himself in the later period of his life, but he died before he had finished it.

3388. TINTORETTO.

Leda. Given to the Gallery by chev. Arthur de Noè Walker.

571. GIORGIONE (Giorgio Barbarelli, called). Born at Castelfranco, or rather at Vicolago, in the province of Treviso, in 1478, died 1511.

Portrait of General Gattamelata (?) with his shield-bearer.
Half length figures. — On canvas. Life size.

593. BASSANO (Iacopo da Ponte, called).

Moses near the burning bush. — On canvas. Dim. figures.

594. ROBUSTI Domenico, of Venice, the son of *Tintoretto.* B. 1562, d. 1637.

Apparition of St. Augustin. Above and below the principal subject, are some figures of sick people, expecting to be cured through the prayers of the Saint. — On canvas. Half life size.

599. TIZIANO.

Portrait of the Duchess of Urbino, the wife of Francis della Rovere. The lady is sitting near a window, through which a fine landscape is seen. A little dog is lying aside.
This precious master-piece is in a state of perfect

preservation. It was brought to this gallery from the Casa della Rovere in 1795.

On canvas. Above half length. Life size.

596. CALIARI Paolo, called *Paolo Veronese.*

Esther before Ahasuerus; a large composition of many figures. — On canvas. Life size.

Taken from the store-rooms of the Royal Palace in 1793.

605. TIZIANO.

Portrait of Francis Maria I della Rovere, Duke of Urbino. The duke hall harnessed holds a scepter in his right hand, and lays the left on the hilt of is sword.

This portrait and that of the Duchess (N. 599) are to be numbered among the most famous work of Titian. — On canvas. Life size. — Signed in golden letters: « TITIANUS F. »

It was brought to this Gallery from the Casa Della Rovere in 1795.

595. BASSANO (Iacopo da Ponte, called).

Portrait of the painter's family. Half lengths. In the middle is Jacob, the father; left and right of him are his sons Francis and Leander, with their children and the two wives, all singing and playing on different instruments.

This painting is one of the finest works of this famous artist. — On canvas. Life size.

598. CAPPUCCINO VERONESE (Fra Semplicino da Verona, called *il).* Born 1589, d. 1654.

The corps of our Lord lying on a shroud: the *Holy Virgin, St. John* and the *Magdalene.* — On canvas. Life size. — Signed: *Simplex Veronensis Cappuccino F.*

587. BORDONE Paris.

Portrait of a bearded man, in a black dress, trimmed with fur. — Half length. On canvas. Life size.

600. BASSANO (Iacopo da Ponte).

A landscape, with figures of shepherds and animals. — On canvas. Dimin. fig.

601. TINTORETTO (Robusti Iacopo).

Portrait of the venetian admiral Veniero; a half length figure in an armour, laying his right hand on a helmet. In the back-ground a sea-view, with some fortresses in the distance. — On canvas. Life size.

Taken from the store-rooms of the Royal Palace in 1794.

577. BORDONE Paris.

Portrait of a boy. — On wood. Life size.

602 *bis.* RICCI Sebastiano, of Cividale, near Belluno. B. 1662, d. 1734.

The sacrifice of Iphigenia. Purchased in 1869. — On canvas. Dim. fig.

604. CARLETTO (Carlo Callari, called), Paolo Veronese's son. B. 1572, d. 1596.

A large painting representing *the Holy Virgin with the Infant Jesus* surrounded by many figures of angels. Below are: St. Mary Magdalene, St. Margaret and St. Fredian bishop of Lucca, holding a rake, as a simbol of the prodigious hydraulich works through which Lucca has been saved from the frequent danger of inundation of the river Serchio, and the country around has acquired its well deserved renown of uncommon fertility.

This painting is one of the most valuable works of Carletto, and was given to this Gallery by the granduke Ferdinand III, who purchased it from a church in Castel Franco di Sotto. — On canvas. Life size. — Signed: « *Carlo filio Pauli Caliari U.ˢᵗ f.* »

581. TINELLI Tiberio, of Venezia. B. 1586, d. 1638.

The head of a young man. On canvas. Life size.

585. PORDENONE (Giovanni Antonio Licinio, called). Born at Pordenone in Friuli in 1483, died at Ferrara in 1539.

Portrait of a man, holding a book in his right hand and a handkerchief in the left. — On canvas. Life size.

Taken from the store-rooms of the Royal Palace in 1794.

606. BASSANO.

A landscape with figures of shepherds and animals. — On canvas. Dim. fig.

608. PALMA Iacopo, called *Palma il Giovane* (the younger), in order to distinguish him from his uncle, who is called *Palma il Vecchio* (the elder). Born at Venezia, in 1544, d. 1628.

St. Margaret, with the winged dragon.—A two thirds length. Life size. On canvas.

607. BORDONE Paris.

Portrait of a man in a black and red suit, holding a glove in his right hand, which is laid on a table.— On Canvas. Life size.

Taken from the store-rooms of the Royal Palace in 1794.

626. TIZIANO.

Portrait of a young woman holding some flowers in her right hand. A splendid figure, generally called *La Flora;* one of the most admired paintings of Titian. — On canvas. Life. size.

Taken from the store-rooms of the Royal Palace in 1793.

(Second Hall).

645. SAVOLDI Giovan Girolamo, called *Savoldo,* of Brescia. XVI Cent.

The transfiguration of Our Lord, in presence of the apostles Peter, John and James, on the mount Tabor. — On wood. Half life size.

646. TINTORETTO (Robusti Iacopo).

The sacrifice of Abraham. — On canvas. Half life size.

612. VERONESE Paolo (Paolo Caliari).

The head of St. Paul (a study). — On canvas. Life size.

629. MORONE (Gio. Battista Moroni).

A male portrait. — On canvas. Life size.

614. TIZIANO.

Portrait of John de' Medici, the famous captain called Giovanni delle Bande Nere. Ha was the father of Cosmus I Grand-duke of Tuscany; and died at the

battle of Mantua. — On canvas. Above half length.
Life size.

615. TINTORETTO (Robusti Iacopo).

Portrait of an old man. — A half length. On canvas.
Life size.

616. PORDENONE (Gio. Antonio Licino).

The conversion of St. Paul. The saint is represented
when struck down by a flash from a cloud, amidst his
frightened soldiers. — On canvas. Life size.

Taken from the store-rooms of the Royal Palace
in 1798.

617. TINTORETTO.

The Marriage in Cana. This painting is a diminu-
tive copy, which Tintoretto himself made of that he
executed for the refectory in Santa Maria della Salute
at Venice, and which is now kept in the sacristy of
that church. — On canvas. Half life size.

Taken from the store-rooms of the Royal Palace
in 1796.

618. TIZIANO.

The Holy Virgin and Child. A study for the Ma-
donna in the famous painting belonging to the Pesaro
family in the church of the Frari at Venice.

A peculiar importance of this painting relys on being
a simple sketch by which one can observe the preceed-
ing this great artist used in the performance of his
works. — On canvas. Life size.

Bought in 1863.

619. PALMA Iacopo (*the Elder*). Born at Serinalto in the pro-
vince of Bergamo in 1480, died in Venezia in 1528.

Judith. — Half length. Life size. On canvas.

Taken from the store-rooms of the Royal Palace
in 1798.

620. MAGANZA Alessandro of Venezia. B. 1556, d. 1630.

Portrait of a man in a spanish dress, holding a child
on his left arm. Above half length. — On canvas
Life size.

642. MORONE (Gio. Battista Moroni, called).

Portrait of John Anthony Pantera, the author of a

poem intitled *La Monarchia di Cristo,* which was published in 1535 and dedicated to Francis I. — A half length. On canvas. Life size.

Brought from the Poggio Imperiale Villa in 1795.

622. GIORGIONE (Giorgio Barbarelli, called), of Castelfranco in the province of Treviso. Born 1478, d. 1511.

Portrait of a knight of Malta. This portrait is considered as one of Giorgione's finest paintings. — On canvas. Half length. Life size.

Taken from the store-rooms of the Royal Palace in 1798.

591. SALVIATINO (Porta Giuseppe, of Garfagnana, called). Born 1478, d. 1511.

Bersabea bathing whilst King David is observing ker in the distance.

624. CARLETTO (Callari Carlo).

Adam and Eve expelled from Paradise. — On canvas.

621. GIORGIONE.

The child Moses undergoing the Ordeal by Fire. The Pharaon is sitting on his throne, surrounded by several personages in various and pictoresque costumes. — On wood. Dim. fig.

589. PAOLO VERONESE (Paolo Caliari).

The Martyrdom of St. Justina. The same composition was executed in large proportions by the same author, for the church of St. Justina in Padoa. — On canvas. Dimin. fig.

Taken from the store-rooms of the Royal Palace in 1794.

628. BONIFAZIO VERONESE. Born at Verona in 1497, died in 1553.

The last supper. A large painting, much admired on account of its bold and strong colouring. This painter is one of the best followers of the great Titian's manner. — On canvas. Life size.

Taken from the store-rooms of the Royal Palace in 1798.

630. GIORGIONE (Giorgio Barbarelli).

The judgement of Solomon. A rich composition of

many figures, on a fine landscape back-ground. Similar to N. 621, and both belonging to the primitive manner of this painter. — On wood. Dim. fig.

Taken from the Poggio Imperiale Villa in 1795.

625. TIZIANO.

The Virgin holding the Divine Infant on her arms, and St. Catharine offering to him a prommegranade. A splendid painting chiefly remarkable for the grace and vivacity of its colouring. — On canvas. Half life size.

639. BONVICINO Alessandro, called *il Moretto da Brescia.* Born 1498, d. 1555.

Portrait of a man in black, playing on a guitar. — On wood. Life size.

623. PALMA Iacopo (*the Elder*).

The Virgin and Child, St. Mary Magdalene, St. John and St. Joseph. — On wood. Half life size.

Taken from the store-rooms of the Royal Palace in 1793.

632. CARLETTO (Callari Carlo, called).

Adam and Eve, with their children, tilling. — On canvas. Dim. fig.

633. TIZIANO.

The Holy Virgin holding the Divine Infant on her arms, to whom young St. John presents some flowers. Aside St. Anthony the Hermit, in profile. — On wood. Life size.

Taken from the store-rooms of the R. Palace in 1793.

583. BELLINI Giovanni, of Venezia.

Jesus Christ dead, among the apostles. Chiaro-scuro, half length figures. — On wood. Half life size.

635. CARLETTO (Caliari Carlo, called).

The creation of Eve. — On canvas. Dim. fig.

636. PAOLO VERONESE (Paolo Caliari).

The crucifixion; a rich and very expressive composition of many figures. — On canvas. Dim. fig.

Taken from the store-rooms of the Royal Palace in 1798.

3389. PAOLO VERONESE (Paolo Caliari).

Moses found in the Nyle. — On canvas. Life size.

638. TINTORETTO.

Portrait of the celebrated sculptor and architect San-sovino, in his old age. — On canvas. Life size.

On the back-ground, the words: « JACOPO TATTI SANSOVINO. »

647. TINELLI Tiberio, of Venezia. B. 1586, d. 1638.

Portrait of the poet Gio. Battista Strozzi. — A half length. On wood. Life size.

Taken from the Poggio Imperiale Villa in 1795.

640. BASSANO (Iacopo da Ponte).

Noach shutting himself into the Ark. — On canvas. Dim. fig.

641. CARLETTO (Callari Carlo, called).

The first sin of Adam. — On canvas. Dim. fig.

3390. TINTORETTO.

Portrait of an unknown man.

613. BORDONE Paris.

Portrait of a man. — On canvas. Life size.

643. VAROTARI Alessandro, of Padova, called *il Padova-nino.* Born 1580, d. 1650.

Lucretia. — A half length. On canvas. Life size.

609. TIZIANO.

Sketch of a battle, between the imperial troops and the Venetian army at Cadore. On the foreground is Bartholemew Alviano, the Venetian chief-commander, laying his right hand on the scepter.

This painting was executed by Titian, in large pro-portions, in one of the halls of the Ducal Palace in Venice, but a fire destroyed it entirely in 1570. Ridolfi gives a minute description of this work: V. I, p. 148. — On canvas. Dim. fig.

610. BASSANO (Iacopo da Ponte).

Two hounds. — On canvas. Life size.

649. SCHIAVONE Andrea.

Portrait of a sitting black bearded man, in a black

suit of cloth. — Above half length. On canvas. Life size.

590. TIZIANO.

The Holy Virgin surrounded by seraphims: the Infant Jesus upright before her, and St. John. — On canvas. - Life size.

644. PINI Paolo, of Venezia. XVI Cent.

Portrait of the physician Coignati, in black clothes and a glove on his right hand. — On canvas. Life size.

611. BASSANO.

Portrait of an old man, holding a pencil in his right hand and a paper in his left. — On canvas. Life size.

650. UNKNOWN. — XVI Cent.

Portrait of a Geometrician; painted on a semicircular slate. Signed: MDLV. — Half length.

French School.

The ceiling of this room and of the four following between this and the Tribune, are painted by some pupils of *Bernardino Poccetti.*

651. COURTOIS Jacques, called *il Borgognone.* Born at Saint-Hyppolite, Franche-Comté, in 1621, d. at Rome in 1676.

A small battle-piece. Skirmishing horsemen. — On canvas. Dim. fig.

652. THE SAME.

The same subject.

653. PARROCEL Joseph, of Brignoles (Provence). Born 1646, died 1704.

Combat of cavaliers. A small painting. — On canvas. Dim. fig.

654. COURTOIS Jacques, called *il Borgognone.*

A battle. A large painting, representing some troops of soldiers assailing the castle of Radicofani. — On canvas. Dim. fig.

655. VERNET Joseph, of Avignon. B. 1714, d. 1789.

A small landscape, with a water fall and some fishermen. — On canvas.

656. BOUCHER François, of Paris. B. 1740, d. 1781.

The Infant Jesus, St. John and some seraphims. — On canvas. Dim. fig.

657. LOO (Van) Charles André, of Nice. Born 1705, died in Paris in 1765.

The Holy Virgin and Child. Above half length. — Life size. On canvas.

658. VALENTIN. Born at Coulommiers in 1601, died at Rome in 1634.

A man playing on a guitar. A half length. — On canvas. Life size.

659. NAIN (Antoine le), of Laon. Born 1568 or 1578, d. 1648.

Adoration of the shepherds. — On canvas. Half life size.

691. CHAMPAGNE Philip, of Bruxelles. B. 1602, d. 1674.

Vocation of St. Peter. A ship and several figures in the distance. — On canvas. Dim. fig.

661. LOIR Nicholas, of Paris. Born 1623, d. 1679.

The Holy Virgin, Child and St. John. Half lenght. — On canvas. Life size.
Taken from the R. Pitti Palace in 1797.

662. UNKNOWN.

A small battle. — On copper. Dim. fig.

663. GAGNERAUX Benedict, of Dijon. B. 1673, d. 1795.

A battle. A small painting. — On canvas. Dim. fig. — Signed: « *B. Gagneraux 1795.* »

664. HYRE (De La) Laurence, of Paris. B. 1606, d. 1656.

The Virgin holding the Infant Jesus on her lap. A full figure on a landscape back-ground. — On wood. Half life size.

665. VERNET Joseph.

A small sea piece. A ship in danger of going to wreck. — On canvas.

666. UNKNOWN.

A small landscape, with figures of huntsmen. — On wood. Dim. fig.

667. CLOUET or CLOET François, called *Jehannet*, of Tours. Born about 1500, died about 1573.

Portrait of Francis I, king of France; a full figure on horseback, executed with a great carefulness of finish, and much skill. — On wood. Dim. fig.

668. DUGHET Gaspar, called *Gaspero Pussino*. Born in Rome in 1613, died 1675.

A small landscape, with two figures of fishermen. — On wood. Dim. fig.

669. BORGOGNONE (Jacques Courtois).

A battle. A large and splendid composition. A group of combatants on the fore ground and several horsemen fighting in the distance. — On canvas. Dim. fig.

On the trappings of a white horse are the words: « JACOMO CORTESE. » This painting as well as N. 654, are believed to have been made for Prince Mattias de' Medici who much protected this artist. They were both taken from the Royal Pitti Palace in 1773.

670. MIGNARD Pierre, of Troyes. Born 1610, d. 1695.

Portrait of the Countess of Grignan. — On canvas. Life size.

671. WATTEAU Anthony, of Valenciennes. Born 1681, died at Nogent near Vincennes in 1721.

A party of horsemen and a lady, listening to a flute player, in a garden. — On canvas. Dim. fig.

Taken from the store-rooms of the Royal Palace in 1860.

672. GRIMOUX (Grimou or Grimoud) Alexis. Born in Switzerland in 1680, died in Paris 1740.

A young pilgrim. Above half length. — On canvas. Life size.

673. MEULEN (Anthony-Francis Van der), of Bruxelles. Born 1634, died at Paris in 1690.

Portrait of Francis William, Elector Palatine, on

horseback, in the act of commanding, at the head of his army, which is seen at a distance. — On canvas. Half life size.

Taken from the store-rooms of the Royal Palace in 1861.

676. UNKNOWN.

Portrait of Louis XIV, king of France. A full length. — On wood. Half life size.

Taken from the store-rooms of the Royal Palace in 1862.

675. STELLA James, of Lyon. B. 1596, d. 1657.

Jesus sitting at table in a beautiful country, attended by some angels. — On canvas. Half life size.

Taken from the store rooms of the Royal Palace in 1773.

684. RIGAUD Hyacinthe, of Perpignan. Born 1654, died on july 18th 1743.

Portrait of the celebrated Bossuet, bishop of Meaux. — On canvas. Life size.

Brought from the Poggio Imperiale Villa in 1861.

674. LARGILLIÈRE Nicholas, of Paris. Born 1656, died 1746.

Portrait of the poet J. B. Rousseau. A half length. — On wood. Life size.

677. JOUVENET John, of Rouen. Born 1644, died 1717.

St. Anna. — On canvas. Half life size.

678. VALENTIN.

Christ giving the sentence: « Thou seest the fescue in the eye of thy neighbour and not the beam in thyne own. » Half lengths. — On canvas. Life size.

679. FABRE François-Xavier, of Montpellier. B. 1766, d. 1837.

Portrait of Victor Alfieri, executed with much skill and perfect likeness. Above half length. — On canvas. Life size.

The author himself made a present of this portrait and that of the Countess of Albany (N. 689) to this

Gallery in 1824. — Behind this is the following authographic sonnet by Alfieri:

Sublime specchio di veraci detti,
 Mostrami in corpo e in anima qual sono.
 Capelli or radi in fronte e rossi pretti;
 Lunga statura e capo a terra prono;
Sottil persona in su due stinchi schietti :
 Bianca pelle, occhi azzurri, aspetto buono;
 Giusto naso, bel labbro, e denti eletti,
 Pallido in volto, più che un re sul trono:
Or duro, acerbo; ora pieghevol, mite;
 Irato sempre e non maligno mai;
 La mente e il cor meco in perpetua lite:
Per lo più mesto, e talor lieto assai;
 Or stimandomi Achille, ed or Tersite:
 Uom, se' tu grande o vil ? Muori, il saprai.
<div align="right">V. A.</div>

<div align="center">— Scampato, oggi a du' anni,
Dai Gallici Carnefici Tiranni.</div>

Firenze, 18 agosto 1794.

680. POUSSIN Nicholas. B. at Andelys in Normandy in 1594, died at Rome in 1665.

Theseus in Trezene. Theseus in presence of his mother Etra, lifts with great effort the huge stone, under which his father Egeus had hidden the sword his son had to show in order to be recognised by the Athenians. — On canvas. Half life size.

Taken from the store-rooms of the Royal Palace in 1793.

681. PILLEMENT John, of Lyon. Born 1728, d. 1808.

A sea port, on a misty morning. In pastello. — On paper.

682. CLOUET François, called *Jehannet.*

Portrait of a young man. — A half length dimin. figure.

683. PERELLE Nicholas, of Paris. Born 1638, d. 1695.

· *A small landscape,* with-a figure of St. John sitting by the bank of the river Jordan. — On copper.

660. BOURDON Sebastian, of Montpellier. Born 1622, died in Paris on may 8th 1671.

Repose in Egypt, with a fine landscape back-ground. — On canvas. Dim. fig.

Taken to the Gallery in 1793.

685. BRUN (Charles Le), of Paris. Born 1619, d. 1690.

Jepta's vow. A beautiful composition, on a circular canvas. — Half life size.

Taken from the store-rooms of the Royal Palace in 1793.

686. PILLEMENT John.

A sea storm. In pastello. — On paper.

687. CALLOT Jacques, of Nancy. Born 1594, d. 1635.

A grotesque portrait. — On copper. Dim. fig.

688. MIGNARD Pierre.

Portrait of the Marquise de Sévigné. Almost a full length. — On wood.

689. FABRE François-Xavier.

Portrait of the Countess of Albany. — Above half length.

An authographic sonnet by Alfieri, is written behind, as follows:

> Di quanti ha pregi la mia donna eccelsi,
> (Cui più il conoscer che il narrar m'è dato)
> Quello per cui me da me stesso io svelsi,
> È il cor d'alta bontà sì ben dotato.
> Questa in mille virtù da prima io scelsi.
> E più assai che beltade hammi allacciato:
> Questa dopo anni ed anni, ancor riscelsi
> Per vera base al mio viver beato.
> Non che i suoi brevi sdegni ella non senta;
> Nè che pur tarda od impassibil sia:
> Ma vie men sempre al perdonare è lenta.
> Nel suo petto non entra invidia ria;
> I benefizi al doppio ognor rammenta;
> Le offese, in un coll'offensore, oblia.

Firenze, 18 agosto 1794.

> Compie in quest'oggi il second'anno appunto
> Che agli schiavi cannibali assassini
> Io lei sottrassi; e diemmi Apollo il punto.
> V. A.

690. GAGNERAUX Benedict.

A Lion Hunt. — On canvas. Half life size. — Signed: « *B. Gagneraux 1795* » Purchased in 1796.

690 *bis.* FABRE François-Xavier.

Portrait of the painter Joseph Mary Terreni.

692. VOUET Simon, of Paris. Born 1590, d. 1649.

The Annunciation. — On canvas. Dim. fig.

693. POUSSIN Nicholas.

Venus and Adonis on mount Ida. A sketch. — On canvas. Dim. fig.

694. DUFRESNOUY Charles Alphonse, of Paris. Born 1611, died 1665.

The death of Socrates; a composition of many figures. — On canvas. Half life size.

Taken from the store-rooms of the Royal Palace in 1793.

695. CHAMPAGNE Philip.

A male portrait. — On canvas. Life size.

Taken from the Royal Palace in 1797.

696. GRIMOUX Alexis.

A pilgrim girl. Above half lenght. Supposed to be the portrait of Mad. Dangeville. — On canvas. Life size.

697. HYRE (De La) Laurence.

St. Peter healing the sick with his shadow. — On canvas. Dimin. fig. — Taken from the store-rooms of the Royal Palace in 1793.

Flemish and German Schools.

(First Saloon).

698. GOES (Hugh Van der), of Bruges or of Ghent. — XV Cent.

The Holy Virgin, sitting and holding her Divine Son on her arm. St. Catherine and another Saint. A painting worthy of particular remark for its fineness and skill of execution.

The works of this painter are very rare, particularly in the Flanders, as the greatest part of them were executed in Italy. On these the most remarkable is the large painting which he made for the church of Santa

Maria Nuova in Florence, by commission of the Portinari family. — On wood. Dim. fig..

According to Prof. John Semper's recent opinion this painting is however to be attributed to Henry Aldegrever rather than to Goes (See *Arte e Storia*, January 24th 1886, N. 3, Anno V).

748 *bis*. KULMBACK.

Conversion of St. Paul.

700. TENIERS David (the younger), of Antwerp. Born 1610, died at Bruxelles in 1690.

An old woman and an old man, caressing each other, in an inn. — On canvas. Dimin. fig.

701. SON (George Van), of Antwerp. Born 1650, died 1700.

Two gamblers fighting. — On wood. Dim. fig.

702. NEEFS Peter (the Elder).

Interior of a vast church, by the light of two torches carried by two men who walk before a group of women coming from the baptismal font, with a child. — On wood. Dim fig. — Signed: « *Peter Neefs.* »

703. MEMLING John (in old catalogues erroneously spelt as *Hemeline*). Died in Bruges 1495.

The Holy Virgin with the Divine Child enthroned. Left and right are two angels, playing a violin and a harp. In the back-ground a landscape with very minute figures. This painting is precious for its exquisite execution and perfect state of preservation. — On wood. Dim. fig.

704. GERMAN SCHOOL.

Christ on the Cross, and the figures of a knight, a gentle-woman and a child in the act of adoration — On wood. Half life size.

705. TENIERS David (the elder), of Antwerp. B. 1582, d. 1649.

A Physician, sitting and holding a phial. — On wood. Dim. fig.

706. TENIERS David (the younger).

St. Peter weeping. A half length. Reminiscent of the Bolognese school. — On wood. Dim. fig.

707. NEEFS Peter.

Interior of Antwerp cathedral. — On wood. — Signed: « *Peter Neefs.* »

708. FLEMISH SCHOOL. — XV Century.

Adoration of the Wise Men. — On canvas. Dim fig.

713 *bis.* KULMBACH John, of Nuremberg. B. 1492, d. 1539.

Martyrdom of St. Peter. — On wood. Dim. fig.

710. STALBENT Adrian, of Antwerp. B. 1580, d. 1662.

A landscape; a forest by a river.

711. FLEMISH SCHOOL.

A small landscape. — On slate.

712. FLEMISH SCHOOL. — XVII Century.

Landscape by night, with figures of men, fording a river. — On slate.

713. KULMBACH.

St. Peter walking on the water. — On wood. Dim. figures.

714. MIEL (or Meel) John. Born at Antwerp in 1599, died at Turin in 1656.

A landscape with figures. — On canvas.

749. FLEMISH SCHOOL (Van der Goes style).

Two half length portraits; a man and a woman on two separate compartments. They are both dressed in the Flemish fashion, and have a book on their hands. They are painted on two panels on the reverse of which is an Annuntiation. — On wood. Life size.

Taken from the hospital of S. Maria Nuova in 1825.

717. NEEFS Peter.

Interior of a church. This painting is remarkable for a splendid effect of light of some candles on an altar, and for its size which is larger than in any painting of this artist generally is. — On wood. — Signed: « *Neefs 1636.* »

731. EYCK (?) (John Van). Born at Eyck about 1390, died at Bruges on july 14th 1440.

The Adoration of the Wise Men. A triptyc. — On

wood. Dim. fig. — Found out of the store-rooms of the Gallery in 1863.

Prof. John Semper has however recently sentenced this painting to be the work of *Martin Van Veen* called *Keemskerck*, born at Keemskerck in 1498, died at Harlem 1574.

719. RUBENS SCHOOL.

Bacchanals. Imitation of a painting by Titian. — On wood. Dim. fig.

721. GŒBAUW Anthony, of Antwerp. B. 1616, d. 1698.

Some peasants, by the door of a farm house. Signed: « *A Gebow F.* » — On wood. Dim. fig.

722. LAAR (Peter Van), called *il Bamboccio.* Born at Lauren, near Naarden in Holland in 1613, died at Harlem in 1673 or 1674.

A man watering three dogs. A small painting on slate.

723. UNKNOWN. — XVII Century.

A landscape. On an oval copper plate. The size of N. 720.

724. KULMBACH John.

Martyrdom of St. Paul. — On wood. Half life size.

725. ASSELYN John, of Antwerp. Born 1610, d. 1690.

A landscape with a large water-fall. — On canvas. — Signed: « *J. A.* »

726. BEGA Cornelius, called *Kornelis Begyn,* of Harlem. Born 1720, died 1664.

A group of gamesters, by a cottage. — On canvas. Dim. fig.

727. UNKNOWN. — XVII Century.

A landscape with ruins, and figures representing the resurrection of Lazzarus. — On wood.

750. GERMAN SCHOOL. — XVI Century.

Male portrait. — On copper. Dim. fig.

728. UNKNOWN. — XVII Century.

The temptation of St. Anthony. — On copper. Dim. figures.

729. KULMBACH.

St. Peter delivered from prison. — On wood. Half life size.

730. DE BLESS Henry, called *il Civetta,* of Bovignes, near Dinaut. Born 1480, died 1550.

A landscape, with figures of miners, working by a mine.

718. BRILL Paul, of Antwerp, painter and engraver. B. 1554, d. in Roma 1626.

A large sea-piece, with many ships. — On canvas.

732. FLEMISH SCHOOL. — XVII Century.

The flight into Egypt. The Virgin bearing the Infant Jesus on a donkey, followed by St. Joseph and preceded by an Angel. — On copper. Dim fig.

733. UROOM Cornelius, of Harlem.

A sea piece. — On wood.

734. UNKNOWN. — Flemish School.

Landscape, with animals. — On wood.

751. KRANACH (or Cranach) Luke, of Cranach. Born 1472, died at Weimar in 1553.

St. George. A small painting. — On wood.

758. ELZHEIMER.

A landscape with a figure of a shepherd playing the bag-pipe. — A small painting. On copper.

740 *bis.* KULMBACH.

Ascension of St. Paul.

699. SUSTERMANS Just, of Antwerp. Born 1597, d. 1681.

Portrait of a noble man of the Puliciani family. — On canvas. Life size.

Found out of the store-rooms of the Royal Gallery in 1862.

740. KULMBACH.

St. Peter preaching. On wood. Dim. fig.

737. FRANK Francis, called *il Vecchio d'Anversa* (the Elder of Antwerp). Born 1544, d. 1616.

Danse of Cupids, in presence of some nimphs. — On wood. Dim. fig. — Signed : « *F. Frank inv. F. A.* »

735. MIEL John.

A peasant family. — On canvas. Dim. fig.

739. LAMBRECHTS.

Family scene. Similar to N. 746. — Signed: « *Lambrechts.* » — On wood. Dim. fig.

1029. UNKNOWN. — XV Century.

The adoration of the Wise Men. — On wood. Dim. figures.

743. MOUCHERON.

A landscape. — On canvas.

742. TENIERS David (the Elder).

An old chemist. — On canvas. Dim. fig.

744. FRUMENT Nicholas, of Avignone, France. XV Century.

A large triptych: German School. In the center: the resurrection of Lazarus; upon the right panel: Martha at the feet of Jesus; to the left: Mary Magdalene who is washing our Saviour's feet. Outside of the two doors are: *the Virgin* in chiaroscuro, and some *portraits.* — On wood. Half life size.

On the lower edge of the picture are the words: « NICOLAVS FRVMENTI *absolvit opus* XX.° KC.° JUNII MCCCCLXI. »

747. FRANCK Francis.

Triumph of Neptune and Amphitrite. Similar to N. 737. — On wood. Dim. fig. — Signed: « *D. L. F. Frank inv. A. F. A.* »

709. SUSTERMANS.

Portrait of the wife of Puliciani. — On canvas. Life size.

Found out with N. 699.

745. KESSEL (John Van), of Antwerp. B. 1626, d. 1678 or 79.

Fish. — On copper.

746. LAMBRECHTS.

Family scene. Similar to N. 739. — On wood. Dim. figures. — Signed: « *Lambrects.* »

748. KULMBACH.

St. Peter and St. Paul led to prison.

741. MOUCHERON Frederic, of Embden. B. 1634, d. 1686.

A landscape. — On canvas.

752. UNKNOWN. — Flemish School.

Small landscape. — On canvas.

753. UNKNOWN. — Flemish School.

Small landscape. — On canvas.

754. BRILL Paul.

A landscape, with a wild boar hunt. — On canvas.

755. DEAL (John Van).

A skull, with other emblems of Death. A small painting. — On wood.

756. GŒBAUW Anthony.

An old man playing the guitar. — On wood. Dim. figures.

757. VERENDAEL (or Varendael) Nicholas, of Antwerp. Born 1659, d. 1717.

A vase of flowers. On wood.

758. ELZHEIMER Adam, of Francfort. Born 1574, d. 1620.

A landscape.

759. DEAL (John Van).

The same subject than N. 755. Signed: « *J. F. Deal.* » — On wood.

760. FLORIS Francis, of Antwerp. — Flourished in 1570.

Adam and Eve in the act of tasting the apple. A large painting. — Full figures. Life size. — Signed: « *F. Floris F. A. 1560.* »

761. BRUEGHEL John, of Antwerp, called *Brueghel des velours.* Born 1568, died at Antwerp in 1625.

A landscape. In the distance a large town crossed by a river.

Inside this painting, which opens, and just on the back of Brueghel's landscape, their is a fine chiaroscuro composition by Albert Dürer, representing the ascent of Christ to the Golgotha and opposite to this a copy of it with colours, signed: « *A. D. Inventor 1505. Brueghel Fec. 1604.* » On wood. Dim. fig.

762. CLEEF Just, called *Giusto da Gand.* XVI Century.

Bust of a Saint, with joined hands and a white veil on her head. — On wood. Life size.

830. SEGHERS Daniel, called *the Jesuit,* of Antwerp. B. 1590, d. 1661.

Bust of a man (chiaroscuro) surrounded with flowers. (Signed: *D. Seghers. Soc. Jesu*). — On copper. Taken from the Gallery of Vienna in 1793.

(Second Salon).

766. DURER Albert, of Norimberg. Born 1471, d. 1528.

Portrait of an old man, with a chaplet in his hand; believed to be the father of the painter. — On wood. Life size. — Signed vith the usual cypher of Dürer, and the date 1490.

Brought from the Poggio Imperiale Villa, in 1672.

769. MEMLING.

Portrait of a man in the act of praying, and a book open before him. Bearing the date 1442.

Taken from the Hospital of S. Maria Nuova in 1825.

800. SCALKEN Godfrey.

A young woman, by the light of a candle which she bears and covers with one of her hands. — Life size.

767. NEEFS Peter.

Interior of a prison. The death of Seneca. Signed: « *Peter Neefs.* » — On wood. Dim. fig.

768. DURER Albert.

The Apostle St. Philip. The head alone painted in distemper. — On canvas. Life size.

On the lower edge of the painting is the cipher of the author, with the date 1816.

779. MESSYS (or 'Metsys) Quintin. Born at Louvin in 1466, died at Antwerp in 1539.

St. Jerome. A half length. — On wood. Dim. fig.

770. RYCKAERT David (the Younger). Born 1612, d. 1661.

Temptation of St. Anthony. — On wood. Dim. fig.

771. POELEMBURG (Cornelius van), of Utrecht. Born 1466, dead 1531.

Five small figures of Apostles and other Saints, in separate compartments. — On copper. Dim. fig.

772. THE SAME.

Landscape, with an Angel appearing to a woman. — On copper.

773. THE SAME.

Another painting similar to 771, containing *five small figure of Saints.* — On copper.

774. GELLÉE Claudius, called *Claudius of Lorrain.* Born at Château de Champagne in 1600, died at Rome in 1682.

A Marine scene, by the sitting sun. The sun is just setting on a calm sea; a distant tower with battlements is seen in the evening mist, and near it a light tower and several ships around. On the fore ground, to the left are some large vessels with flags bearing the coat-of-arms of the knights of St. Stephen; to the right a magnificent palace, representing the Medici Villa at Rome, and before is another rich edifice, decorated with columns and statue. On a large door is a clock surmonted by the coat of arms of the Medicis, to show that this painting was made by the commission of that family. This stupendous work of Claudius of Lorrain is one of his best master-pieces, and bears his signature and the date, still quite readible.

It was brought hither from the Pitti Gallery in 1773.

831. SANDRART Joahim, of Francfort. B. 1606, d. 1683.

Apollo rejoicing for having killed the serpent Python. — On canvas. Dim. fig.

778. MEMLING.

St. Benedict. A half length. — On wood. Life size.

801. FLEMISH SCHOOL. — XV Century.

A male portrait. — On wood. Half life size.

777. DURER Albert.

St. James; the head, painted in distemper; similar to N. 768 (the cypher of Dürer and the date: 1516). — On wood. Life size.

780. MEMLING.

St. Benedict. A half length. On wood. Life size,

776. NEEFS Peter.

Interior of a church. To the left there is a chapel lighted by two candles on the altar. On the fore-ground a wall, and two men with torches. — On canvas. Half life size.

781. UNKNOWN. — XV Century.

An old woman. — On wood. Life size.

782. MANS Francis Anthony, of Stettin. XVIII Century.

A Village crossed by a river, with several boats and figures. Signed: « *F. Mans.* » — On canvas.

842. RUBENS Peter Paul.

The three graces (chiaroscuro) a sketch. — On wood. Dim. fig.

Given by Monsignore Airoldi in 1671.

784. MOR (or Moor) Anthony, of Utrecht. Born 1521, d. 1581.

Portrait of an unknown man. — On wood. Life size.

786. DOV (or Dou) Gerard, of Leyden. B. 1613, d. 1680.

A school-master, teaching a girl, at a table, by the light of a candle. On the floor lays a kindled lantern: some other lighted lamps in different parts of the room. Signed: « *G. Dov.* » — On wood. Dim. fig.

787. SWANEVELT Herman. Born at Woerden in 1620, died at Roma in 1690.

Landscape. Imitation of Claudius of Lorraine's style. — On canvas.

788. AMBERGER Christopher, of Nuremberg.

Portrait of Camillus Gross. — On wood. Life size.

785. FLEMISH SCHOOL.

The shoemaker's family, at table. — On canvas. Dim. fig.

789. HOREMANS Peter, of Antwerp. B. 1617, d. 1680.

A school. — On canvas. Dim. fig.

790. SCHOEVAERDTS Mathew, of Bruxels. XVII Century.

View of a village, with many figures. Signed: « *M. Schœvœrdts.* » — On wood.

792. MIGNON Abraham, of Francfort. Born 1639, died 1679 ? or 1697 ?

Fruit with accessories. — On wood.
Taken from the store-rooms of the R. Palace in 1764.

793. ELZHEIMER Adam.

A landscape with figures, of nymphs, guided by Mercury with some offerings to a temple. It is believed to represent the triumph of Psyches. — On copper. Dim. fig.

795. WEYDEN (Rogers Van der), called delle *Pasture*. Born at Tournai in 1400, died at Bruxels in 1464.

The Body of Our Saviour being carried to the Sepulchre. One of the finest works of this painter, who belongs to the best period of Flemish art. — On wood. Half life size.

765. HOLBEIN John (the Younger). B. at Augsbourg in 1497, died in London in 1543.

Portrait of Richard Southwell, counseler of State of Henry VIII king of England. A half length. — On wood. Life size. — On the back-ground are the following words in golden letters: « X Julii Anno H. VIII. XXVIII. Etatis suæ XXXIII. »

797. SCALKEN Godfrey, of Dordrecht. Born 1643, d. at Haag in 1706.

A sculptor in his studio, looking at a marble female bust, by the light of a candle. — On wood. Dim. fig.

798. KESSEL.

Fish and Fruit. — On canvas.

811. VOS (Martin De).

The Crucifixion, a small painting with many figures. — On canvas. Dim. fig.

801 *bis.* FLEMISH SCHOOL. — XV Century.

Portrait unknown.

799. HOLBEIN John (the Younger).

Male portrait. — On wood. Life size.

802. FLEMISH SCHOOL. — XVII Century.

A family by the light of the fire side and a lamp. — On wood. Dim. fig.

803. HOREMANS Peter.

Interior of a kitchen. Signed: « *P. Horemans.* » — On canvas. Dim. fig.

804. BREYDEL Charles, of Antwerp, call. *il cavalier Breydel.* Born 1677, d. 1744.

A small landscape, with many figures. — On wood.

805. FERG Francis, of Paula. Born at Vienna 1689, d. 1740.

A small landscape, with several figures. — On copper.

806. BRILL Paul.

A landscape. — On canvas.

807. THE SAME.

A small landscape. — On copper.

808. AGRICOLA Christopher, of Ratisbonne. B. 1667, d. 1719.

A landscape, with the rainbow. — On canvas.

812. RUBENS Peter Paul.

Venus and Adonis. In a pleasant landscape, Adonis is represented in the act of quitting Venus. A little Cupid strives to detain him, while the three Graces uncover the goddess; but a malignant Fury draws him away from her, by the edge of his mantel. Some other Cupids are playing with some dogs, aside.

This painting is executed with an admirable carefulness of finish, and is also in a perfect state of preservation. — On wood. Dim. fig.

813. BRILL Peter Paul.

A large landscape, with figures and animals. — On canvas.

814. BREYDEL Charles.

A small landscape, similar to N.ʳ 804. — On wood.

815. FERG Francis, of Paula.

A small landscape, with various figures. — On copper.

816. BRILL Paul.

A landscape. — On wood.

817. THE SAME.

Landscape, with a sea-view in the distance. — On canvas.

818. AGRICOLA Christopher.

A landscape. The dawn. — On canvas.

825. SAVERY Roland, of Bourtray. Born 1576, d. 1639.

A landscape, with figures. — (Signed: *R. Savery, 1614*).

821. HOLBEIN John (the Younger).

. *Male portrait.* — On wood. Half life size.

822. KRANACH Luke.

Portrait of Catharine Bore, Luther's wife. — On wood. Half life size. .

823. HOREMANS Peter.

The tailor's family. — On canvas. Dim. fig.

820. BALEN (Henry van), of Antwerp. Born 1560, d. 1632.

Numptials of the Holy Virgin. — On canvas. Dim. fig.

824. BOUDEWINS Nicholas and F. BAUT. — XVII Century.

A landscape, with the view of an old castle. — A small painting. On wood.

819. RYCKAERT David.

Temptation of St. Anthony. — On wood. Dim. fig.

826. TENIERS David (the Elder).

Landscape, with many figures. — On wood.

827. HOREMANS Jean.

The Shoemaker's family. — On canvas. Dim. fig.

828. MERA Peter, of Bruxels.

Pan and Syrinx, and some nymphs bathing in a river. — On copper. Dim. fig.

846. SUAVIO Lambert, called *Lamberto Lombardo,* of Liège. Born 1506, died 1560.

The Deposition. A small painting on wood, in a fine antique enamelled metal frame. On the revers of it, *Adam and Eve* engraved on a gilded metal plate.

829. WINCKENBOOMS David, of Malines. Born 1578, d.

Landscape, with figures dancing on the ice. — On cooper.

845. KRANACH Luke.

John and Frederic, Electors of Saxony. — Signed

with the usual cypher of the author, and dated 1533.
— On wood. Dim. fig.

847. KRANACH Luke.

Portraits of Luther and Melancthon, bearing the monogram of the author with the date 1543. — On wood. Dim. fig.

809. MIEL John.

A shepherd, and an ox. — On canvas.

764. DENNER Balthasar, of Hambourg. B. 1685, d. 1740.

Portrait of a man, wearing a furred coat and a bonnet. This painting is to be well examined with an eye-glass, in order to admire its inimitable minuteness of details. — On canvas. Life size. — Signed: *Denner, 1726.*
Taken from the store-room of the R. Palace in 1792.

810. RUBENS Peter Paul.

An old Silenus, with some satyrs. A sketch. — On canvas.

832. BOUDEVINS Nicholas.

Landscape, with the view of an old castle. — On wood.

836. HOREMANS John.

Card-players. (Signed: *Horemans*). — On canvas.

834. TENIERS David (the Elder).

Landscape, with several dimin. figures. — On canvas.

835. HOREMANS John.

The female tea-seller. — On canvas. Dim. fig.

833. RYCKAERT Martin, of Antwerp. Born 1587, d. 1631.

Landscape. The cascade of Tivoli. — On canvas.

838. KRANACH Luke.

Portrait of Luther. — On canvas. Half life size.

839. HOLBEIN John (the Younger).

Portrait of woman. — On wood. Half life size.

840. HOREMANS John.

Family grace before meat. — On canvas. Dim. fig.

837. RUBENS SCHOOL.

The birth of Erychthonus. The nymph Aglaura in the act of covering with a cloth the cradle in which Erychthonus lays, naked, with serpentine legs. — On wood. Dim. fig.

Taken from the Pitti Palace in 1793.

783. VAN-DYCK Anthony.

The Holy Virgin and Child, surrounded by some Angels. The Eternal above. — Chiaroscuro. On canvas. Dim. fig.

843. RUBENS SCHOOL.

Venus and Cupid, and three nymphs. — On wood. Dim. fig.

844. AGRICOLA Christopher.

Landscape, by night. — On canvas.

848. GELLÉ Claudius, called *Claudius of Lorraine.*

A landscape. Shepherds playing and dancing in a wood, where some goats are grazing. — On wood. Dim. fig.

This composition is engraved by Claudius himself among the 28 engravings of his *Liber Veritatis.* — Signed: *Claudio Gelle F. Rome 1672.*

849. LYS (John Van der), of Oldenburg. Born 1600, d. 1657.

The prodigal son. A composition of many figures. — On canvas. Half life size.

851. DURER Albert.

The Holy Virgin and Child. — Half length. On wood. Life size.

Bearing the monogram of the author, with the date 1526.

852. DURER SCHOOL.

The Virgin adoring the Child Jesus. — On wood. Dim. fig.

853. AGRICOLA Christopher.

Landscape. A rainy day. — On canvas.

Dutch School.

This room contains a most remarkable choise of paintings of the Dutch School, the greatest part of which were collected and purchased by Cosmus III de' Medici.

854. MIERIS (Francis Van), pupil of Gerard Dow. B. at Delft in 1635, d. at Leyden in 1681.

A Charlatan, and his wife before the door of their little shop, in the act of recommending their specifics to a little crowd of various people who are listening to them. (Signed: *F. Mieris*). — On wood. Dim. fig.

861. POELEMBURG'S style.

Small landscape. — On copper.

855. POELEMBURG Cornelius, of Utrecht. B. 1586, d. 1660.

A landscape, with figures of passengers on horse back. — On copper.

856. WATERLOO Anthony, of Utrecht. Died 1662.

Landscape, with figures of fishermen. — On canvas.

857. HEEMSKERK Egbert (the Elder). of Harlem. Born 1610, died 1680.

Portrait of an old man. — Half length. On canvas. Half life size.

858. BRUEGHEL John, called *dei Velluti,* of Harlem.

Landscape, with figures. Carters crossing a wood. — On copper.

969. BEGA Cornelius.

A man playing the lute. — On wood.

973. LINGELBACH John, of Frankfort A-M. Born 1625, died at Amsterdam in 1687.

A landscape, with some figures of sportsmen at rest and ladies on horse-back. — Ond wood. Dim. fig.

863. QUELLIN Erasmus, of Antwerp. Born 1607, died 1678.

The Holy Virgin and Child, surrounded with flowers painted by *Van Thielen de Malines.*

905. WERFF (Adrian Van der), of Rotterdam. B. 1659, d. 1722.

The judgment of Solomon. The King is sitting among his courtiers on his throne and bids a soldier to kill the child in the arms of the mother who is kneeling and entreats her son to be given to the other woman. A painting executed with admirable carefulness of finish. — On wood. Dim. fig.

860. MIERIS (Francis Van).

Portrait of the painter's son John Mieris. A half length, in profile. — On wood.

864. MARCELLIS Otho, of Amsterdam. B. 1613, d. 1773.

A butterfly pursued by a serpent. — On canvas.

867. NETSCHER Gaspar, of Heidelberg. B. 1613, d. 1673.

A woman winding up her watch, by the light of a candle. (A small painting). — On wood.

866. NEER (Eglon Van der), of Amsterdam. B. 1643, d. 1703.

Esther before Ahasuerus. — On canvas. Dim. fig. — Signed: *Eglon Hendrik Van der Neer fec. 1696.*

986. BEGA Cornelius.

A woman playing the lute. — On wood. Dim. fig.

870. HEEMSKERK Egbert.

An old woman, wearing a veil on her head. — On wood. Half life size.

871. BRILL Paul.

A landscape, with an old castle in the distance. — On copper.

982. PYNACKER Adam, of Pynacker (Holland). B. 1621, d. 1673.

Landscape. A village near a river: some shepherds and a cow. — On canvas.

873. SCHALKEN Godfrey.

A woman playing the horn, by the light of a torck. — On canvas. Half life size. (Signed: *G. Schalken*).

874. DOUVEN John-Francis, of Roermont. Born 1655, d. 1727.

St. Anna teaching the Virgin to read, by the light of a candle. — On wood. Dim. fig.

862. POELEMBURG'S Style.

Landscape, with grottos. — On copper.

875. POELEMBURG (Cornelius van), of Utrecht. Born 1466, dead 1531.

Landscape, with ruins and figures. — On copper.

876. THE SAME.

Landscape, with figures representing *Moises found on the Nile.* — On canvas. Dim. fig.

877. THE SAME.

A small landscape, with old ruins. — On canvas.

878. THE SAME.

Landscape, with old ruins and figures of dancing country people. — On copper. Life size.

879. LAAR (Peter Van), called *il Bamboccio*. Born at Lauren, near Naarden in Holland in 1613, died at Harlem in 1673 or 1674.

A landscape, with figures. — On canvas.

884. BRUEGHEL John, of Antwerp, called *Brueghel des velours*. Born 1568, died at Antwerp in 1625.

The four elements: a composition rich of accessories and animals. — On wood.

880. POELEMBURG Cornelius.

Small landscape, on an oval copper plate.

881. KESSEL (John Van), of Antwerp. B. 1626, d. 1678 or 79.

Fruit, fish, etc. A small painting. — On copper.

882. RUYSDAEL Jacob, of Harlem (?). Born 1632, d. 1682.

A landscape after a storm. A sun beam crossing a cloud, shines on the damp ground. A large and dark tree in the middle of the painting, rises distinctly before the vast plain. (Signed: *Ruysdael*). — On canvas.

883. POELEMBURG Cornelius.

A landscape, with figures representing *Moises found on the Nile.* — On copper.

972. METSU (or Metzu) Gabriel.

A lady and a sportsman. A lady in a rich garment is standing near her dressing table in a sumptuous bedroom; a sportsman in his hunting dress and followed by a hound, approaches respectfully to her, presenting her a dead fowl. This painting is one of the finest

and most remarkable in this collection. — On wood. Dim. fig.

887. MIERIS (William Van), the son of the famous Francis Mieris, of Leyden. Born 1662, d. 1747.

St. Mary Magdalene. Above half length. — On wood. Dim. fig.

888. SLINGHELAND (Peter Van), of Leyden. B. 1640, d. 1691.

The soap bubbles. A very remarkable painting, executed with a rare carefulness of finish. — On wood. Dim. fig. (Signed: *P. Slingheland, 1661*).

889. AELST (Paul Van), of Delft. B. 1602, d. 1658.

Some dead game. — On canvas. (Signed: *W. V. Aelst*).

890. MIERIS (Francis Van).

His own portrait. A small oval painting. — On copper.

979. REMBRANDT (Van Ryn).

Landscape. Some steep rocks on the fore ground: a village in a vast plain in the distance. — On wood.

Given to the Gallery by the Baroness Mary Hadfied. Cosway, in 1839.

892. BRUEGHEL Peter (the Elder). Born at Brueghel near Breda, d. 1569.

Christ bearing his Cross. A rich composition of many diminutive figures. — On wood. (Signed: *P. Breughel, 1599*).

981. MIERIS (Francis Van).

The painter with his family. The lady is dressed in a silk garment of satin and velvet, and sitting by the fire side in the act of drinking from a glass, which her youngest son who is standing before her has brought to her on a plate he is still holding in his right hand. The eldest daughter in a white satin dress is also standing and is turning her face to the father who is playing aside with a little monkey, and laughing.

This painting was ordered by Cosmus III de' Medici, and is admirable for minuteness of details and perfect execution. — On wood. Dim. fig. (Signed: *F. Van Mieris fecit 1675*).

895. LEYDEN (Luke of). Born in Leyden 1494, d. 1533.

Portrait of Ferdinand Infant of Spain, Archduke of Austria; inscribed: EFF. FERDIN. PRINCIP. ET. INFANT. HISPAN. ARCH. AUSTR. etc. RO. IMP.° AN.° ETAT. SUE. XXI. VICAR. — On wood. Half life size.

896. KESSEL (John Van).

Study of a Naturalist put in disorder by Children and Monkeys. — On copper. Dim. fig. (Signed: *F. V. Kessel 'fecit anno 1660*).

897. BERKEYDEN Gerard, of Harlem. Born 1643, d. 1693.

The Cathedral of Harlem. — On canvas.

898. POELEMBURG Cornelius.

A landscape: a danse of satyrs. — On copper.

899. THE SAME.

Small landscape. — On an oval copper plate.

900. THE SAME.

Small landscape, with figures of men and animals.

901. THE SAME.

Moises striking the rock. — On copper.

902. LAAR (Peter Van), called *il Bamboccio.*

A barn. Figures of country people and horses. — On canvas.

903. BRUEGHEL John, called *dei Velluti.*

The Elements. (Similar to N.ʳ 884). — On wood.

904. POELEMBURG Cornelius.

The Adoration of the shepherds. A painting admirable for a most careful execution of details and a remarkable effect of lights and shades. — On copper. (Signed: *C. P.*).

865. STEENWYCK (Henry Van), the Younger, of Amsterdam. Born 1589.

A subterranean, with diminutive figures, representing the Beheading of St. John the Baptist. The executioner who has already cut off the head of the Saint, presents it to Herodiade: one of the king's ministers stands waiting at the summit of stair-case: Herod with his

courtiers is seen aside on a terrace. A page with a torch enlightens the whole scene. — On wood.

917. DUTCH SCHOOL.

Landscape, during a storm, with some figures. — On canvas.

907. BOUDEWINS Nicholas. — XVII Century.

A landscape, crossed by a river. To the left a church and many small figures grouped before it on a little square. — On canvas.

908. KESSEL (John Van).

Fruit and vegetables, partly kept in some baskets, and partly scattered on the ground, in a field. — On copper.

909. LAER (or Laar) Peter, called *il Bamboccio*.

A Village scene, with Sportsmen and Horses. — On canvas. Dim. fig.

925. AELST (Van).

Some dead game. — On canvas. Life size.

910. BRUEGHEL John, called *dei Velluti*.

Small landscape. — On copper.

911. POELEMBURG Cornelius.

A landscape, with ruins; a shepherd and some animals. — On an oval copper plate.

912. MARCELLIS Otho, of Amsterdam. B. 1613, d. 1673.

Mushrooms and butterflies. — On wood.

913. POELEMBURG Cornelius.

Landscape, with figures of person and animals. — On copper.

775. JORDAENS Jacob, of Antwerp. B. 1593, d. 1678.

Venus with the thee Graces. — On canvas. Dim. fig.

915. LAAR (Peter Van), called *il Bamboccio*.

Landscape. A farm house, near which a man is holding two horses by their bridles, and some dogs are resting aside. At a distance two men sitting on a wall are drinking in company of another man who is standing before them; to the right is a sportsman conversing with a woman. — On canvas. Dim. fig.

916. MIEL John ?

Two shepherds, with a cow and some goats. — On wood. Dim. fig.

906. DUTCH SCHOOL.

The Crucifixion. — On wood. Dim. fig.

933. BRUEGHEL Peter (the Elder).

Hell. Several monsters of various fashions. Dante and Virgil aside. — On wood. Dim. fig.

918. METZU (or Metsu) Gabriel, of Leyden.

Domestic scene : a woman playing the guitar and a boy caressing a dog on a table covered with a turkish carpet. — On wood. Dim. fig.

919. DOUVEN Bartholemew, of Dusseldorf. Born 1688.

Portrait of John William the Elector Palatine and his wife Anna Maria Luisa de' Medici. A copy of a painting by Adrian Van der Werf, made by B. Douven in 1722.

The two portraits are painted in two medallions hanging from the hands of two hovering geniouses. Between is the basis of an obelisck, bearing the coats of arms of the two families. Below are the allegorical figures of arts and sciences and the portrait of Van der Werf (the author of the original composition) in another medallion supported by the figure of. painting. — On canvas. Dim. fig.

920. DOUVEN John Francis, Bartholemew's father. Born at Roermont in 1615, died 1727.

Portrait of Maria Luisa de' Medici, wife of John William the Elector Palatine. — On canvas. Dim. fig.

921. PLATTENBERG (Nicholas Van), called *Van Platen*. B. at Paris in 1631, died 1706.

A tempest. — On canvas.

922. REMBRANDT (Ryn Van). Born at Leydendorf, a village near Leyden, in 1607, d. at Amsterdam in 1669.

The interior of a cottage. The light of the sun shines through a large window, beside which a man is working: a young woman, sitting by a cradle is nursing her little child at the breast; an old woman is reading a book near her, with a pair or large spectacles before her

eyes : to the left a hearth. — On wood. Dimin. fig. (Signed : *Rembrandt*). A small painting exactly like this is kept in the Louvre Museum at Paris, and is called: " *The joiner's family.*"

928. BRUEGHEL Peter (the Elder).

Landscape, with a dance of peasants. — On wood..

924. HEEM (John David De), of Utrecht. Born 1600, died at Antwerp in 1674.

Fruits, oysters and various utensils. — On canvas.

926. DOU (or Dov) Gerard.

The pancake seller. An old woman, making and selling pancakes by the door of her own house, and two girls. A pretty landscape on the back-ground : on the fore-ground a large tree to the left and various utensils to the right. — On wood. Dim. fig.

1047. VANVITEL (or Vanvitelli) Gaspar, called *degli Occhiali,* of Utrecht. Born 1647, d. at Rome in 1736.

A view of Rome, from the Tiber, near *Castel Sant'Angelo.* A very fine painting in distemper, on paper.

927. BERKEYDEN Gerard.

St. Mary's church a Cologne, with some figures of persons and animals at a fountain. — On wood. D. fig. (Signed : *Gerrit Berk Heyden*).

923. WOUWERMAN Peter, born at Harlem in 1623, d. 1683.

Some sportsmen reposing. — On wood. Dim. fig.

929. LAAR Peter, called *il Bamboccio.*

A woman washing ; oil painting on slate. — D. fig.

930. NETSCHER Gaspar.

A lady in a red dress, praying before a Crucifix. — On canvas. D. fig.

931. LAAR Peter, called *il Bamboccio.*

A poor man caressing a dog. — Oil painting on slate. Dim. fig.

932. MARCELLIS Otho.

A large composition of various plants, flowers, serpents and insects. — On canvas. (Inscribed : *W.... liurs.... 16....*).

914. JORDAENS Jacob.

Neptune striking the earth, from which a horse springs. On the opposite side of the painting Galathea is represented on a carriage, in the act of caressing a Cupid. — On canvas. Dim. fig.

934. SCHALKEN Godfrey.

A girl in a red garment, sewing by candle light. — On wood. Dim. fig.

1053. VANVITEL Gaspar.

View of the Villa Medici, at Rome. — In distemper, on paper.

935. BERGHEM (or Berghen) Nicholas, of Harlem. Born 1620, died at Amsterdam in 1683.

Landscape, with two cows, and a woman suckling a child. — On wood. D. fig. (Signed : *D. V. Berghen*).

936. WELDE (Adrian Van der), of Amsterdam. Born 1639, died 1672.

Landscape, with animals. — On canvas. D. fig.

937. WERFF (Peter Van der), the brother of the celebrated Adrian. Born near Rotterdam in 1665, d. 1717.

A boy and a girl toying with a little bird, shut up in a cage, while a cat is looking at it greedily. Other figures aside, an architectural back-ground. — On wood. Dim. fig.

938. BERGHEM (Dick Van). B. at Harlem, d. about 1780.

A landscape, with two cows and a horse. — On canvas.

939. HEEM (John David De).

Flowers. (Signed : *D. de Heem*). — On canvas.

940. MARCELLIS Otho.

A green lizard and some insects. — On canvas.

941. MIERIS (Francis Van).

A young woman asleep in an undress, near her bed. Aside in the shade a man speaking with an old woman. — On wood. Dim. fig.

942. HEEMSKERCK Egbert.

Many persons smoking and playing the violin. — On canvas.

943. VYSTENBROECH (or Vitenbroek) Michæl.

Landscape, with ruins and animals grazing: a shepherd dancing and a woman playing the tambourin. — On wood. Dim. fig.

On the lower edge of the painting are the letters: *M. X. B.*, and the date 1624.

944. BREEMBERG Bartholemew, of Utrecht. B. 1620, d. 1660.

Landscape, with Roman ruins. — On wood.

945. MIERIS (Francis Van).

Two old folks at table. At a table near a window an old woman is sitting and drinking bear: an old man at the apposite side is slicing a loaf. A bird cage hangs before the window, by the sill of which is a pot with a plant of pinks. Left and right are two bunches of carrots. — On wood. D. fig. (Signed: *F. V. Mieris*).

946. GALLÉ Jerome.

A feston of flowers. — On wood. (Signed: *Hieronimus Gallé f. A. 1655*).

947. HOREMANS Peter.

A game at Skittles. — On canvas. Dim. fig.

948. MOUCHERON Isaac, of Amsterdam. B. 1670, d. 1744.

Landscape, with large trees. — On canvas. (Signed: *Moucheron*).

949. NETSCHER Gaspar.

A sacrifice to Venus. A young woman in a white garment is kneeling before a statue of Venus. A maid stands behind her, bearing two doves in a basket. A satyr is looking at the two women, aside. — On wood. Dim. fig.

950. THE SAME.

The portrait of the painter, with his wife and two pretty children toying with a goat. A landscape background. — On canvas. Dim. fig. (Signed: *G. Netscher 1654*).

951. WELDE (Adrian Van der).

Landscape, with figures of persons and animals. — On canvas. Dim. fig.

868. BRUEGHEL SCHOOL.

Small landscape, with ruins. — On copper.

952. MIERIS (Francis Van).

The aged lover. An old man, dressed in a pilgrim's dress is in the act of declaring his love to a young woman who flies from him refusing the money he has put for her upon a table. The scene is lighted by a candle. By the upper edge of the painting are the following words : " OUDT. MAL. IS. NIET. METAL. " (*This time gold is not the conqueror*). — On wood. Dim. fig.

953. RUYSCH (Rachel Van Pool), of Amsterdam. Born 1664, d. 1750.

Fruit and flowers. A splendid painting, considered as one of the most admirable works of this famous artist. — On wood. (Signed : *Rachel Ruysch 1711*).

954. MIERIS (Francis Van).

Tipplers. A man, sitting on a table shows an empty glass to a woman. Another man is sleeping aside. (Signed : *F. V. Mieris fe.*). — On wood. Dim. fig.

955. BRAUWER Adrian, of Harlem. B. 1608, d. 1640.

Interior of a village inn. — On wood. Dim. fig.

956. DUTCH SCHOOL.

Dead game, and a tortoise. — On canvas.

957. NETSCHER Gaspar.

A sacrifice to Love. A young lady dressed in a white satin garment, is playing the guitar in a garden, sitting before a fountain, on which is a statue of Love astride upon a lion. Behind her is a maid bearing a basket of flowers. (Signed : *G. Netscher 1697*). — On wood. Dim. fig.

958. TERBURG (or Ter Borch) Gerard, of Zwol. Born 1608, died 1681.

A dutch lady, in a white satin garment is sitting near a table and drinking some liquor. A young officer is sleeping aside, his head leaning on the table. — On canvas. Dim. fig.

869. POELENBURG Cornelius.

Small landscape, with figures. — On copper.

959. BRAUWER Adrian, of Harlem. B. 1608, d. 1640.

Drinkers, sitting at a table, and smoking. — On wood. Dim. fig.

960. PAULYN Horace, of Amsterdam. Born about 1645.

A miser. An old man, in a black suit of cloths is sitting at a table, keeping one hand on some bags of gold and silver money. — On wood. Dim. fig. — Bearing the monogram: *H. P.*

961. RUYSCH (Rachel Van Pool), of Amsterdam. Born 1664, d. 1750.

Some flowers in a basket. — On wood. (Signed: *Rachel Ruysch, 1711*).

962. HOREMANS Peter.

A game at dice. — On canvas. Dim. fig.

963. MOUCHERON Isaac, of Amsterdam. B. 1670, d. 1744.

Landscape. A forest. — On canvas. (Signed: *Moucheron*).

964. NETSCHER Gaspar.

A servant cleaning a copper pan. — On wood. (Signed: *G. Netscher 1664*).

965. HEEMSKERCK Egbert.

Card players, sitting at table and smoking. — On canvas. Dim. fig.

966. MOLYN Peter (the Elder). Born at London, d. at Harlem in 1661.

Landscape. A wood near a river. — On wood. (Signed: *Molyn*).

967. BREEMBERG Bartholemew.

Landscape, with ruins. (Similar to N.r 944). — On wood.

968. SCALKEN Godfrey, of Dordrecht. Born 1643, d. at Haag in 1706.

Dead Jesus and the vailing Virgin. An angel holding a kindled torch. — On wood. Dim. fig.

859. FRANK Francis (the Younger), of Antwerp. Born 1581, d. 1646.

The flight into Egypt. — On copper. Dim. fig.

970. WYCK Thomas (the Elder), of Harlem. B. 1616, d. 1686.

A sea port, with many figures and some packs of wares on the shore. — On wood.

975. DUTCH SCHOOL.

Landscape, with figures of persons and animals. — On canvas.

893. NEER (Eglon Van der).

A small landscape, executed with admirable skill and accuracy. — On wood. (Signed: *Egl. Van der Neer 1697.*

886. BEGA Cornelius.

A Gipsy, telling a young shepherd his fortune, in a group of other country people, standing before a farm house. — On wood. Dim. fig.

974. BRUEGHEL Peter (the Elder).

Hell, with an immense quantity of diminutive figures, monsters, etc. and Orpheus playing upon his lyre on his way to Pluto's court in order to deliver Eurydice. — On copper. Dim. fig.

971. HOREMANS Peter.

Dancing at an inn. — On canvas. Dim. fig.

976. MIERIS (Francis Van).

His own portrait, in the act of playing on a lute. — On wood. Dim. fig.

977. STEIN John, of Leyden. Born 1626, d. 1679.

Breakfast. A young woman and a man breakfasting in a garden at a table; and two other people standing aside and listening to a boy who is playing on a fiddle. — On wood. Dim. fig.

978. OSTADE (Adrian Van), of Lubech. B. 1610, d. 1685.

A man looking out of a window, a lantern in his hand: a woman behind him. — On wood. Dim. fig.

891. HEYDEN (John Van der), of Gorcum. B. 1637, d. 1712.

View of the market place of Amsterdam. One of the best works of this painter. — On canvas. (Signed: *Jan Van der Heyd f. an. 1667*).

980. HONDUS Abraham, of Rotterdam. Born 1638, d. 1691.

Setting out for the chase. Several sportsmen on horse-back preceded by some dogs assailing a wild boar. — On canvas. Dim. fig.

885. NEER (Eglon Van der).

A small landscape. — On wood. Signed: *Egl. Van der Neer fec. 1697.*

894. DUTCH SCHOOL.

A wind mill. — On copper.

983. POELEMBURG Cornelius.

Landscape, with figures, representing four nymphs, one of which is dancing with a satyr. — On canvas. Dim. fig.

872. OSTERWICK (Mary Van), of Notdorp. B. 1630, d. 1693.

Flowers, fruit and insects. — On wood. Signed: *Maria Van Osterwick.*

985. WERFF (Adrian Van der).

The Adoration of the Shepherds. The Holy Virgin lifting a linen cloth which covers the cradle, in which the Infant Jesus lays, and some shepherds kneeling around. St. Joseph is standing aside. A group of little angels hover above the scene. This painting is one of the finest in this collection. — On wood. Dim. fig. — (Signed: *Adr. V. Verf. fec. an.º 1703*)..

984. MOLENAR Francis.

The dentist. — On wood. Dim. fig. (Signed: *Fran. Molenar*).

987. BOTH John, of Utrecht. Born 1610, died 1650.

A fine landscape, with figures of persons and animals. — On canvas.

988. HOREMANS Peter.

A tavern. — On canvas. Dim. fig.

989. PLATTENBERG (Nicholas Van), called *Van Platen.*

A marine scene. (Similar to N.ʳ 921). — On canvas.

3449. HUYSUM (Jan Van). B. Amsterdam in 1682, d. 1749.

A vase with flowers, painted on glass.

Given to the Galery by Chev. Arthur de Noè Walker.

Italian School.

1044. ALBANO Francesco.

Cupid dancing, in a fine landscape. A composition similar to that of a larger painting of the same author, which is seen in the Brera Museum at Milan. — On copper. D. fig.

1039. PROCACCINI Cammillo, of Bologna. B. 1545, d. 1625?

The Holy Virgin with the Infant Jesus, and St. John. — On wood. D. fig.

991. GRANACCI Francesco, of Florence. B. 1469, d. 1543.

The Supper. — On wood. Dim. fig.

1015. PAOLO VERONESE (Paolo Caliari, called).

The Holy Virgin and Child; St. John, and a bishop. — A sketch. D. fig.

1043. MASSARI Lucio, of Bologna. Born 1569, died 1633.

The Holy Virgin with the Divine Infant and young St. John, holding a little bunch of cherries. — On copper. Dim. fig.

1077. CANALETTO (Antonio Canale, called).

The grand canal of Venice. — On canvas.

1012. ROSA Salvatore.

Landscape. A water-fall by a grotto, and some figures. — On canvas.

998. RENI Guido, of Bologna. Born 1575, d. 1642.

The Holy Virgin, with the Infant Jesus and St. John. in the act of kissing the Child's feet. A pretty little painting, of which a sketch is seen in the famous collection of drawings of this Gallery. — On copper. D. fig.

3417. BOLTRAFFIO Gio. Antonio, of Milano. B. 1467, d. 1516.

Portrait of a young man. — On wood. Dim. fig.

1085. BAROCCI Federico.

Head of a young woman. — On canvas. Life size.

1054. MAGNASCO Alessandro.

Landscape. Preaching of St. John the Baptist. — On canvas. D. fig.

1007. CARACCI Annibale.

The Virgin seated, and the infant Saviour standing by her. Aside, to the right is St. John. — On copper. D. fig.

1003. ROSA Salvatore, of Napoli. Born 1615, d. 1673.

Sea piece. — A small painting (Signed: *Rosa*). — On canvas.

1004. PARMIGIANINO (Mazzuoli Francesco, called).

The Holy Virgin sukling her divine Child. — A very small painting. — On copper.

1005. ROSA Salvatore.

Landscape. A rocky shore, with a group of soldiers on the fore-ground. — On canvas.

1006. PARMIGIANINO (Mazzuoli Francesco, called).

The Holy Virgin with the infant Jesus, St. John, St. Mary Magdalene and the prophet Zachariah. — On wood. Dim. fig.

1002. TIZIANO.

The Holy Virgin, and Child, surrounded by angels. A precious little painting in perfect state of preservation. — Senator Morelli in his book: *Le opere dei Maestri italiani nelle Gallerie di Monaco, Dresda e Berlino* (page 123, Bologna, 1886) speaks of this painting as a work by Correggio. — On wood.

1027. ALBANI Francesco.

Young St. John, with a lamb, in a pleasant landscape. — On wood. Dim. fig.

1026. ZAGO Santi, Titian's pupil.

The Virgin and Child. — On wood. Dim. fig.

1048. MAGNASCO Alessandro, of Genova. B. 1681, d. 1747.

Landscape. Some hermits in a wood.

1011. CIGNANI Carlo, of Bologna. B. 1628, d. 1719.

The Virgin embracing her Divine Son, who is fitting a chaplet on her neck. — The bust. On wood. Life size.

1064. CANALETTO (Antonio Canale, called).

View of the Ducal Palace at Venice. — On canvas.

1013. LUINO Bernardino, of Luino, on the Lago Maggiore. Born about 1460, died after 1530.

The Holy Virgin kneeling; the divine Child to her left, and to the right St. John, playing with a lamb. — On wood. D. fig.

1014. CASTIGLIONE Gio. Benedetto, of Genova. Born 1616, died 1670.

Noah leading the animals into the ark. — On canvas. D. fig.

1041. LIGOZZI Iacopo, of Verona. Born 1542, d. 1632.

The Sacrifice by Abraham. — On wood. D. fig.

1082. CALVART Denis, of Antwerp. B. 1540? d. 1619.

The Assumption. — On copper. D. fig.

1018. SAVONAZZI Emilio, of Bologna. — XVI Century.

Holy Family. — On canvas. D. fig.

1019. PALMA Iacopo (the Elder).

The Virgin, Jesus, St. John and a Franciscan monk. — On wood. D. fig.

1023. ALBANI Francesco.

Repose in Egypt. The infant Saviour attended by some Angels. — On canvas. D. fig.

1024. CASTIGLIONE Giov. Benedetto.

Some animals, with a shepherdess. — On canvas. D. fig.

1021. PAOLO VERONESE (Paolo Caliari, called).

St. Agnes kneeling, and two hovering angels. — A small sketch. On wood.

1149. ALLORI Cristofano.

St. Mary Magdalene in the desert. A Copy of Correggio's famous painting which was formely at Modena and is now in the public gallery at Dresden. — On copper. D. fig.

1020. ZELOTTI Gio. Battista, of Verona. Born 1532, d. 1592.

St. Victor and St. Corona. — On canvas. D. fig.

1032. MAZZOLINI Lodovico.

The Holy Virgin offering some cherries to the divine Infant; St. Anne, St. Joachim ad St. John the Evangelist. — On wood. D. fig.

1025. MANTEGNA Andrea, of Padova. Born 1431, died on september 13th 1506.

The Holy Virgin seated near a rock, with the infant Jesus on her lap. — A landscape back-ground with the view of a town in the distance on a hill, and a stone quarry, with some diminutive figures of workmen on one side.

When Vasari published the life of Mantegna; this precious little painting was already possessed by the prince Francis de' Medici. — On wood. D. fig.

999. CARACCI Annibal (School of).

Holy Family. — On copper. D. fig.

1028. BONATTI (or Bonati) John, of Ferrara. B. 1636, d. 1681.

St. Charles Borromeo, succouring the infected with plague. — On canvas. D. fig.

995. DOSSI Dosso, of Ferrara. Died about 1560.

Massacre of the innocents; a composition of many figures, all gathered in a small space, and worked with a great carefulness of finish. — On wood. Dim. fig.

1030. MAZZOLINI Lodovico, of Ferrara. Born about 1481, died about 1528.

The Nativity. Some shepherds adoring the Divine Child; and angels hovering above. — On wood. D. fig.

1031. AMERIGHI, called *Caravaggio.*

The head of Medusa, painted on a round board, imitating the shape of a shield.

1033. TIZIANO.

The Pharisee, showing the piece of money to Jesus Christ. A diminutive reproduction of a painting by the same author, which is kept in the Museum at Dresden. — On wood. fig.

994. CARPI Girolamo, of Ferrara. B. 1501, d. 1559.

Martha and Mary at the feet of our Saviour, with several other figures. — On wood. D. fig.

1034. MAZZOLINI Lodovico.

The Circumcision. On wood. D. fig.

1035. FETI Domenico, of Roma. Born 1589, d. 1624.

Artemisia in mourning, swallowing the ashes of·her husband. — On canvas. D. fig.

1036. DOSSI Gio. Battista, of Ferrara; died 1549.

A Saint in extacy. — On wood. D. fig.

1165. ALLORI Cristofano.

The Child Jesus sleeping on the cross, bearing an inscription: « *Cor meum vigilat.* » — Brought to this Gallery from the Grand-ducal Villa of Castello, in 1799. — On wood. Half life size.

1045. BASSANO (Iacopo da Ponte, called).

A peasant family. — On canvas. D. fig.

1057. ALBANI Francesco.

The rape of Europa. — The same composition as N.ʳ 1094. — On copper. D. fig.

1022. THE SAME.

St. Peter delivered from prison. — On canvas. D. fig.

1058. TREVISANI Francis, of Treviso. B. 1666, d. 1746.

The Holy Virgin, sewing, and the infant Jesus standing at her side, with a flower in his hand. — On canvas. D. fig.

1042. CASTIGLIONE Gio. Benedetto.

Circe and the companions of Ulysses. — On wood. D. fig.

1102. GIORDANO Luca.

The rape of Dejanira by Nessus. — On canvas. D. fig.

1038. GAROFOLO (Benvenuto Tisi, called).

The Annunciation. A landscape in the back-ground. Above is the Eternal, surrounded by Angels. — On wood. D. fig.

1094. ALBANI Francesco.

Rape of Europa. The same composition as N.ʳ 1057, but larger and more skilfully executed. — On canvas. D. fig.

1001. PARMIGIANINO.

The Holy Virgin suckling her divine Child. — Half length, dim. fig. On wood.

1096. PARMIGIANINO (Mazzuoli Francesco, called).

Our Lady, with the infant Jesus and St. John. A sketch. — On wood. D. fig.

1017. CAGNACCI Guido, of Bologna. Born 1601, d. 1681.

The head of a young man. Above life size. — On canvas.

1088. CORREGGIO (copy of).

Christ praying in the garden. The original of this painting was once in Spain, and then passed into the possession of the duke of Wellington. — On copper. D. fig.

1056. TIARINI Alessandro, of Bologna. B. 1577, d. 1668.

The Virgin, in the act of wrapping her divine Child in a swaddling cloatch which is held by an angel. Aside is St. Joseph speaking to an angel, followed by some shepherds. — On wood. D. fig.

996. PIOLA Pellegrino, of Genova. Born 1617, died 1640.

The Virgin, Child and St. John. Half length figures. — On wood.

1050. PANNINI Gio. Paolo, of Piacenza. Born 1691, d. 1764.

Ruins, and several diminutive figures. — On canvas.

1084. SCARSELLINO (Ippolito Scarsella, called), of Ferrara. Born 1551, d. 1621.

Holy Family. — On wood. D. fig.

1051. UNKNOWN.

Landscape, with figures representing the Baptism of Jesus Christ. — On wood. D. fig.

1052. UNKNOWN.

Sacrifice by Abraham. — On canvas. D. fig.

1061. PARMIGIANINO (Mazzuoli Francesco, called).

Bust of a young man. — On wood. Life size.

1066. PAOLO VERONESE (Callari Paolo, called).

Prudence and Hope bound by Cupid. — On canvas. D. fig.

1040. GUERCINO (Barbieri Gio. Francesco, called). Born at Cento in 1591, d. 1666,

Landscape, with diminutive figures of some singing people. — On copper.

1049. BASSANO (Iacopo da Ponte).

A miser. One third length. — On canvas. D. fig.

1046. GIORDANO Luca, called *Luca fa' presto,* of Napoli. B. 1631, d. 1705.

Thetys on a sea shell, dragged by two dolphins. — On canvas. D. fig.

1092. SCARSELLINO (Ippolito Scarsella, called).

The judgement of Paris. — On copper. D. fig.

1103. FONTANA Lavinia, of Bologna, Born 1552, d. 1614.

Christ appearing to the Magdalene under the semblance of a gardener. — Signed: « *Lavinia Fontana de Zappis, faciebat 1581.* »

997. VERONESE (Paolo Callari).

A woman dressed in white, and other figures. — A sketch, in oil, on canvas. D. fig.

1059. TREVISANI Francesco.

St. Joseph's dream. — On canvas. D. fig.

1070. MICHELI (De) Andrea, called *il Vicentino.* Born 1539, d. 1614.

The Visitation. — On canvas. D. fig.

1065. TINTORETTO (Robusti Iacopo, called).

Bust of a man. — On canvas. D. fig.

1067. PALMA Iacopo (the Younger).

St. John in the desert. — On copper. D. fig.

1100. SCHIDONE Bartolommeo.

The Holy Virgin, with the divine Child in the act of embracing St. John, and St. Joseph aside. — On canvas. D. fig.

1068. PAOLO VERONESE (Paolo Caliari, called).

Bust of a woman. — On canvas. Life size.

1069. BASSANO (Iacopo da Ponte, called).

Jesus crucified. — On canvas. D. fig.

1074. SOLIMENE (or Solimena) Francis, of Nocera. B. 1667, d. 1747.

Diana bathing among her nymphs, in the act of driving Calisto away on account of having discovered her to have been seduced by Jupiter. — On canvas. D. fig.

1086. SCHIDONE Bartolommeo, of Modena. B. 1580, d. 1615.

The Holy Virgin, Child and St. Joseph. — On wood. Half life size.

1078. PARMIGIANINO (Mazzuoli Francesco, called).

Portrait of young man. — On wood. Life size.

1075. CARACCI Lodovico, of Bologna. B. on the 21st april 1555, d. on december the 31st 1619.

St. Francis. — On canvas. D. fig.

1079. SCHIDONE'S Style.

St. Catharine, embracing the wheel and the sword, which were the instruments of her martyrdom. — A half length, on slate. Half life size.

1055. CARPIONI Giulio, of Venezia. Born 1611, died 1674.

Coronis persecuted by Neptune. One of the arms of Coroneus' young daughter who was transformed into a rook, has already become a wing, and the girl is flying towards the sky. A view of a sea shore in the background. — On canvas.

1087. PALMA Iacopo (the Elder).

Bust of a unknown woman. — On wood. D. fig.

1080. PULZONE Scipio, called *Scipione Gaetano,* of Gaeta. B. 1562, d. 1600.

Christ in the garden. — On wood. D. fig.

1081. MICHELI (De) Andrea, called *il Vicentino.*

A Sainted Queen, in the act of receiving a holy image, in the cottage of a hermit. — On canvas. D. fig.

1037. PALMA Iacob (the Elder).

Christ in Emaus. — On wood. D. fig.

992. UNKNOWN.

A young woman getting up. — On copper. D. fig.

1000. TURCHI Alessandro, called *l'Orbetto*, of Verona. Born 1580, died 1650.

An allegory of the Baptism of a son of G. Cornaro, a Veronese captain. To the right is a personification of *Faith* holding a heart in her left hand; in the middle *the Baptism,* represented in the figure of a man bearing the keys of Heaven while a radiant dove hovers on his forehead. A woman representing Verona holds the child; an old man crowned with sea weeds means the river Adige. (Signed: *Alessandro Turchi*). — On slate. D. fig.

1010. PARMIGIANINO (Mazzuoli Francesco, called).

The Holy Virgin and the infant Jesus, keeping an open book on her lap. — On wood. D. fig.

1016. CORREGGIO (Antonio Allegri, called), of Correggio. Born 1494, d. 1534.

The head of a Child. — Above life size. On paper.

1098. CASTIGLIONE Gio. Benedetto.

Different animals and figures. — On canvas. D. fig.

1093. AMBROGI Domenico, of Bologna; Brizio's pupil. XVIIth Century.

Landscape, with figures representing *St. John's preaching in the desert.* This painting as well as N.ʳ 1099 was formely attributed to *Domenichino.* See a recent illustration of Baron Hector de Garriod in the 96th pamphlet of his work "*La Galerie de Florence.*" Société Editrice et Paris.

990. ALBANI Francesco, of Bologna. Born 1578, d. 1660.

Venus reposing. The goddess is lying among some little Cupids, whom she teaches to shoot at a heart, hanging on a tree. Aside is a grotto where some workmen are forging the arrows. — On copper. D. fig.

1091. UNKNOWN.

St. John the Baptist, in the desert. — On copper. D. fig.

1060. TINTORETTO (Robusti Iacopo, called).

Bust of a man. On the back-ground the words: ANNO ÆTATIS XXX. — On wood. D. fig.

1089. FERRI Ciro, of Rome. Born 1634, d. 1689.

Alexander lying in his bed, and reading Homer. — On wood. D. fig.

1095. PALMEGIANI Mark, of Forlì. — XVI Century.

Christ crucified, with the Holy Virgin, Martha, St. Mary Magdalene and St. John. (Signed: *Marchus Palmeganus forlivensis faciebat).* — Brought into the Gallery from the church of *Monte Oliveto* near Florence, in 1843. — On wood. D. fig.

993. CORREGGIO (a copy from).

St. Mary Magdalene. A standing figure, bearing a book with the date 1564. — On canvas. D. fig.

1097. VENETIAN SCHOOL. — XVI Century.

Bust of an unknown man in a black coat. — On wood. D. fig.

1062. CASTIGLIONE Gio. Benedetto.

Medea renewing Eson's youth. — On canvas. D. fig.

1099. AMBROGI Domenico.

Landscape, with figures representing the *Baptism of Christ.* Similar to N.ʳ 1093. — On canvas. D. fig.

1011. ROSA Salvadore.

Landscape, with three figures. — On canvas. D. fig.

1090. RESCHI Pandolfo, of Dantzick. Born 1643, d. the 17th of august 1696.

Small landscape, with some figures of travellers on horseback. — On canvas.

1008. CERQUOZZI Michelangiolo, of Rome. B. 1602, d. 1660.

An old woman spinning. — On canvas.

1009. BONVICINO Alessandro, called *il Moretto da Brescia.*

The Descent of Christ into Hell. — On slate. D. fig.

Tribune.

1104. SPAGNOLETTO (Ribera Giuseppe, called), of Valencia. Born 1588, d. 1656.

St. Jerome, holding a Crucifix in his right hand, and turning his face toward a trumpee appearing in the air. — Above half length. On canvas. Life size.

1107. RICCIARELLI Daniel, of Volterra. B. 1509, d. 1656.

The massacre of the Innocents.

1108. TIZIANO.

Venus reposing. She is nude and lying on a bed: a small Cupid caresses her hair, and a little dog is curled up at her feet. On the fore-ground is a table with a flower pot. A partridge is in the back-ground which represents a fine landscape. — This painting as well as N.ʳ 1117 were executed for Francis Mary della Rovere, duke of Urbino, and were then inherited by the Medicis, in consequence of Victoria della Rovere's marriage with Ferdinand II. They were taken to this Tribune before 1646. — On canvas. Life size.

1109. DOMENICHINO (Zampieri Domenico, called). Born at Cento, near Bologna, in 1519; d. 1666.

Portrait of Cardinal Agucchia, sitting by a table, his left hand resting on a little bell. Above half length. — On the back-ground, the words: « *S. R. E. Card. Agucchia.* » — It was brought to the Gallery in 1794. — On canvas. Life size.

1114. GUERCINO (Barbieri Giovan Francesco, called).

The Samiam Sybil, standing with both hands resting on an open book on which are the words: *Salve casta Syon per multaque passa puella.* — *Sibilla Samia.*

This painting was executed for Prince Matthew of the Medicis in 1651 and purchased for the Gallery in 1777. — Engraved by Anthony Perfetti. — On canvas. Life size. Half length.

197. RUBENS.

Portrait of Elizabeth Brandes. The painter first wife. Half length. — On wood. Life size.

1141. DURER Albert.

The Adoration of the Kings. The Holy Virgin is sitting by a cottage, holding her Divine Child on her lap. The three kings are before her in adoration. A long train of servants and animals is seen in the distance.

This painting once belonged to the Imperial Gallery of Vienne, and was brought to Florence in 1793. — It bears the monogram of the author with the date 1504. — On wood. Half life size.

1122. PERUGINO (Pietro Vannucci, called), of Perugia. Born 1416, died 1524.

The Holy Virgin and two Saints. Our Lady is seated, with the Infant Jesus on her lap : St. John the Baptist is standing to he right and St. Sebastian to the left. An elegant portico is in the back-ground, through which a fine landscape is seen.

This painting, which is one of the finest works of this author, was executed for the church of San Domenico of Fiesole, but the Grand-duke Peter Leopold I purchased, it, and had it placed in this Gallery in 1786.

On the basis of the throne of the Virgin is the following inscription : PETRUS PERUSINUS PINXIT. AN. MCCC. LXXXXIII. — On wood. Life size.

1131. RAFFAELLO SANZIO.

Portrait of Pope Jule II, sitting in an arm-chair on which his left hand is resting. The other hand holds a handkerchief. — Above half length ; life size. — On wood.

This portrait belonged to the Della Rovere family and was inherited by the grand-dukess Victoria, the mother of the last duke of Urbino and wife or Ferdinand II de' Medici.

Another portrait of the same pope, quite similar to this and also painted by Raphael is seen in the Pitti Gallery. The original cartoon is to be found in the Corsini Palace in Florence.

1119. BAROCCIO (or Fiori) Federigo, of Urbino. Born 1528, died 1612.

Portrait of Francis Maria della Rovere, duke of Urbino, in full face, entirely clad in a rich armour, his right hand resting on a helmet ornamented with long feathers.

Taken from the store-rooms of the Pitti Palace in 1795. — On canvas. Above half length.

1136. PAOLO VERONESE (Paolo Callari, called).

Holy Family and St. Catherine. The Virgin is near her Child, who is lying on a linen cloth and asleep. St. Joseph to her left ; St. Catherine to the right, and young St. John kissing Jesus' feet. The figures are half length, with the exception of the Divine Child who is in full length.

This painting was purchased by Cardinal Leopold de' Medici in 1654, from the collection of Paolo del Sera, a florentin merchant, who had settled in Venice.

It was placed in this Gallery in 1798. — On canvas. Life size.

1117. TIZIANO.

Venus reposing on a bed, which is believed to be a portrait of the Duke of Urbino's mistress. She is completely nude, lying on a bed covered with white draperies. A little dog is sleeping at her feet. In the back-ground at a distance are two maids, one of whom is kneeling before a trunk, from which she is taking her lady's dresses, while the other is standing by it. — See N.' 1108. — Engraved by Strange. — On wood. Life size.

This famous painting is mentioned in the principal histories af fine arts, and particularly by Vasari and Algarotti.

1115. DYCK (Anthony Van), born at Antwerp in 1599, died at Blackfriars, near London, in 1641. — Flemish School.

Jean de Montfort. — The bust. Life size. On canvas.

1120. RAFFAELLO SANZIO.

Portrait of a young woman, in full face, dressed after the florentine fashion. Around her neck is a golden chain, from which a little cross is hanging. It was for-

mely believed to be the portrait of Magdalene Strozzi the wife of Angel Doni, and just bears the name of that lady in an engraving by Jerome Scotto.

This painting belongs to the first style of Raphael and is still in a state of perfect preservation. It was taken from the grand-ducal villa of Poggio a Cajano in 1713. — A half length. Life size. On wood.

1121. MANTEGNA Andrea?

Elizabeth wife of Guidobaldo da Montefeltro, duke of Urbino. — The bust, in full face. On wood. Life size.

1140. RUBENS Peter Paul.

Hercules between Vice and Virtue. The hero is sitting between Venus who caresses him, and Minerva who presents him some arms and a white steed, which is led by a young man. An allegorical figure of Time and a little Cupid are hovering above the scene. The hovering Cupid tries to remove the goddess: another one is standing by Hercules and caressing his leg.

The back-ground represents a landscape with two figures in the distance. — On canvas. Half life size.

1123. RAFFAELLO SANZIO?

Portrait of a woman. This beautiful portrait with the date 1512 marked out in the ancient inventory of the Gallery as the portrait of a young unknown woman and attributed to Raphael, afterwards attributed to Giorgione and in the last years of the last century again to Raphael, named « *La Fornarina,* » was believed to be the portrait of the beloved woman of Raphael, which Vasari declared to exist in Florence in the house of the florentine merchant Matteo Botti.

Modern critics nevertheless maintain the doubt on the person which it represents and many of them attribute the painting to Sebastiano Del Piombo who at that time followed Raphael's school.

Dr. Cav. Enrico Ridolfi, Director of the Galleries of Florence, in one of his works on some celebrated portraits of these Galleries (*Archivio Storico dell'Arte,* fasc. VI, Anno IV, Roma, Unione Cooperativa Editrice) has proved with documents that this portrait is not, as it

was believed, that of Raphael's beloved woman painted
by him, of which Vasari spoke, finding it beautiful and
posseded by the florentine merchant Matteo Botti and
which Borghini and Bocchi also saw in his house, but
that a portrait the only one authentic of the lover of
Sanzio, because acknowledged by the contemporary
writers, is instead, the very remarkable painting in the
Pitti Gallery known under the name of the *Donna Ve-
lata*, which from the Palazzo Botti was transferred to
that of the Medici in 1620 with the inheritance of the
Marquis Matteo Botti grand child of the rich merchant
mentioned by Vasari, and last of that family.

The portrait of the Gallery Pitti called *La Velata* is
therefore the only one who has really the right of
being called *La Fornarina*.

1124. FRANCIA (Raibolini Francesco, called), of Bológna. B.
1450, d. 1517.

Portrait of Evangelist Scappi, in full face, holding
a letter on which his name, E. Scappi, is written. —
A life size half length. A landscape in the back-ground.
— On wood.

1125. RAFFAELLO SANZIO.

The Virgin of the well. Our Lady is sitting and
holding her divine Child, who is in the act of embrac-
ing her. Young St. John is standing to her right side,
showing to the Infant Jesus a sheet of paper on which
are the words: *Ecce Agnus etc.* The back-ground re-
presents a landscape, in which the ruins of an old castle.
are seen and several figures around a well. — On woold
Half life size.

1126. FRA BARTOLOMMEO DELLA PORTA, born near
Prato, in Tuscany, in 1475; died in the Convent of St.
Marco, in Florence, in 1517.

The prophet Isaiah. Full figure, sitting and holding
a large paper-roll in his left hand with the words:
Ecce Deus Salvator Meus. — On wood. Life size. —
See N.r 1130.

1127. RAFFAELLO SANZIO.

St. John in the desert. Full figure; sitting on a piece
of stone. He is nude, with the exception of a part of

the right thigh which is covered by a panther skin. His right hand is pointing to a little cross simply formed of two reeds and fastened to the trunk of a three. The back-ground represents a wild and desert landscape.

This famous painting is perhaps the only work by Raphael which is made on canvas. It belongs to Raphael's last style and was executed by commission of Cardinal Colonna, who made a present of it to the physician James de Carpi, who asked for it after having cured the Cardinal of a dangerous disease. At the time of Vasari this painting was in possession of Francis Benintendi in Florence, but it was already in this Gallery in 1589. The original sketch of this St. John in red pencil is also possessed by the Gallery, in its collection of drawings of the old master. — On wood. Life size.

1129. RAFFAELLO SANZIO.

The Virgin of the Goldfinch. The Madonna is sitting in a plaisant country, her Divine Child standing between her knees. She holds an open book by her left hand, and by the right she softly draws young St. John towards the Infant Jesus, to whom he offers a little Goldfinch to caress.

This painting which belongs to Raphael's first style, was executed by commission for Laurence Nasi in 1548, whose house then falling into ruin, this precious painting was torn into several pieces, but John Baptist Nasi, Laurence's son had it restored as well as it was possible. — Engraved by Morghen, Martinet, P. Nocchi etc. — On wood. Smaller than life.

1130. FRA BARTOLOMMEO DELLA PORTA.

The prophet Job. A figure, sitting and holding an unfolded paper-roll, inscribed: « *Ipse erit Salvator meus.* »

This painting, as well as N.ʳ 1126, were executed by commission for *Salvator Belli*, a Florentine merchant, and with the large one representing *the Resurrection of our Saviour and the Evangelists,* which is now in the Pitti Gallery (N.ʳ 159), they decorated one of the chapels in the SS. Annunziata church in Florence. Car-

dinal Charles de' Medici purchased it for his collection
in 1666. — On canvas. Life size.

1110. ALFANI Orazio di Domenico. Born at Perugia about
1540, d. 1583.

Holy Family. The Virgin sitting and holding her
divine Child on her arm; St. Elisabeth and young
St. John. A landscape in the back-ground. — On can-
vas. Dim. fig.

1132. CORREGGIO (Allegri Antonio, called).

The head of St. John on a dish, with a cross and a
papyrus bearing the inscription: *Ecce Agnus,* etc.
Taken from the Royal Villa del Poggio Imperiale.—
On canvas.

1133. CARACCI Annibal.

A Bacchante; seen from behind. The god Pan hands
over to her a cup full of grapes, a young satyr embra-
ces one of her legs, while e little cupid in the air, is
bringing some flowers to her. — On canvas. Life size.

1134. CORREGGIO.

The Holy Virgin adoring her Child. The Virgin is
kneeling in the act of adoring the Infant Jesus who is
lying on the ground upon the edge of her mantle. The
back-ground represents a portico, behind which a plea-
sant landscape is seen.
This painting was given by the Duke of Mantua to
Cosmus III de' Medici, and was placed in this Gallery
in 1617. Half life size.

1135. LUINI Bernardino, of Luino, near Milano. Born 1460,
died 1530.

Herodias attended by her maid, in the act of handing
a dish to the executioner, to receive St. John's head,
which he holds by the hair and gives to the princess.
Half length.
This painting was formely attributed to Leonardo da
Vinci, but it was then recognised as the work of his pupil
Bernardino Luini. It was discovered in the store-rooms
of the Pitti Palace in 1793. — On canvas. Dim. fig.

1118. CORREGGIO.

After the flight into Egypt. The Madonna sitting in

the shade of some plants, holds her divine Child on her arms while St. Joseph is gathering some dates from a palm-tree. St. Francis is kneeling before the Virgin.

This painting was executed for the church of the Franciscans in Parma, for the price of 100 golden ducates. Many accounts about its authenticity are given in Lanzi's *Storia Pittorica*. It is doubtful how this painting has ever come to belong to this Gallery. — On canvas. Dim. fig.

1138. CRANAK Luke.

Eve. Standing and holding the apple. — The same size than *Adam*. (N.ʳ 1142). — Bearing the author's monogram and the date 1528. — On wood. Life size.

1139. BUONARROTI Michelangiolo, b. 1475, d. 1564.

The holy Family. Our Lady is kneeling and lifting her divine Child to St. Joseph who stands bebing her. Several diminutive figures of nude men are in the background. — Painted on a round board.

This precious work is the most authentic among Michelangelo's paintings. It was executed by commission of Angel Doni, of Florence, for the price of 70 ducats. But as Messer Doni only sent 40 to Michelangelo, he refused the sum and asked for 100.˙ Messer Doni then sent the 70 ducats he had promised at first; but at Michelangelo still refused the sum, he was forced to give 70 ducats again so that he had to pay at last the double of what he had previously settled.

1128. DYCK (Anthony Van).

Portrait of Charles V. A figure in full length, in armour, on the back of a white steed. An eagle is hovering and bearing a laurel wreath over is head. — It belongs to the Gallery since 1804. — On canvas. Life size.

1116. TIZIANO.

Portrait of Monsignor Beccadelli, of Bologna; sitting on an arm-chair and holding a paper, on which one reads: JULIUS P. P. III. « *Venerabili Fratri Ludovico Episcopo Rauellen, apud Dominum Venetorum nostro et Apostolicae sedis Nuntio, cum annum age-*

ret LII. Titianus Vecellius faciebat, Venetiis M. D. L. II mense, Julii. » And a little lower, with the same writing: *Translatus deinde M. D. L. V. die XVIII Septembris a Paulo quarto Pont. Maximo ad Archiepi- scopatum Ragusinum, quo pervenit die IX Decembris proxime subsequentis.* » — This portrait was then exe- cuted in 1552 while Monsignor Beccadelli was in Ve- nice as a papal legate. — On canvas. Life size.

1142. CRANACK Luke.

Adam. — See N.ʳ 1138. Dated 1528.

1143. JACOBTZ Luke, of Leyden, called *Lvca d'Olanda.*

Christ crowned with thorns. Above half length. The cross and several instruments of our Lord's passion in the back-ground.—Belonging to this Gallery since 1795. — On wood. Life size.

1137. GUERCINO (Barbieri Gio. Francesco, called).

Endymion sleeping. He is sitting and laying his head on his left arm. The back-ground represents a pleasant landscape, by night, with the crescent shining among clouds. — It was purchased in 1795. — On can- vas. Life size.

Tuscan School.

(*First Hall*).

34. LORENZO DI CREDI.

Portrait of a young man.

1163. THE SAME.

Portrait of Andrea Verrocchio, the celebrated florentine painter and sculptor.

30. POLLAIOLO (Antonio Del), a florentine painter, sculptor and engraver. Born 1429, d. in Rome 1498.

A portrait of John Galeazzo Sforza. It was disco- vered in the store-rooms of the Gallery in 1880.

1178. ANGELICO (Fra Giovanni).

Marriage of the Holy Virgin. Dim. fig.

30 *bis.* UNKNOWN. — XV Cent.

A male half length portrait. On wood. Life size.

1246. BRONZINO Angelo.

Female portrait. — On wood. Life size.

1182. BOTTICELLI (Alessandro Filippepi, called).

Calumny, according to the description of Appelles' painting, by Lucian. Calumny is in the middle of the painting, attended by two women, representing *Hypocrisy* and *Treachery,* both busy in dressing her hair. She holds a torch in her right hand, and by the left she is dragging a strengtless and naked young man along upon the ground. who is crying and raising his hands and look to heaven in the act of prayer, and is the symbol of *Innocence.* A hideous black figure meaning *Eavy* precedes the group. Behind is another personage with Midas' ears, sitting on a throne and listening to what two other women (*Ignorance* and *Distrust*) are whispering to him, while he stretches his right arm towards Calumny, in the act of approving what she is doing. Aside is another strange figure, the symbol of *Repentance* or *Remorse* who turns himself and looks at *Truth,* a fine nude girl all modest and pleasant in her demeanour, who is coming on alone.

The back-ground represents a hall in a Royal Palace with fine columns and statues.

By the time of Vasari this painting belonged to *Messer Fabio Segni* a florentine noble man, and after to Anthony Segni. — On wood. Dim. fig.

1235. FRA BARTOLOMMEO DELLA PORTA.

The Virgin and the Child, a small painting not finished. From a composition by Raphael. — On wood. Dim. fig.

1199. ALLORI Cristofano.

The Holy Virgin and Child. — On wood. Dim. fig.

1162. ANGELICO (Fra Giovanni).

Nativity of St. John the Baptist. Some women show-

ing the new-born to his father, who is writing on a parchment : « *Johannes est nomen ejus.* » — On wood. Life size.

1183. ALLORI Alessandro.

Portrait of Bianca Cappello ; a fresco which the painter had executed in a room of the parish house of St. Maria ad Olmi, and was brought into this Gallery in 1817. Life size.

1184. ANGELICO (Fra Giovanni).

The Transit of the Virgin. A rich and admirable composition of many figures. — On wood. Dim. fig.

1208. UNKNOWN. — XV Cent.

Three monks. — On wood. Dim. fig.

1152. FRA BARTOLOMMEO DELLA PORTA.

God the Father in Glory.

1166. BRONZINO Angelo.

Portrait of a warrior. The bust. — On wood. Life size.

1241. ROSSO Gio. Battista di Giacomo, called *il Rosso Fiorentino.* Born 1494, d. 1541.

An angel playing the guitar. — On wood. Half life size.

1200. ZUCCHERI Federigo.

The silver age, represented by many allegorical figures and the words: *Argenteum Sœculum.* — On wood. Dim. fig.

1190. ALLORI Cristofano.

The disciples in Emmaus. — On canvas. Dim. fig.

1128. BRONZINO (Allori Alessandro, called). B. 1535, d. 1607.

St. Lawrence conducted before the Tyrant. — On wood. Dim. fig.

1245. CHIMENTI Iacopo, of Empoli. B. 1551, d. 1640.

The sacrifice af Abraham. — On copper. Dim. fig.

1218. ALLORI Alessandro, called *il Bronzino.*

Martyrdom of St. Lawrence. — On wood.

1243. UNKNOWN. — XVI Cent.

The Virgin sitting and holding an open book. Left and right of her the Persic and the Lybie Sybils. — On wood. Dim. fig.

1215. ZUCCHERI Federigo, of S. Angelo in Vado. Born 1543, d. 1609.

An allegory. Jupiter in the act of presenting two golden keys to Juno, at whose feet are two altars. To her right is Mercury, and to the left is the goddes Ceres on a car dragged by two dragons. — On copper. Dim. fig.

1248. BANDINELLI Baccio, of Florence; sculptor and painter. B. 1493, d. 1560.

His own portrait.

1194. BRONZINO (Allori Alessandro, called).

Susanna bathing. — On wood. Dim. fig.

1173. BRONZINO Angelo.

Venus and Cupid. — On wood. Dim. fig.

1147. DOLCI Carlo, of Florence. B. 1616, d. 1687.

St. Lucia. A head in the act of looking upwards. A radiant wound is on the neck. — On canvas. Life size.

1127. BRONZINO Angelo, of Florence. B. 1502, d. 1572.

Portrait of Bianca Cappello (The head alone. Life size). Behind is an allegorical composition : *The dream of human life.* — On wood. D. fig.

1214. ALLORI Alessandro, of Florence, called *il Bronzino.* B. 1535, d. 1607.

The Chastity of Joseph.

1197. RAMACCIOTTI Gio. Battista, of Siena. — XVII Cent.

Nativity of the Virgin. — On canvas. D. fig.

1196. CARRUCCI Iacopo, called *il Pontormo.*

Adam and Eve, expelled from Paradise. — On wood. D. fig.

1231. FRANCESCHINI Baldassarre, of Volterra, called *il Volterrano*. B. 1611, d. 1689.

St. Catharine of Siena, crowned with thorns; before a crucifix. — On wood. D. fig.

1203. UNKNOWN. — Tuscan School of the XVII Cent.

Portrait of the Petrarca. — On wood. S. fig.

1172. CARDI Lodovico, called *il Cigoli*. B. 1559, d. 1613.

St. Francis.

1207. UNKNOWN. — Tuscan School of the XVII Cent.

Portrait of Dante Alighieri. — On wood. S. fig.

1234. SALIMBENI Ventura, of Siena. B. 1557, d. 1613.

Apparition of St. Michael to St. Galgan the hermit. — On copper. S. fig.

1238. BOTTICINI Raffaello di Francesco di Giovanni, of Florence. Born 1477, d. 1529. (1)

Gradino with three compositions : The Samaritan.; Christ driving the money-changers from the temple; Christ's entrance into Jerusalem. This gradino belongs to the large painting representing the Deposition, which is in the second hall of the Tuscan School (N. 1283). — On wood. S. fig.

1181. VASARI Giorgio, of Arezzo. B. 1511, d. 1574.

Allegory of the Conception. Adam and Eve lying on the ground ; Abraham kneeling, and some Saints, Patriarchs and Prophets tied the trunk of a tree, on which a large serpent is twisted in human shape down to the waist. — This painting is a diminutive reproduction of that in the church of the Apostoli in Florence. — On wood.

1187. CARRUCCI Iacopo, called *il Pontormo*.

Martyrdom of St. Maurice and the Teban Legion, baptized by an Angel. — Executed by commission of Charles Neroni. — On wood. S. fig.

(1) Not to be confounded with Raffaellino del Colle or Raffaellino del Garbo. He was once called Raffaello Vanni.

1201. DOLCI Carlo, of Florence. B. 1616, d. 1687.

Jesus seated, attended by the Holy Virgin, St. Joseph, St. John, the Apostles and the Maries. — On canvas. S. fig.

1174. CARDI Lodovico, called *il Cigoli*.

The head of a woman. — On wood. Life size.

1232. ROSSI Francesco, called *Cecchino Salviati*, of Florence. B. 1510, d. 1663.

Artemisia weeping for the death of Mausolus. — On wood. S. fig.

1188. MANNOZZI Giovanni, called *Giovanni da S. Giovanni*. B. 1590, d. 1636.

Jesus sitting at a table, and enting, attended by some angels. — On copper. S. fig.

1193. TUSCAN SCHOOL. — XVI Century.

The Virgin and Child, attended by two monks, in white cloth. — On wood. S. fig.

1233. CHIMENTI Iacopo, of Empoli, called *l'Empoli*. B. 1551, d. 1640.

Noah in a state of drunkness. — On copper. S. fig.

1198. PONTORMO (Carrucci Iacopo).

Nativity of St. John Baptist. — Executed by Pontormo for Elisabeth Tornaquinci wife of Paul Aldighieri, on a wooden basin. Such basins decorated with paintings were used to bring presents. — S. fig.

1151. MANNOZZI Giovanni, called *Giovanni da S. Giovanni*.

The Painting. An allegorical female figure, with a little Cupid in the act of handing some pencils to her. — A fresco on a tile. H. fig.

1146. DEL SARTO Andrea, of Florence. Born 1487, d. 1507.

The Virgin and Child, with the little St. John.

1205. GENGA Girolamo, of Urbino. B. 1476, d. 1551.

Martyrdom of St. Sebastian. A rich composition of many figures dressed in various odd and picturesque fashions. — On wood. S. fig.

1312. PIERO DI COSIMO, of Florence. B. 1462, d. 1521.

Perseus delivering Andromeda from the monster. Vasari in giving a detailed description of this painting, says that it was executed for Philip Strozzi the elder. — On wood. S. fig.

1150. PINTURICCHIO'S SCHOOL.

The Holy Virgin with her Divine Child, attended by St. Joseph and St. Blasius. — On wood. S. fig.

1177. ROSSO Gio. Battista di Iacopo, called *il Rosso Fiorentino.* B. 1494, d. 1541.

The Virgin enthroned with the infant Jesus on her lap. Left and right of the Madonna are St. Francis and St. Jerome, with two angels and a lamb. — On wood. Half life size.

1237. PAGANI Gregorio, of Florence. B. 1550, d. 1605.

Tobias restoring his father's sight, in the presence of his family and assisted by the Angel. Half length. Bearing the signature of the author and the date 1604. — On canvas. Life size.

1219. CURRADI Cav. Francesco, of Florence. B. 1570, d. 1661.

Martyrdom of St. Tecla. — On copper. D. fig.

1211. BRONZINO Angelo, of Florence. B. 1502, d. 1572.

Allegory of happiness. The figures of Justice and Prudence in triumph are particularly remarkable. Above are Fortune, Fame, some Vices and Victory in the act of crowning the figure of Happiness. — On wood. D. fig.

1222. DOLCI Carlo, of Florence. B. 1616, d. 1687.

The head of St. Peter. — On wood. D. fig.

1216. CAMBI Francesco, of Florence. — XVI Cent.

The engraver Stefano della Bella. Painted in 1646. — On canvas. Life size.

1225. ALLORI Alessandro, called *il Bronzino.* Born 1535, died 1607.

Hercules crowned by the Muses, after having killed the giants. — On copper. D. fig.

1170. BIZZELLI Giovanni, of Florence. B. 1556, d. 1612.

The Annunciation. — On wood. D. fig.

1242. MORANDI Gio. Maria, of Florence. B. 1622, d. 1717.

The Visitation. — On copper. Dim. fig.

1192. BRONZINO (Allori Alessandro).

St. Francis kneeling before the Cross. The background is a landscape. — On wood. D. fig.

1195. ZUCCHERI Federigo, of S. Angelo in Vado, near Urbino. B. 1543, d. 1609.

The Golden Age. A rich composition of many figures. Two hovering nymphs are spreading flowers and holding a paper roll on which are the words: O BELL'ANNI DELL' ORO. — On wood. D. fig.

1229. ALLORI Alessandro, called *il Bronzino*

St. Peter walking on the water. — On copper. D. fig.

1202. ALLORI Cristofano, of Florence. B. 1577, d. 1621.

The Virgin and Child. — On an oval copper plate. D. fig.

1236. ZUCCHERI Taddeo, of S. Angelo in Vado, near Urbino. B. 1543, d. 1609.

Diana. A standing full figure, holding an arrow and followed by a hound. — On wood. D. fig.

1244. MANZUOLI Tommaso, called *Maso da S. Friano*, of Florence. B. 1536, d. 1571.

Portrait of Helene Gaddi, wife of Andrew Quaratesi. — The bust. — On wood. D. fig.

1209. BRONZINO Angelo, of Florence. B. 1502, d. 1572.

The body of Christ in the hands of the Mother. — Signed : BROZ. FAC. — On copper. D. fig.

1210. ANSELMI Michelangelo, of Parma. B. 1491, d. 1554.

The Nativity of our Lord. — On wood. D. fig.

1247. MARINARI Onorio, of Florence. B. 1627, d. 1716.

David, with Goliath's head at his feet. A full figure. — On copper. D. fig.

1221. VASARI Giorgio, of Arezzo. B. 1511, d. 1571.

Vulcan's forge. — On copper. D. fig.

1148. CARRUCCI Iacopo, called *il Pontormo*. Born at Pontormo, near Florence, in 1494, d. 1557.

Leda, in full length and standing. Four Cupids at heer feet. — On wood. Life size.

1213. ALLORI Alessandro, called *Bronzino*.

Christ on the cross. Right and left of it, are St. John and St. Mary Magdalene. From a drawing by Michelangel. — On wood. D. fig.

1212. GABBIANI Antonio Domenico, of Florence. Born 1652, d. 1722.

. *Madonna,* holding an open book in her left hand. — On wood. D. fig.

1185. VASARI Giorgio, of Arezzo. Born 1511, d. 1571.

The Prophet Elisha, in the act of making bitter meals sweet, by seasoning then with flour. This painting is a sketch of that which the same author executed in large proportions for the church of St. Peter in Perugia. — On wood.

1186. FONTEBUONI.

Young St. John. A nude full figure sitting on a stone in a desert. A small painting given to the Gran-duke Cosimo II de'Medici by the author. — On copper. D. fig.

1175. SANTI DI TITO, a florentine painter and architect. Born at S. Sepolcro in 1538, died in 1603.

Head of a young girl. — On wood. Life size.

1189. BRONZINO Angelo, of Florence. Born 1502, d. 1572.

Portrait of Eleanor of Toledo, wife of Cosmus I, The bust. On the back-ground are the words: Eleonora Toleta, Cos. Med. D. II. Uxor. — Life size.

3435. SCHOOL OF ANDREA DEL SARTO.

Portrait of a young girl. — On wood. Life size.

1240. MORANDINI Francesco, of Florence, called *il Poppi*. Born 1544, d. 1597.

The three Graces. — On wood. D. fig.

1164. BRONZINO Angelo.

Portrait of Mary de' Medici, daughter of Cosmus I, in her childhood. — On wood. Life size.

1179. FILIPEPI Alessandro, called *Sandro Botticelli*. B. 1447, d. 1510.

St. Augustin, in full length; sitting in a nich and writing. This wonderful little work formely belonged to the Vecchietti family, and then passed into possession of the painter Hugford, from whom it was purchased for the Gallery in 1799. — On canvas. Dim. fig.

1157. LEONARDO DA VINCI. Born at Vinci in Valdarno, near Florence, in 1452, died at Château de Clot, near Amboise, on may 2d 1519.

Head of a young man. — On wood. Dim. fig.

1155. BRONZINO Angelo, of Florence. B. 1502, d. 1572.

Portrait of Prince Don Garzia, the son of Cosmus I in his childhood; with a little bird in his right hand Above half length. — On wood. Life size.

1180. ALLORI Cristofano, of Florence. B. 1577, d. 1621.

Judith (sketch for the picture in the Palatine Gallery). — On copper. Dim. fig.

1161. FRA BARTOLOMMEO DELLA PORTA, of Florence. Born 1469, died 1517.

Two small paintings in one frame, representing the *Circumcision* and the *Nativity.* Behind this is the *Annunciation,* in chiaro-scuro. They once served as doors to a little shrine, which was ordered by Peter del Pugliese and contain a marble Madonna in bas-relief, by Donatello. — On wood. Dim. fig.

1153. POLLAIOLO (Antonio del), of Florence. B. 1429, d. 1498.

Two small paintings in one frame : 1st *Hercules strangling Antaeus;* 2d *Hercules and Hydro.* — On wood. Dim. fig.

1159. LEONARDO DA VINCI.

Head of Medusa. The head of the Gorgon is cut off and turned upwards; the hair is changed into snakes, and others reptiles and monsters are scattered around it. This admirable painting formely belonged to the collection of the duke Cosmus I. — On wood. Life size.

1230. ANDREA DEL SARTO.

Portrait of woman, bearing a basket with some spindles. — The bust. — On wood. Life size.

1156. FILIPEPI Alessandro, called *Sandro Botticelli,* of Florence. B. 1447, d. 1510.

Judith. — On wood. Dim. fig.

3450. DELLA FRANCESCA Piero, of Borgo S. Sepolcro. Born 1416, d. 1492.

Portrait of a young girl. — On wood. Life size.

1220. CARRUCCI Iacopo, called *il Pontormo,* of Florence. Born 1494, died 1557.

Male portrait. — On wood. Life size.

1217. PERUGINO (Pietro Vannucci, called), of Perugia. Born 1416, d. 1524.

Bust of a young man. On wood. Life size.

1167. MASACCIO (Tommaso di Ser Giovanni Guidi della Scheggia), born at S. Giovanni in Valdarno, near Florence, in 1401, d. 1428.

Portrait of an old man, wearing a white coat and hat. — Once belonging to the Corboli family. The bust. Life size. Fresco on a tile.

1176. ANDREA DEL SARTO (Vannucci Andrea, called), of Florence. B. 1487, d. 1531.

His own portrait, in full face. — On canvas. Life size.

1158. BOTTICELLI (Alessandro Filipepi, called).

Holophernes found dead in his tent by his soldiers. A small painting of which a certain Messer Rodolfo Sirigatti made a present to the Serenissima Bianca Cappello de' Medici, Granduchessa. — On wood. Dim. fig.

1154. BOTTICELLI (Alessandro Filipepi, called).

Portrait of Piero di Lorenzo de' Medici holding a medal with the portrait of Cosimo the elder. — On wood. Life size.

1169. ANDREA DEL SARTO (Vannucci Andrea).

Bust of a young man in a black suit; believed to be the clerck of the convent of Vallombrosa who was a friend of Andrea. — On wood. Life size.

(Second Hall).

1279. SODOMA (Razzi Gio. Antonio, called).

St. Sebastian bound at a tree and looking up to Heaven whence an angel is descending and bringing a crown to the martyr. On the reverse of the same canvas the same artist has represented the Holy Virgin with the Infant Jesus on a cloud and on each side of her a saint : St. Sigismond and St. Roch.
This painting was once a processional flag, which belonged to the Confraternity of St. Sebastian in Camollia, but in 1786 from the Patrimonio Ecclesiastico of Siena it was taken to this Gallery. — On canvas. Life size.

1264. FRANCIABIGIO Francesco di Cristofano, of Florence. Born 1482, d. 1525.

The Holy Virgin and Child, attended by St. John the Baptist and the prophet Job. On wood. Life size. (Signed : F. B. C.). The head of St. John is believed to be the portrait of the author.

1252. LEONARDO DA VINCI. Born at Vinci in Valdarno, near Florence, in 1452, died 1519.

The Adoration of the Magi. A large painting sketched in black and white. This painting was to be executed by commission of the monks of St. Donato at Scopeto. (1480). It was taken to this Gallery from the store-rooms of the Royal Palace, in 1794. — On wood. Life size.

50. PIERI Stefano, of Florence. Died on january 13th 1629.

Jesus dead, in the arms of the Marys and some of his disciples, and the Holy Virgin fainting. Signed: « *P. S. 1587.* » — On wood. Life size.

1280. GRANACCI Francesco, of Florence. Born 1469, d. 1543.

The Holy Virgin giving her girdle to St. Thomas, in the presence of St. Michael. — Taken from the Academy of Fine Arts in 1803. — On wood. Life size.

1280 *bis*. ROSSELLI Cosimo. Born in Florence 1439, d. 1507.

Madonna enthroned suckling her divine son, and caressing the child St. John who is devoutly standing before her. On her right St. James, the Apostle; on her left St. Peter; above two angels hovering and supporting a crown. — On wood. Life size.

This picture, according to an old document quoted in a note to Vasari, is supposed to have been executed about the year 1505 for the monks of Cestello, now Santa Maria Maddalena de' Pazzi, and was brought to this Gallery in consequence of the abolition of Religious Orders.

1281. VASARI Giorgio, of Arezzo. Born 1511, d. 1574.

Alexander of the Medicis; a sitting full figure in armour. — On wood. Life size.

1283. BOTTICINI Raffaello di Francesco, of Florence.

The Deposition. Full figures. — This painting was made for the Pieve d' Empoli. In 1786 it was taken to the Accademy of Fine Arts, and was finally placed in this Gallery in 1794. — On wood. Life size.

1262. GIOVANNI DA SAN GIOVANNI (Mannozzi Giovanni, called), of S. Giovanni in Valdarno. B. 1590, d. 1636.

The Holy Virgin with the Infant Jesus and St. Catharine.

1257. LIPPI Filippo, of Florence, called *Filippino Lippi.* Born 1457, died 1504.

Adoration of the Kings. A large and rich composition of which many figures are the portraits of well known personages of that time, particularly of the Medici family, among whom is Peter Francis the elder's, under the figure of an astrologer, to the left on the fore-ground.

This painting was executed in 1496 for the convent of San Donato degli Scopetini. On the reverse of it is the following original inscription: FILIPPUS ME PINXIT DE LIPIS, FLORENTINUS, ADDÌ 29 DI MARZO 1496. — On wood. Dim. fig.

1258. LOMI born Gentileschi Artemisia, of Pisa. Born 1590, died 1646.

Judith, in the act of killing Holophernes. A large painting. The figures are above life size. On canvas.

1268. LIPPI Filippino.

The Holy Virgin enthroned. To her right St. Victor and St. John the Baptist, to the left St. Bernard and St. Zanobius: above two angels supporting a long festoon, and still higher the coat of arms of the Florentine community. On the lower edge of the picture one reads: ANNO SALUTIS 1485 DIE 20 FEBRUARII.

This painting had been made to adorn the hall called degli Otto di Pratica in the Palace of the Signoria in Firenze. — On wood. Above life size.

1261. CHIMENTI Iacopo, called *l'Empoli,* of Empoli, near Florence. Born 1551, died 1640.

St. Ives reading the petition presented to him by the widows and orphans. This painting is one of the finest works of this artist, who made it for the Warden of the orphans in Florence in 1616, as it is read in an inscription on the back-ground. — On wood. Life size.

1284. PONTORMO (Carrucci Iacopo, called).

Cupid kissing Venus; from a carton by Michael-Angelo. The goddes is all nude and lying on a blue cloth stretched on the ground. A diadem adorns her forehead. Her son softly approaches her in order to kiss her, while she furtively puts an arrow into his quiver. To the right is an altar covered with a brown cloth on which a bundle of darts lays with a cup full of roses, from which the mask of a satyr and that of a young man hang. Before the altar is a young man prostrated and deprived of his right arm. All these symbols seem tho mean the frailty of the pleasures of Love.

This painting was long deposited in the store-rooms

of the Grand-Duke and the figure of Venus had been covered with a white drapery painted in oil; but in 1850 it was cleverly cleaned and restored and placed in the Academy of Fine Arts whence it was taken to this Gallery in 1861. — On wood. Larger than life.

1272. BRONZINO Angelo, of Florence. Born 1502, d. 1572.

Portrait of Ferdinand de' Medici, son of Cosmus I. — On wood. Life size.

1273. THE SAME.

Portrait of Mary daughter of Cosmus I de' Medici. (The bust). — On wood. Life size.

1251. FRANCESCHINI Baldassarre, of Volterra called *il Volterrano*. Born 1611, d. 1689.

An Augustinian monk, supposed to be the portrait of the celebrated Fra Paolo Sarpi.

Placed in this Gallery in 1794. — Above half length. — On canvas. Life size.

1265. FRA BARTOLOMMEO DELLA PORTA.

A large painting sketched in black and white, representing the Holy Virgin enthroned, bearing the infant Jesus on her lap. By the Virgin is young St. John and behind her is St. Anne looking up in adoration to the Holy Trinity which is represented above in a glory of several angels all playing different instruments. Left and right of the throne are the figures of then Saints protectores of Florence : the second one to the right is the portrait of the painter. Two little angels are sitting on the steps of the throne.

This painting which was to be one of the most remarkable works of Fra Bartolommeo, has remained unfinished in consequence of his death. — It was meant to decorate the room of the Councel of the Republic in Florence, but under the government of the Medicis, it was placed in the church of St. Lawrence, whence it was later brought to this Gallery. — On wood. Life size.

1266. BRONZINO Angelo.

Portrait of a man in a black suit and cap. Behind

is a table upon which is a female statuette. — On wood. Life size.

Prof. Milanesi thinks this to be the portrait of Santi Alberighi, son of John Alberighi called *della Cammilla*, who was a sculptor like his father and is known to have sculptured a Venus.

1267. PONTORMO (Carrucci Iacopo, called), of Florence. Born 1494, d. 1557.

Portrait of Cosmus the elder. A standing full fig. — On wood. Life size.

1112. VANNUCCI Andrea, called *Andrea del Sarto*, of Florence. Born 1486, died 1531.

Madonna, between St. Francis and St. John the Evangelist, called *Madonna delle Arpie.* — The Virgin is standing on a pedestal, holding the Infant Jesus on her right arm, and a book with the left; St. Francis is also standing to her right and St. John to the left. On the pedestal is the following inscription : AND. SAR. FLOR. FAC. AD. SUMMU. REGINA. TRONU. DEFERTUR. IN. ALTUM. MDXVII.

This work is one of the most famous by Andrea, who executed it for the convent of the Franciscans in Florence. Prince Ferdinand de' Medici purchased it and ordered that a copy of it should be made by Francis Petrucci and put into the place of the original, which was then taken to the Pitti Palace, whence it was finally brought to this Gallery in 1785, by the order of Peter Leopold. — On wood. Life size.

1269. VASARI Giorgio, of Arezzo. Born 1511, d. 1574.

Portrait of Lawrence de' Medici, called *il Magnifico.* — A half length. Life size. On wood.

1270. PONTORMO (Iacopo Carrucci, called).

Portrait of Cosmus I de' Medici. A standing full figure. — On wood. Life size.

1271. BRONZINO Angelo, of Florence. B. 1502, d. 1572.

The descent of our Saviour into Hell; a large and rich composition and the most remarkable work of this painter. Vasari says that the principal figures of this painting are portraits of the most known men and the finest florentine ladies of that time; Iacopo Pontormo;

Gio. Battista Gello, the celebrated florentine academician, and the painter Bachiacco among the men; Costanza de Somaia wife of Gio. Battista Doni, and Cammilla Tedaldi del Corno among the ladies. — Signed: « MDLII. *Opera del Bronzino Fiorentino.* »

This painting formely decorated the altar of the Zanchini chapel in Santa Croce. Leopoldo Ricasoli who was the owner of this painting at the beginning of the present century, gave it to the Gallery in 1821. — Above life size. On wood.

1256. ROSSI Francesco, called *Cecchin Salviati*, of Florence. B. 1510, d. 1563.

Portrait of a man, in the act of unsealing a letter. (Half lenght). — On wood. Life size.

44. GRAZIADEI Mariano, of Pescia, pupil of Rodolfo Ghirlandaio. He died when still young, about 1551.

The Holy Virgin, St. John and St. Anna. This painting was made for the chapel of the Signoria in Palazzo Vecchio, and according to Lanzi it is probably the only remaining work of this painter. — On wood. Life size.

1254. ANDREA DEL SARTO (Vannucci Andrea, called).

St. James with two children kneeling on each side of him, dressed in the white gown of the brothers of the Confraternity called del Nicchio for which this painting was made. — It was taken to this Gallery in 1795. — On canvas. Life size.

1274. BILIVERTI Giovanni, of Florence. B. 1585, d. 1644.

Chastity of Joseph. The youth is in the act of flying from the arms of Putiphar's wife, who is jumping out of her bed to arrest him and is only able catch hold of his cloack.

This painting was executed in 1624 by commission of Cardinal Charles and Lawrence de' Medici. — On wood. Life size.

1275. GHIRLANDAIO (Bigordi Rodolfo del), of Florence. Born 1483, d. 1561.

St. Zanobius bishoph of Florence restoring to life a french lady's child who had fallen from a window.

The miracle is wrought in the presence of a great

number of people and the mother of the child who is full of gratefulness and amazement.

This splendid painting as well as Nr 1277 which is quite of the same size and represents another miracle of the same saint had been made for the Confraternity of St. Zanobius, but they were later brought into the Academy of Fine Arts, and in 1794 they were taken to this Gallery. — On wood. Life size.

1259. ALBERTINELLI Mariotto, of Florence. B. 1474, d. 1515.

The Visitation. The two figures of the Holy Virgin and St. Elisabeth in the act of embracing each other stand out in the soft colour of a serene sky that is seen through the arch of a beautiful portico in the back-ground. Below is a *Gradino* with three small compositions by the same artist, representing the Annunciation, the Nativity and the Presentation.

This admirable work was executed in 1503 (this date is written in the back-ground) for the altar of the little church *della Congrega dei Preti* of St. Elisabeth. — It was taken to this Gallery in 1786. — On wood. Life size.

1255. RUSTICI Gio. Francesco, called *il Rustichino,* of Siena. Died 1636.

Painting and Poetry (Above half length). — On canvas. Life size.

1277. GHIRLANDAIO (Bigordi Rodolfo del).

Translation of the body of St. Zanobius, from the church of San Lorenzo to the Cathedral The bier which contained the body of the Saint and was carried by some bishops, when passing near the church of St. John touched the branches of a dry tree which was then in that place and the plant instantly began to blossom. See Nr 1275. — On wood. Life size.

1278. VANNINI Ottavio, of Florence. Born 1585, d. 1643.

Herminia curing the wounds of Tancred. — On canvas. Life size.

1278 *bis.* VERROCCHIO (Andrea of Michele Cioni, called), of Florence; painter, sculptor and jeweller. B. 1435, d. 1488.

The Virgin on a throne with the infant Jesus. On

both sides are St. John and St. Zanobius; kneeling
St. Nicholas of Bari and St. Francis.

This painting was formely in the Convent of SS. An-
nunziata in Florence.

It is one of the finest specimens of old florentine art,
and layed hidden and forgotten till 1881 in the store-
rooms of the Royal Ufizi Gallery. Having then been
discovered and examined by the members of the royal
Commission of Art it was voted a painting of Verrocchio
after comparing it with a similar one in the Academy
of the Belle Arti (See verbal act of the Assembly of
the 29th of may 1881). — On wood. Life size. ·

3436. BOTTICELLI (Alessandro Filipepi, called).

The adoration of the Magi. This picture, drawn and
prepared « a chiaro-scuro » by the author, though, in
the XVII century spoiled with colour by an unexpert
hand, is nevetheles very interesting, being the com-
position of this (several times repeated subject) the most
splendid composition ever made by Botticelli. — On
wood. Dim. fig.

3452. LORENZO DI CREDI.

Venus. This beautiful figure, splendidly drawn, aside
the Art's merit, is besides interesting for the other
subject, differing completely to all the other subjects
performed by Credi. — On wood. Dim fig.

(Third Hall).

1298. SIGNORELLI Luca, of Cortona. B. 1441, d. 1532.

Gradino, divided into three compartments: 1st The
Annunciation; 2d The Nativity; 3th The Adoration of
the Magi. — Taken from the church of St. Lucie at
Montepulciano. — On wood. Dim. fig.

1313. LORENZO DI CREDI, of Florence. B. 1459, d. 1537.

The Magdalene kneeling before Jesus, who is sitting
on the wall of a bridge. — On wood. Dim. fig.
Purchased in 1818.

1300. PIERO DELLA FRANCESCA, of Borgo S. Sepolcro. — XIV Century.

Frederic of Montefeltro, duke of Urbino, and his wife Baptista Sforza. Two busts in profile, painted on two little doors.

On the reverse of each is an allegorical composition. Behind the portrait of the first, the duke is represented in armour sitting on a charriot and crowned by Victory, preceded by four figures representing some virtues. A little Cupid is leading the two white horses by which the charriot is dragged. Behind the other portrait is the duchess also on a charriot dragged by two unicorns, and attended by four Virtues.

1311. LORENZO DI CREDI.

The Saviour appearing to the Magdalene, under the figures of a gardner. Purchased in 1848. — On wood. Dim. fig.

1301. POLLAIOLO (Antonio del), of Florence. B. 1429, d. 1498.

St. Eustachius, St. Jacob and St. Vincent; three standing figures painted with admirable boldness and freshness painted with admirable boldness and freshness of colouring. According to Vasari this painting was made in 1470 for the chapel of Cardinal of Portugal in the church of San Miniato al Monte near Florence. He also thinks Piero del Pollajolo, Antonio's brother, to have worked on it as he was more skilful than his celebrated brother in painting, while this was peculiarly clever in drawing and composing. — On wood. Life size.

1288. LEONARDO DA VINCI. .

The Annunciation. Several art–critics think this painting to be one of Leonardo's earliest works and others attribute it to Rodolfo del Ghirlandaio or to Lorenzo di Credi. It was once in the sacristy of the church of Monte Oliveto, near Florence, and was brought into this Gallery 1867. — On wood. Dim. fig.

1295. GHIRLANDAIO (Bigordi Domenico).

Adoration of the Kings. A very fine composition and splendid colouring (Dated 1487). — On a round board.

1292. LANDINI Iacopo, call. *Iacopo dal Casentino.* XIV Cent.

A gradino containing six subjects. In the center: St. Peter distributing the ecclesiastical dignities; to the left: St. Peter delivered from prison; to the right: St. Peter's crucifixion. On the sides are eight figures of Apostles, viz: St. Andrew, St. John, St. Philip, St. Matthew, St. Thomas, St. James and St. Luke.

Taken from the store-rooms of the Gallery in 1861. — On wood. Dim. fig.

1315. MAINARDI Sebastiano (or Bastiano), of Florence, pupil of Domenico Ghirlandaio. Born 1466, d. 1513.

St. Peter martyr between two apostles. — Taken from the convent of Santa Maria Maddalena de' Pazzi in 1815. — On wood. Life size.

1205. BRESCIANINO (Andrea del), of Siena. Worked in 1500.

The Holy Virgin with the infant Jesus and little St. John and Angels. — On wood. Dim. fig.

1160. LORENZO DI CREDI.

The Annunciation on an architectural back-ground. Three composition in black and white are in the frame, below, representing: the Creation of Eve, the Original sin, and: Our first parents expelled from Paradise. — On wood. Dim. fig.

1307. LIPPI (Fra Filippo), of Florence. Born 1412, d. 1469.

The Holy Virgin adoring her Divine Child, attended by two angels. — On wood. Life size.

This work was made for the chapel in Cosmus the elder's palace, and was taken to this Gallery from the Royal store-rooms in 1776. — The original sketch of this painting is seen in the collection of Original Drawings of Ancient Great Masters belonging to this Gallery.

1287. LORENZO DI CREDI.

The Holy Virgin adoring her Divine Child. The Infant Jesus is lying on the ground: St. Joseph is near him, to his right, and young St. John, led by an angel, stands to his left. The back-ground represents a cottage and a fine landscape in the distance. — Painted on a round board. Dim. fig.

1223. FRANCIABIGIO Francesco di Cristofano, of Florence. Born 1482, d. 1525.

The temple of Hercules. The god of Strength stands and a pedestal in the middle of the temple, surrounded by several personages dressed in various fashions. This painting once served to adorn one of the sides of a wedding trunk (cassone). — On wood. Dim. fig.

1303. BOTTICELLI (Alessandro Filipepi, called), of Florence. Born 1441, d. 1523.

The Virgin, sitting under a portico, and holding the Infant Jesus on her lap, to whom she is giving a pomegranate. — On wood. Half life size.

1304. FRANCESCO DI GIORGIO DI MARTINO, of Siena. Born 1439, d. 1522.

Gradino, containing three scenes in St. Benedict's life. The middle one represents the Saint in his childhood, performing the miracle of the Capisterio (the wooddish) which had been broken by his mother. In the left compartment the Saint is represented in penitence in the grotta of Subiaco; in the right one St. Benedict is seen at Monte Cassino, visited by Totilas. — On wood. Life size.

1314. LORENZO DI CREDI.

The Annunciation. Purchased in 1718. — On wood. Dim. fig.

1168. THE SAME.

The wailing Virgin attended by St. John. The figures are in full lenght and upright, in a fine landscape. — Purchased in 1818. — On wood. Dim. fig.

1291. SIGNORELLI Luca, of Cortona. Born 1441, d. 1532.

Holy Family. On a round board. The Holy Virgin is sitting on the ground and reading, while the Infant Jesus is standing by her, St. Joseph is kneeling a little aside in adoration. — A painting of a grand style and full of sentiment. — On wood. Life size.

1306. POLLAIOLO (Antonio del).

Prudence; a full figure sitting on a throne. Taken from the store-rooms of the Gallery in 1861. — On wood. Life size.

1289. BOTTICELLI (Alessandro Filipepi, called).

The Virgin and Child. The Infant Jesus holds a pomegranate: six angels surround the group.

This painting was purchased in 1785. — On wood. Life size.

1316. THE SAME.

The Annunciation. Taken from the convent of Santa Maria Maddalena de' Pazzi, in 1872. — On wood. Life size.

1267 *bis.* THE SAME.

The Holy Virgin with the Infant Jesus, called il *Magnificat.* The Virgin is sitting and bearing her Divine Child on her lap, who is holding a pomme-granade in his left hand. Six angels are around her and two of them hold a golden crown over her head. — Painted on a round board. Life size. Purchased in 1785.

1299. THE SAME.

Fortitude: an allegorical figure sitting on a throne. It was executed for the merchant's hall (Sala della Mercanzia) of Florence, and discovered in the store-rooms of the Gallery in 1816. — On wood. Life size.

1290. BEATO ANGELICO.

The Coronation of the Virgin. · A splendid composition of many personages representing Saints, all gathered around a central group consisting in the figure of our Lord in the act of putting a crown on the head of the Holy Virgin, amidst a glory of angels.

This precious painting, which is one of the most admirable works of Fra Angelico, was formerly in the church of Santa Maria Nuova in Florence. It was taken to this Gallery in 1825. — On wood. Life size.

CORRIDOR WHICH LEADS TO THE PALATINE GALLERY

This corridor was constructed by commission of Cosmus I, in order to join the Pitti Palace where he lived with the old palace of the *Signoria* or *Palazzo Vecchio*, where his son Francis was to dwell after his marriage with Jeanne of Austria. The celebrated architect and painter George Vasari was charged with the direction of this work, which he succeeded in finishing in five months, according to what he relates himself in his authobiography (Vol. I, p. 49, ed. Le Monnier).

Engravings.

In the first part of this corridor are exhibited since 1871 over 1200 engravings chosen from the collection of about 20,000 possessed by the Gallery, and also provening from the Medici house.

We shall only indicate how the collection is here ranged according to the different schools and epocs, as follows:

LANDING AND FIRST HALL.

Old engravings in wood.

SECOND HALL.

Italian engravings in copper, before Marcantonio's time.

CORRIDOR.

Engravings by *Marcantonio, Agostino Veneziano* and *Mark of Ravenna.*

Engravings of Marcantonio's school and imitators.

Engravings by *Cornelius Cort* and of his school.

Roman engravings, from the half of the XVIth Century, to that of the XVIIIth Century.

Tuscan engravings, from the XVIth Century, to the half of the XVIIIth Century.

Venetian engravings.

Bolognese and Lombard engravings.

Engravings in wood and copper, of ancient German masters.

Engravings by *Albert Dürer.*

Engravings by *Luke of Leyden* and the brothers *Wierx.*

Engravings by *Rembrandt* and his imitators.

Dutch and Flemish engravings.

Engravings of works by *Rubens* and his school.

French engravings.

English engravings.

Engravings of modern Italian, German and French artists no longer alive.

PORTRAITS

OF EMINENT PERSONAGES

The greatest number of these portraits were copied by Christopher Papi, called *dell'Altissimo*, by order of Cosmus I de'Medici, from a collection that Mons. Paul Giovio, bishop of Nocera, had made in his villa near Como. However not a few were added later on, so that it contains now not less than 533 pieces, which are arranged here in an alphabetical order and in several categories, according to their historical rather than artistic importance.

DIFFERENT NATIONS

—

Kings, Princes and Ministers of State.

476 Alphonse I, king of Naples.
687 Anna of Boleyn.
840 Anna, James II's daughter.
394 Annibal.
375 Antony Perrenot, cardinal of Granvele.
392 Artaxerxes, king of Perse.
395 Attila, king of the Huns.
669 Batori Stephen.
208 Charles, archduke of Austria.
443 Charles of Bourbon, constable of France.
376 Charles of Bourbon, cardinal.
588 Charlemagne.
439 Charles of Orléans, count of Angoulême.

834 Charles I, king of England.
835 Charles II, king of England.
458 Charles II, king of Spain.
590 Charles V.
431 Charles VIII, king of France.
438 Charles IX, king of France.
682 Charles XII, king of Sweden.
685 Catherine of Aragon, queen of England.
434 Catherine of the Medicis, queen of France.
675 Corvin Matthew, king of Hungaria.
389 Crammer Thomas, archbishop of Canterbury.
677 Christian II, king of Danemark.
681 Christine, queen of Sweden.
842 Cromwell Olivier.
831 Edward VI, king of England.
830 Elisabeth, queen of England.
672 Frederic Augustus, king of Poland.
599 Frederic 1, emperor, called *Barbarossa*.

603 Ferdinand, archduke of Austria.
592 Ferdinand I, emperor.
596 Ferdinand II.
454 Ferd. II, king of Spain.
597 Ferdinand III.
430 Francis I, king of France.
433 Francis II, king of France.
450 Gaston, duke of Orléans.
838 George I, king of Great Bretain.
398 Godfrey of Bouillon.
680 Gustavus Adolphus II, king of Sueden.
464 Gutzman Gaspard, count and duke of Olivares.
470 Haro (De) Louis.
435 Henry II, king of France.
437 Henry III, the last of the Valois.
436 Henry IV, king of France.
686 Henry VIII, king of England.
370 Henry, cardinal and king of Portugal.
841 Howards Thomas, duke of Norfolck.
674 Jablonowsky Stanislaus.
833 James I, king of Great Britain.
836 James II, king of Great Britain.
829 James V, king of Scotland.
601 John of Austria, natural son of Charles V.
472 John IV, duke of Bragance, proclamed king of Portugal.
599 Joseph I, of Germany.
475 Ladislaus, king of Naples.
598 Leopold I, of Germany.
448 Louis of Berbone, the great Condè.
676 Louis II, king of Hungaria.
432 Louis XII, king of France.
441 Louis XIII, king of France.
688 Mary, queen of England.
832 Mary Stuart, queen of Scotland.
839 Mary II, queen of Great Britain.
591 Maximilian I. emperor.
593 Maximilian II.
595 Matthew I.

334 Mazarin, cardinal Jules.
843 Monk George.
714 Moore Thomas.
459 Philip of Austria of Bourgogne, king of Castilla, surnam. *the handsome.*
455 Philip II, king of Spain.
456 Philip III, king of Spain.
457 Philip IV, king of Spain.
393 Pirrhus, king of Epirus.
381 Richelieu, cardinal.
474 Robert, king of Naples.
594 Rodolphus II, emperor.
396 Scipio the African.
471 Sebastian, king of Portugal.
670 Siegismund III, king of Poland.
671 Sobiescki John, king of Poland.
613 Sophia, Electrice of Hannover.
397 Totilas, king of the Goths.
837 William III, pr.ᵉ of Orange.
366 Wolsey Thomas, cardinal of York.
673 Zamoski John, chancellor of Poland.

TURKEY
—
Princes and Princesses.

412 Achmet III.
415 Amethe, scheriff, the great, king of Mausitania.
424 Aiaf, pacha.
404 Amurat II.
408 Amurat III.
410 Amurat IV.
413 Architrof, emperor of Ethiopia.
416 Ariadene Barberousse, pirate.
414 Atana David (of) Dinghel, emperor of Ethiopia.
411 Bajazet I, emperor.
406 Bajazet II.
421 Caith-Bey, sultan of Cairo.
422 Camposons-Gauro, sultan.
429 Castriotte George Scandebeg.
426 Gameria, daughter of Soliman II.

409 Ibraim I.
418 Ismael Sophi of Persia.
402 Mahomet I.
403 Mahomet II.
411 Mahomet IV.
423 Mahomet, grand-visir
417 Muléas, kng of Tunis.
427 Roxelane, wife of Soliman II.
428 Salaheeden.
405 Sélim I.
407 Sélim II.
399 Soliman III.
460 Tamerlan, emperor of the Tartars.
420 Tamur-Bey, the last sultan of Cairo.
419 Thomas, Sophi of Persia.
425 Zyzime, brother of Bajazet II.

GERMANY

Electors and Dukes.

600 Albert V, duke of Bavaria.
461 Charles, duke of Bourgogne.
606 Frederic, elector Palatine.
617 Frederic, elector of Saxony.
605 Ferdinand, elector of Bavaria.
604 Hugues, count of Hadembourg.
460 John, duke of Bourgogne.
616 John, elector of Saxony.
619 John Fred., elect. of Saxony.
618 John Giorgio, duke of Sax.
602 Maurice, elect. of Saxony.
611 Maximilian duke and elector of Bavaria.
614 Maximilian Emmanuel elector of Bavaria.
620 Philip, landgraf.

LOMBARDY AND VENICE

Princes and Dukes.

537 Alfonso I, duke of Ferrara.
535 Alfonso II, duke of Ferrara.
519 Barbarigo Agostino, doge of Venice.

518 Christina of Lorraine, wife of Francis II Sforza.
511 Este (d') Borso, duke of Ferrara.
510 Este (d') Lionel, duke of Ferrara.
478 Ezzelino (da) Romano, tyrant of Padua.
539 Farnese Alessandro, duke of Parma.
543 Gonzaga Ferdinando, duke of Mantua.
495 Gonzaga Francesco II, marquis of Mantua.
486 Montefeltro Frederic, duke of Urbino.
524 Rovere (della) Francis Maria, duke of Urbino.
492 Scala (della) Gran Cane.
493 Scala (della) Cane, of Verona.
490 Scala (della) Mastino, of Verona.
514 Sforza Luigi, called il Moro, duke of Milan.
506 Sforza Galeazzo Maria.
504 Sforza Francesco, duke of Milan.
515 Sforza Francesco III, last duke of Milan.
530 Veniero Sebastiano, doge of Venice.
480 Visconti Matteo.
388 Visconti Giovanni, duke and archbishop of Milan.
498 Visconti Galeazzo.
491 Visconti Bernardo.
485 Visconti Gian Galeazzo.
500 Visconti Filippo.

TUSCANY

Citizens and Dignitarians.

582 Acciajoli Nicola.
696 Capponi Neri.
700 Capponi Pietro.
692 Donati Corso.
484 Faggiola (della) Uguccione.
489 Gualtieri, duke of Aten.
431 Interminelli (degli) Castruccio, called Castracani, lord of Lucca.

570 Lando (di) Michele.
799 Malespini Tebalducci Giacomini Antonio.
546 Medici (de) Pietro.
541 Medici (de) Giovanni.
387 Pietramala (da) Guido.
563 Pitti Luca.
496 Scolari Filippo.
701 Soderini Pietro.
528 Strozzi Leone.
533 Strozzi Pietro.
551 Uberti (degli) Farinata.
753 Valori Nicola.

DIFFERENT NATIONS

Generals, Captains and Celebrated Warriors.

488 Acuto (Hawkwood) John, English general.
725 Alviano Bartolommeo.
532 Baglioni Giov. Paolo.
522 Baglioni Malatesta.
786 Balbiano (da) Alberico.
683 Bannier John.
494 Bentivoglio Giovanni, lord of Bologna.
363 Borgia Cesare duke Valentin.
821 Borro (del) Alessandro.
499 Bussone Francesco, called Carmagnola.
547 Caprara Enea.
503 Cappello Vincenzo.
548 Caraffa Jerome, marquis of Montenegro.
508 Coleone Bartolomeo.
451 Cologny Gaspard, admiral of France.
517 Colonna Prospero.
483 Colonna Sciarra.
482 Colonna Stefano.
464 Consalvo Fernandez.
466 Cortez Ferdinand.
521 Davalos Ferdinand, marquis of Pescara.
538 Davalos Alphonso, marquis of Pescara.
479 Doara (da) Buoso.
536 Doria Andrea.
205 Doria Giov. Andrea.
534 Fieschi Luigi.
444 Foix Gaston.

501 Fondolò Gabrinus, of Cremona.
506 Gattamelata Erasmo.
749 Gonzaga D. Ferrante.
575 Guidi Camillo.
445 Guise (de) duke Henry.
540 Inghirami Giacomo.
467 Leva (de) Anthony.
447 Lorraine Francis, duke of Guise.
526 Lupi Bonifazio, of Parma.
783 Maestro (del) Lorenzo.
782 Maestro (del) Tommaso.
473 Magaglianes Ferdinand.
507 Malatesta Novello.
513 Malatesta Sigismondo.
658 Mansfeld count Ernest.
523 Medici (de) Giov. Giacomo, marquis of Marignano.
442 Montmorency (de) Anne, constable of France.
449 Montmorency (de) Francis Henry, duke of Luxembourg and marshal of France.
690 Montone (da) Braccio.
615 Nassau (of) count Maurice.
465 Navarro Peter.
512 Orsini (degli) Nicola.
552 Orsini (degli) Virginio, count of Pitigliano.
525 Orsini (degli) Virginio, count of Anguillara.
546 Paoli (de) Pasquale, corsican general.
668 Papenheim Henry Geoffrey.
531 Petrucci Pandolfo, tyran of Sienna.
544 Piccolomini Ottavio, duke of Amalfi.
504 Piccinino Nicola.
689 Rais Dragut, pirate.
784 Rena (della) Geri di Maso.
679 Ruyter Michael, admiral of Holland.
610 Saxe-Veymar (of) duke Bernard.
497 Sforza (degli) Attendolo.
542 Spinola Ambrogio.
667 Tilly John.
452 Torre (della) Henry.
678 Tromp Martin.
463 Toledo (of) Ferdinand, duke of Alba.

462 Toledo (of) Peter, marquis of Villafranca and king of Naples.
691 Trivulzi Giov. Giacomo.
468 Vallette (de la) Parisot John.
572 The same.
571 Villers de l'Isle, John Adam.
487 Vitelli Alessandro.
529 Vitelli Chiappino, marquis of Cetona.
527 Vitelli Paolo.
516 Vitelli Vitellozzo.
607 Walstein Albert.
440 William I, prince of Orange.
257 William Louis.
684 Wrangel Charles Gustavus.
819 Zondadari Marc'Antonio.

Saints and Popes.

339 Adriano VI.
317 Alessandro IV.
327 Alessandro V.
337 Alessandro VI.
350 Alessandro VII.
314 S. Antonino, archbishop of Florence.
321 Boniface VIII.
316 Benedetto IX, antipope.
322 Benedetto XI.
313 S. Bernardino, of Sienna.
332 Callisto III.
320 Celestino V.
323 Clemente V.
325 Clemente VI.
346 Clemente VIII.
351 Clemente IX.
353 Clemente XII.
330 Eugenio IV.
315 S. Filippo Bonizi.
344 Gregorio XIII.
310 S. Giovanni Gualberto.
324 Giovanni XXII.
328 Giovanni XXIII.
338 Giulio II.
319 Innocenzo V.
336 Innocenzo VIII.
352 Innocenzo XI.
347 Leone XI.
329 Martino V.
331 Niccolò V.
334 Paolo II.
340 Paolo III.
341 Paolo IV.

348 Paolo V.
333 Pio II.
342 Pio IV.
343 Pio V.
335 Sisto IV.
345 Sisto V.
311 S. Tommaso of Aquin.
318 Urbano IV.
326 Urbano V.
349 Urbano VIII.
312 S. Zanobi, bishop of Florence.

Cardinals.

379 Baronio Cesare.
354 S. Bernardo, cardinal degli Uberti, of Florence.
380 Bentivoglio Guy, of Ferrara.
364 Bembo Peter, of Venice.
378 Bellarmino Roberto, of Tuscany.
357 Cesarini Giuliano.
368 Cibo Innocenzo.
362 Colonna Pompeo.
367 Contarini Gaspare, of Venice.
371 Dominici Giovanni.
365 Dovizi Bernard, of Bibbiena.
361 Grimani Dom., of Venice.
374 Luca (de) Gio. Battista.
386 Noris Enrico, of Verona.
383 Paceco Francis, of Spain.
369 Pole Reginald, archbishop of Canthorbery.
373 Prato (da) Nicola.
358 Riario Pietro.
382 Sadoleto James, of Modena.
372 Sforza Ascanio, of Milan.
385 Sforza Pallavicini, a jesuit.
356 Trebisonde (card. of) Bessarion.
355 Ubaldini card. Ottaviano.
358 Vitelleschi Giov., of Rome.

Celebrated Artists and Writers of different Nations.

562 Acciaioli Donato, gonfaloniere.
578 Accolti Francis, of Arezzo, a jurist.
785 Accursio, florentin jurist.

820 Addison Joseph, of England.
694 Adriani Virgil Marcellus.
788 Agostini Ant., of Sienna.
722 Alamanni Luigi, a florentin poet.
721 Alciato Andrea, of Milan.
549 Albert-le-Grand, a dominican.
576 Alberti Leon Battista.
737 Aldobrandi Ulisse, of Bologna.
553 Alighieri Dante.
742 Ammirato Scipio the historian.
735 Angeli Pietro, a latin writer of Barga in Tuscany.
566 Aretino Guittone, a poet.
693 Aretino Leonard, secretary.
720 Aretino Pietro, a poet.
712 Ariosto Lodovico.
814 Averani Lodovico, of Florence.
816 Bacone Francis.
567 Baldo, of Perugia.
704 Barbaro Hermolaus, of Venice.
813 Bellini Lorenzo, a florentine anatomist.
793 Bellori Giov. Pietro, a librarian.
791 Berni Francesco, poet.
559 Boccaccio Giovanni.
790 Borelli Giov. Alfonso, of Naples.
734 Borghini Vincenzo, of Florence.
799 Boyle Robert, of Irland.
761 Bracciolini Poggio, poet.
747 Brache Ticho, astronomer.
573 Brunelleschi Filippo.
778 Buonarroti Michael-Angel, the great Michael-Angel's nephew, a poet.
585 Calcondila Demetrias, of Athens.
781 Capponi Vincenzo, senator.
729 Cardano Jerome, a physic.
732 Caro Annibale.
731 Casa (della) John, archbishop of Benevento.
390 Castelli D. Benedetto.
713 Castiglione Baldassarre, of Mantua.

756 Causoubon Isaac.
777 Cavalieri Bonaventura, of Milan.
555 Cavalcanti Guido, philosopher and poet.
726 Cellarius Christopher, a geographer.
752 Chiabrera Gabriello, poet of Savona.
742 Clavio Christopher, reformer of the calendar.
755 Canisio Setus, a German chronologist.
766 Cluverio Phit., a geographer.
822 Cocchi Antonio, fiorentine physicians.
586 Colombo Cristoforo.
718 Colonna Vittoria, marchioness of Pescara.
733 Comendino Federico, of Urbino, a mathematician.
710 Copernico Nicholas.
798 Corneille Thomas.
764 Davila Henry-Catherine, historian.
773 Descartes René.
825 Eckel Abbot Joseph, an antiquary.
708 Erasmus, of Rotterdam.
795 Fabretti Raffaello, a prelate and antiquary.
585 Ficino Marsilio.
566 Filicaja Vincenzo.
759 Finckius Tomas, of Danemark, a physician.
716 Fracastoro Girolamo, of Verona, a physician.
760 Galilei Galileo.
772 Gassendi Peter, a physician.
583 Gaza Theod., of Grece.
740 Giovio Paolo, bispop of Nocera.
391 Grandi D. Guy, of Cremona, a mathematician.
803 Grevio Jhon George.
760 Grozio Hugon.
758 Gruter Janus, a phylologist.
715 Guicciardini Francesco.
768 Heinsio Daniel.
453 Hôpital (de l'), a mathematician.
774 Holstenius Luke, of Hambourg.
762 Kleper John, astronomer.

581 Landino Cristoforo.
824 Lanzi ab. Luigi, antiquary.
587 Lascaris (de) John, of Grece.
550 Latini Brunetto.
775 Leibnitz Godfrey.
808 Lemene Francis, of Lodi.
748 Lipsio Just.
709 Machiavelli Niccolò.
698 Maffei Raffaello, of Volterra.
810 Magalotti Lorenzo, a literary man.
802 Maggi Carlo Maria, poet of Milan.
754 Magini Giovanni Antonio, mathematician.
807 Magliabechi Antonio, librarian.
574 Manetti Giannozzo.
806 Marchetti Alessandro, a mathematician and poet.
776 Marini Gio. Battista, a neapolitan poet.
564 Marsili Luigi, a florentin theologer.
724 Martelli Lodovico, florentin poet.
727 Mattioli Pietro Andrea, a siennese physician.
823 Menzini Benedetto, florentin poet.
741 Mercuriale Girolamo, a physician of Forlì.
792 Meursio John, a literary man.
750 Mirabello Vincenzo, of Syracusa.
707 Mirandola (della) Giov. Pico.
697 Nanni (Domenico di), of Florence called Burchiello.
812 Newton Isac.
739 Orsini Fulvio, of Rome.
797 Pagi Antonio, ecclesiastical historian.
577 Palmieri Matteo, ot Florence.
738 Panvinio Onofrio.
805 Patin Charles, à pysician.
769 Petau Fenis, a celebrated jesuit.
557 Petrarca Francesco.
554 Pistoia (da) Cino.
579 Platina Bartolommeo, of Lombardy.
826 Plato.

705 Poliziano Angelo.
763 Pontano John or Jovian, of Spoleto, a poet.
818 Pozzo (del) Cassiano, a literary man.
828 Puccini Tommaso, director of this Gallery.
284 Pulci Luigi, a florentine poet.
815 Ravio John, and English botanist
800 Redi Francesco, of Arezzo, a physician.
695 Ridolfi Lorenzo, of Florence.
771 Rondinelli Francesco, a flo' rentine librarian.
780 Rucellai Orazio, a florentine poet.
565 Salutati Coluccio, secretary of the Florentine Republic.
745 Salviati Leonardo, of Florence.
817 Salvini Anton Maria, of Florence.
706 Sannazzaro James, a poet.
558 Sassoferrato (ot) Bartolo, professor of Jurisprudence.
787 Saumase Claudius.
717 Scaligero Giulio Cesare, a learned man and poet.
744 Scaligero Giusto Giuseppe.
552 Scota, a franciscan theologer.
736 Sigonio Carlo, of Modena. historiographer.
757 Sirmond James, a Jesuit.
801 Spanhemio Ezechiel.
728 Speroni Sperone, Tasso's master.
811 Stenone Nicholas, of Denmark.
746 Tasso Torquato.
699 Tarcagnotta Macel Marhel, historiographer.
751 Thou Jacopo Augustus, a French historian and poet.
789 Torricelli Evangelista, the celebrated physiologer.
767 Usserio James, archbishop of Armach, in Irland.

568 Uzzano (da) Nicola, of Florence.
804 Vaillant John, antiquary.
809 Valletta Giuseppe, of Naples.
730 Varchi Benedetto, a florentine historian.
702 Vespucci Americo.
723 Vettori Pietro, a florentin learned man.
719 Vida Girolamo, a poet of Cremona.
560 Villani Giov., flor. histor.
561 Villani Matteo, idem.
569 Villani Filippo, idem.
703 Vinci (da) Leonardo.
793 Viviani Vincenzo, florentin mathematician.
765 Volsio John Gerard.
794 Wallis John, an English mathematician.
827 Zanoni Giov. Battista, antiquary.

Princes of the House of Lorraine.

621 Anthony, counte of Vaudemont.
632 D. Anthony, son of René II.
623 D. Charles II, son of John I.
624 D. Charles III, son of Francis I.
625 D. Charles IV.
626 D. Henry II, son of Charles III.
629 D. Ferry II, surnamed *Bitche.*
631 Ferry, count of Vaudemont.
628 Ferry II, Vaudemont's son.
630 D. Ferry III.
627 D. Ferry II.
622 D. Francis I.
633 D. Francis II.
635 D. Giov. II, duke of Calabria.
634 D. Giov. I.
636 D. Matthew I, son of Simon I.
637 D. Matthew II.
633 D. Nicholas of Anjou
639 D. René of Anjou.
640 D. René II.
641 D. Rodolphus.
642 D. Simon II.
643 D. Tibaud I.
644 D. Tibaud II.

Princesses of the House of Lorraine.

645 Agnes, surnamed Teomucete, wile of Ferry II.
646 Agnes, wife of Simon II.
647 Agnes, wife of Tibaud I.
648 Bertha, wife of Matthew I.
649 Catherine, wife of Matt. II.
650 Catherine, wife of Tibaud II.
651 Claudia of France, wife of the duke Charles III.
652 Christine, wife of Franc. II.
653 Christine, wife of Franç. I.
656 Isabelle, wife of Ferry IV.
657 Isabelle, wife of René of d'Anjou.
655 Jolanda of Anjou, wife of Ferry II.
658 Margaret, wife of Ferry III.
662 Margaret, wife of William of Vienna.
660 Margaret of Bavaria, wife of Charles II.
661 Mary of Blois, second wife of Rodolphus.
659 Mary of Hancourt, wife of d'Antony, counte of Vaudemont.
663 Mary, wife of Giov. II.
664 Nichola, Charles IV's first wife.
654 Philippine, second wife of René II.
665 Renée of Bourbon, wife of duke Antoiny.
666 Sophia of Wittemberg, wife of Giov. I.

PORTRAITS AND COSTUMES

XVIth, XVIIth AND XVIIIth CENTURIES [1]

1131 Acciaioli senator Angelo. curator of the florentine Academy of fine arts.
1067 Acciaioli, countess born Bolognetti, a noble florent. lady.
187 Adami Francesco Raimondo, a monk of the Servi di Maria.
1151 Alamanni Vincenzo, curator of the florentine Academy of fine arts.
189 Albornotius cardinal Egidio.
1022 Albuquerque (de) Andrew.
1018 Alegreto (d') Co.
228 Alessandri Argentina, wife of marquis Ridolfi, of Florence.
1142 Altoviti senator Guglielmo, curator of the florentine Academy of fine arts.
129 Altoviti, marchionnes, born Corsini, a noble florent. lady.
1076 Angrà (d') Benedetto Silva
217 Anna, queen of England.
224 Anna Maria Luisa de' Medici, palatine princess.
222 The same.
130 Antinori Settimanni, a florentine nobleman.
1123 Bagnesi senator Giuliano, curator of the florentine Academy of fine arts.
123 Baldinucci Antonio
1146 Bardi Ridolfo, curator of the florent. Acad. of fine arts.
1089 Bardi (comtess de').
1020 Barreto (fra), Restaurator of Pernanbucco.
1127 Bartolini Baldelli sen. Francesco, curator of the florent. Academy of fine arts.
219 Bellucci Dolci Vittoria, a florentine lady.
201 Bentivoglio countess Caterina, wife of count Pepoli, of Bologna.

117 Bentivoglio marchioness Tempi, a florentine lady.
877 Berzini Domenico.
1139 Biffi marquis Girolamo, curator of the florentine Academy of fine arts.
235 Bigazzini countess Vittoria, of Perusia.
1094 Bonvisi Elisabeth.
252 Borchi Langrauda, of Florence.
138 Bordoni Faustina.
1162 Borghini Domenico Vincenzo.
157 Borromeo cardinal Carlo.
1049 Boyle Henriette, countess of Rochester. of England, painted by sir Peter Lely.
872 Buonaparte Isabel.
1235 Buonromei Quaratesi Maria.
1223 The same.
233 Campana Panciatichi Tomasa.
251 Campo Isacco.
380 Capinera (de) Bart. Giovanni, of Florence.
1207 Cappello Bianca ?
23 Cappello Bianca ?
1205 Cappello Pellegrina ? Bianca's daughter.
226 Capponi marchioness Rosa Sampieri, of Florence.
1222 Capponi Maria, wife of Guy Pecori.
1247 Capponi Maria, born Pecori.
1244 Capponi Dianora.
1246 Capponi Minerbetti Ottavia.
215 Caprara marchioness Camilla Bentivogli, of Bologna.
247 Caracciolo Francesco, a neapolitain admiral, one of the most celebrated victimes in 1729
1261 Caraffa Belluccia duchess of Cerce ?
1112 Carnesecchi Nasi Lucrezia.
1240 Carnesecchi Rucellai Maria.
1259 Castro (countess of).

(1) These portraits and costumes have been discovered in the store-rooms of the Uffizi Gallery and palazzo Vecchio, and were placed and arranged here in 1831.

939 Castro Etienne - Rodriguez, a portuguea physician.

1021 Castro de Mello. a famous portuguese captain and writer.

890 Caterina wife of Peter the Great, empress of Russia.

238 Cavalieri Sacchetti Clelia, of Rome.

291 Cavallotti Giulio, Olivecciani Vincenzo and Rivani Antonio, musicians.

220 Coeli-Armeni Caetano of Pisa.

1097 Charles John Francis, palatin of the Rhine, duke of Bavaria

955 Charles III of Bourbon, king of Naples

46 Charles IV and Clemente VII, Treir thriumphal entry at Bologna. In four compositions.

992 Charles VII, the emperor, called the Victorius?

885 Charles XII, king of Sweden.

1006 Christian VII, king of Danmark and Norvegia.

208 Ciaia Baldocci Urania, of Siena.

1175 Claudia of France, duchess of Lorraine.

1157 Corsi Simone, curator of the floreutine Academy of fine arts.

1114 Cromwell Olivier.

63 Czomodanof prince Ivan Evanowich, a muscovite ambassador.

1026 D'Acuucha Tristan, a celebrated portuguese sailor, discoverer of several iles; killed by the savages of Rio Grande in 1147.

241 Dati Tornaquinci, Clarice, of Florence.

1250 Dei Scarlatti Caterina.

66 Devereux Robert, count of Essex, a favorite of queen Elisabeth of England, beheaded in the Tower of London at the age of 34 on the 25th February 1501.

1143 Dini Sigismondo-Agostino, curator of the florentine Academy of fine arts.

901 Dulach sister Beatrice, of Germany.

— Elisabeth Cristine of Brunswick Wolfembutel, empress.

60 Elisabeth, queen of England.

213 Erwort Henriette, a german lady.

136 Especo Citerni Isabella, a spanish lady.

851 Este (d') princess Beatrice, wife of prince Ludovic Maximilian of Lorraine.

215 Ferdinand, grand duke of Tuscany.

107 Ferdinand (the weddig of) of Tuscany, with Mary of Austria.

1137 Franceschi sen. Lorenzo curator of the floreutine Acad. of fine art.

1255 Franchi Pecori Orintia.

979 Francis II, emperor of Germany.

998 Francis II of Lorraine, grand duke of Tuscany.

137 Frescobaldi marquis Vitelli, of Florence.

1019 Fronteira (de), portugais.

1152 Gaddi Nicola, curator of the floreutine Academ of fine arts.

253 Gabbiani Giov. Domenico.

1191 Galautini (Beato) Ippolito.

171 The same

894 Gargiolli Filippo.

207 Gerini Arrighetti Maria Maddalena.

1148 Gianfigliazzi Gio. Batta., curator of the florent. Academy of fine arts.

870 Giustz M.

223 Giraldi Giugni marchioness Luisa, of Florence.

1197 Gonzaga Marguerite, of Mantua, wife of Henry II, duke of Lorraine

896 Gori Giovanni.

142 Gori Sabina, of Siena.

1229 Grazzini Maddaleua, wife of Tommaso Corbinelli.

131 Grifoni Marescotti Francesca, of Sieua

249 Grumbergh Silva marchioness Antonietta, of Germany.

1244 Guadagni Salviati Cassandra.

210 Guastalla (princess of) Maria Maddalena.

133 Guglielmini Anna, of Bologna.

1107 Guicciardini Franc. Giovanni.

1161 Guicciardini Angelo, curator of the Accademy of fine arts.

120 Guicciardini Renuccini, marchioness.

232 Guicciardini Altoviti Virginia, a florentine lady.

134 Gwynn Eleanor an english actress, painted by sir Peter Lely.

214 Heimbhausen countess Closent, of Germany.

1123 Henry II, king of France.

1224 Henry II, king of France.
198 Henry IV, receiving the representatives of several towns and provinces of France.
43 Henry IV, king of France.
862 Hoare Villiam, english engraver.
1086 Hugh, count. the founder of the seven Tuscan Abbeys.
212 John William, elector palatine and Anna Maria Luisa of Tuscany.
1017 Ierceira (d') C.
196 Innocenzo XI, pope.
301 Joseph I, emperor of Germany.
309 The same.
845 The same.
199 Jules II, pope.
45 Ladislaus Poloniae.
195 Leon XI, pope.
306 Leopold, archduke palatine of Hungary, son of the grand-duke Peter Leopold I.
89 Löffler Gregory.
1193 Lioni Ricci Costanza.
58 Lorraine (de) duke Henry.
69 Lorraine (de) duke Charles.
65 Lorraine (de) Claudius, duke of Guisa.
1105 Lorraine (de) prince Charles Henry.
995 The same.
54 Lorraine (de) Ludovic Maximilian, son of the grand-duke Peter Leopold I.
1101 Lorraine (de) princess Cristina.
51 The same.
1015 Loubo Gilvas.
92 Louis XIII, king of France and Navarra.
97 The same.
1104 The same.
1185 Louis XIV, king of France.
243 The same.
986 The same.
970 The same.
967 The same.
976 Louis XVI, king of France.
1028 Lourenco G. de S.
944 Lubomiski Theresa Catherine, princess palatine.
830 Ludovic of Spain, king of Etruria.
846 The same.
925 Ludovic Antony, prince palatine, great master of the theutonic order and coadjutor of Mayence.
1191 Mancini Tortori Lucrezia.
1140 Manetti senator, curator of the Academy of fine art in Florence.

132 Marcello Aurora.
126 Marescotti Cennini, a florentine lady.
982 Margaret of Austria, receiving at Geneva the ambassadors of the italian princes.
199 The same, treating her sister's marriage with Cosmus II of the Medici.
983 The same, receiving the cardinals Bandini, S. Clemente and other prelates sent to her by the pope.
103 The same, on her triumphal entry into Ferrara.
100 The same, at ther child's christening.
930 The same, meeting the duke Vincent Gonzaga and Eleanor of the Medic his wife, at Mantua.
101 The same at Valence.
102 The same, receiving at Valence the ambassadors of the Empire.
200 The same in her wedding with Philiph II, king of Spain.
201 The same, kneeling before the Pope.
1023 Marialva (de) M., count of Castanhede, great counseller of Alphonse VI king of Portugal.
904 Maria Teresa, archduchess of Austria and great-duchess of Tuscany.
989 Maria Anna, archduchess of Austria.
853 Maria Anna, archduchess of Austria, wife of the archduke Leopold of Tuscany.
844 Maria Anna, wife of Peter Leopold I, great-duk of Tuscany.
1069 Maria Luisa de' Medici of Tuscany, electress Palatine.
284 Mazzanti Lodovico, a gentleman of Orvieto.
2 Medici (de') Giovanni of Averardo, called Bicci.
1 Medici (de') Cosimo of Averardo, called Pater Patriæ (father of his country).
4 Medici (de') Giovanni and Catherina Sforza.
3 Medici (de') Lorenzo, Giov.'s son.
6 Medici (de') Pietro Francesco.
5 Medici (de') Giovanni, the son of Cosimo Pater Patriæ.
8 Medici (de') Pietro, surnamed il Gottoso, another son of Cosimo Pater Patriæ.

7 Medici (de') Giuliano, Pietro *il Gottoso's* son.

11 Medici (de') Lorenzo, called *il Magnifico*, another son of Pietro *il Gottoso*.

10 Medici (de) Pietro, Lorenzo *il Magnifico's* son.

13 Medici (de) Giovanni, who was later the pope Leone X, another son of Lorenzo *il Magnifico*.

12 Medici (de') Giuliano, duke of Nemours, another son of Lorenzo *il Magnifico*.

15 Medici (de') Giovanni, surnamed *delle Bande Nere*, son of Pietro Francesco and Maria Salviati.

14 Medici (de') Giulio, who was later pope Clemente VII.

18 Medici (de') cardinal Ippolito, son of Giuliano, duke of Nemours.

17 Medici (de') Lorenzo, duke of Urbino, Pietro di Lorenzo's son.

20 Medici (de') Alessandro, duke of Florence, son of Lorenzo, duke of Urbino.

19 Medici (de') Caterina, queen of France, daughter of Lorenzo duke of Urbino.

40 The same.

1121 The same.

21 Medici (de') Cosimo I, grand-duke of Tuscany, son of Giovanni *delle Bande Nere*

37 The same.

22 Medici (de') Eleonora of Toledo, grand-duchess of Tuscany, wife of Cosimo I.

1150 The same.

76 The same.

24 Medici (de') Francesco grand-duke of Tuscany, son of Cosimo I.

73 The same.

25 Medici (de') Giovanna d'Austria, wife of the grand-duke Francesco I.

1160 The same.

84 The same.

27 Medici (de') Maria, daughter of Franc. I, wife of Henry IV, king of France.

42 The same.

26 Medici (de') Ferdinando, grand-duke of Tuscany, son of Cosimo I.

1245 The same.

1239 The same.

67 The same.

861 Medici (de') princess Claudia, daughter of Ferdinando I.

1260 The same.

1254 The same.

1113 The same.

28 Medici (de') Cosimo II, grand-duke of Tuscany, son of Ferdinando I.

1171 The same, at the age of six months.

75 The same.

1218 The same.

1092 The same.

1092 Medici (de') Maddalena of Austria and other unknown personages.

29 Medici (de') Maria Maddalena of Austria, wife of Cosimo II, gran-duke of Tuscany.

1236 The same.

1171 The same.

53 The same.

32 Medici (de') Ferdinand II, grand-duke of Tuscany, son of Cosimo II.

941 The same.

1109 The same.

34 Medici (de') Vittoria Della Rovere, wife of grand-duke Ferdinando II.

173 Medici (de') cardinal Leopoldo, son of Cosimo II, grand-duke of Tuscany.

33 Medici (de') Cosimo III, grand-duke of Tuscany, son of Ferdinando II.

999 The same.

190 The same.

31 Medici (de') card. Giov. Carlo, son of Cosimo II.

36 Medici (de') Giovan Gastone, grand-duke of Tuscany, son of Cosimo III.

1001 The same.

35 Medici (de') Margherita Luisa of Orléans, wife of Cosimo III, grand-duke de Tuscany.

38 Medici (de') Anna Maria of Saxony Lauembourg, wife of Giov. Gastone, grand-duke of Tuscany.

39 Medici (de') Anna Maria, daughter of Cosimo III, grand-duke of Tuscany, wife of Giovanni Guglielmo, elector Palatine.

1154 Medici Francesco, curator of the Academy of fine arts of Florence.

236 Medici Buonaccorsi Aurelia.

1087 Medici Capponi Maddalena.

118 Medici Teresa.

1671 Micheli Laurence-Nain.
1123 Middleton Jane, an english lady, painted by sir Peter Lely.
952 Montorsoli Giov. Angelo (father) a sculptor.
188 Neri card. Enrico.
111 Olivieri Maddalena, of Portugal.
291 Olivecciani Vincenzo, Rivani Antonio, Cavallotti Giulio, musicians.
1064 Orlandini-Capponi, a noble florentine lady.
876 Orléans (d') Maria Luisa, queen of Spain.
937 Orléans (d') princess Isabella, duchess of Guise.
1220 Palmerini Elisabetta, wife of Giacomo Naccetti
1149 Pazzi (de') Còsimo, curator of the florentine Academy of fine arts.
1057 Pazzi Cecilia.
109 Petrucci countess Bichi, of Siena.
977 Piccolomini duchess Colowath.
225 Piccolomini Guadagni marchioness Ottavia.
969 Pierazzini Teresa, daughter of a bolognese painter.
193 Pio IV.
172 Pio V.
984 The same.
160 Pio VII.
303 Pietro Leopoldo I, grand-duke of Tuscany.
852 The same.
847 The same in his youth.
1159 Pitti Giacomo, curator of the flor. Acad. of fine arts.
1214 Pucci Gherardesca Lucrezia.
922 Philip, count and prince palat.
981 Philip II, king of Spain, treating the marriage of his son with Margareth of Austria.
1113 Philip III, king of Spain.
140 Quaratesi Guadagni Maria, a noble florentine lady.
239 Quaratesi Dazzi Anna, a florentine lady.
156 Querini cardinal Angelo.
211 Rastrelli-Bucetti marquis Francesco, of Lucca.
945 Ratzeville (de) princess palatine.
203 Rechberg countess S., of Germany.
1145 Ricasoli Franc. Maria, curator of the florentine Academy of fine arts.
1225 Ricasoli Zanchini Lucrezia.
1237 The same.
1234 Ricasoli Lucrezia, of C. S. Secondo.

1238 Riccio (del) Albizi Selvaggia.
1226 The same.
183 Richelieu-Deplessis (de) cardinal Armand John.
1158 Ridolfi marquis Lorenzo, curator of the florentine Acad. of fine arts.
1068 Risaliti Strozzi Violante, a noble florentine lady.
78 Rossermini colonel Simone.
1258 Rossi (de) Porzia.
179 Rota father Giov. Battista.
1095 Rovere (della) Federico, prince of Urbino.
1129 Sà (de) Salvador Correa, a portuguese admiral, governor of Bresil and founder of the tow of Pernagua.
139 Sansedoni Marsili Caterina, of Siena.
1243 Saminiati Medici Costanza.
230 Santini Mazzarosa Maria, of Lucca.
1178 Savoia (of) princess Francesca Caterina.
1177 Savoia (of) princess Magherita.
49 Sedicivogui Garnkowsby, palatinae leciciae et seueralis majoris Poloniae ?
112 Sergardi Borghese Caterina, a noble siennese lady
1252 Sigismund, king of Poland.
1132 Sigismund, duke of Finland.
305 Simonetti Livia.
272 Sommers (lord), president of the first British Counsel.
1079 Spinelli Chiara, princess of Belmonte.
1261 Spinelli Emilia.
1155 Spini Carlo Giacomo, cur. of the flor. Acad. of fine arts.
268 Spinola Maria, of Genoa.
203 Spuarechburg (countess of), of Germany.
978 Steremberg countess Kauniz, of Vienna.
229 Stirumb (countess), of Germany.
1232 Strozzi Caterina, wife of Filippo Strozzi
1228 Struzzi Maria, wife of Alessandro Strozzi.
1062 Strozzi Cellesi, a noble florentine lady
1216 Strozzi Bardi Maddalena.
1241 Strozzi Caterina.
205 Stuart James, prince of Wales and his sister princess Luisa.
1027 Tavora (de) M.
921 Teodorowna, princess of Wurtemberg, wife of the emperor Paul I of Russia.
1202 Toledo (of) Eleanor.

113 Torricelli Evangelista, the cele-
 brated geometer.
246 Upezinghi Tidi Caterina, of
 Pisa.
985 Urbano VIII?
242 Valuroni countess Merilda, of
 Friuli.
121 Valuroni countess Suarez, of
 Friuli.
1074 Vanni Giuseppe, goldsmith.
1072 Vecchi Gori Livia, a noble
 siennese lady.

170 Verrazzano Alessandro (father).
902 Vignali Giacomo
1025 Villaflor (of) Co.
1024 Villar (of) Major.
114 Villiers Barbe, duchess of Cle-
 veland, painted by sir Peter
 Lely.
1073 Violante princess Beatrice.
1231 Vivai Cepparelli Camilla.
1251 The same.
1065 Zati Cerretani, a noble floren-
 tine lady.

Views of different Towns, Fortresses, popular and religious Fêtes

150 Rome — Plan of the town.
151 Id. — View of the villa Medici.
1036 Florence — Popular fêtes on
 the square of Santa Maria
 Novella.
1047 Id. — A festival in the Cascine.
1041 Id. — A popular festival on the
 piazza della Signoria.
149 Id. — A nocturnal festival at
 the Cascine.
1048 Id. — Nocturnal festival in the
 court yard of Palazzo Pitti.
1042 Id. — La Corsa dei barberi
 (Races).
1030 Id. — A processione in Piazza
 del Duomo.
1031 Id. — A processione in piazza
 della Signoria.
145 Id. — A processione in via de'
 Servi.
1037 Id. — The jockey races on the
 square of S. Maria Novella.
1045 Naples — View of the town.
1046 Id — View of the town.

147 Siena — A popular festival.
1032 Id. — A popular festival.
143 Leghorn — A popular festi-val
 on Piazza del Duomo.
1038 Id. — View of the fortifications
 and port
1040 Id. — View of the fortress and
 port.
1044 Id. — View of the fortress and
 port.
1039 Id. — View of the fortress and
 port.
1043 Pisa — The game of the bridge.
1033 Portoferraio — View of the
 town.
1035 Id. — View of the town.
1034 Id. — View of the town and for-
 tress.
146 Id. — View of the town and
 fortress.
148 Id. View of the town and for-
 tress.
144 A festival in the court yard of
 a Medicean villa.

OTHER PORTRAITS

which are scattered in the different halls of the Gallery

175 Accolti Benedetto, cardinal of Arezzo, painted by Giulio Romano : hall of Baroccio.
1109 Agucchia , cardinal, painted by Domenichino : in the Tribune.
168 Aigemann John, painted by Aretusi : hall of Baroccio.
689 Albany (D'), countess, painted by Fabre.
679 Alfieri Vittorio, painted by Fabre.
1248 Bandinelli Baccio, painted by himself : tuscan school, first hall.
1116 Beccadelli, prelate, painted by Tiziano : in the Tribune.
1216 Bella (Della) Stefano, paint. by Franc. Cambi : first hall.
822 Bore Catherine, wife of Luther, painted by Luke Cranak : flemish school, second hall.
684 Bossuet, bishop of Meaux, paited by Rigaud : french school.
1217 Braccesi Alessandro, painted by Lorenzo di Credi : tuscan school, first hall.
197 Brands Elisabeth, Rubens' first wife: hall of Baroccio.
763 Claudia, princess de' Medici, wife of the archduke of Austria, painted by Sustermans: flemish school, first hall.
643 Cornaro Caterina, queen of Cyprus, painted by Tiziano : venitian school, second hall.
644 Coignati, a physician, painted by Paolo Pino: venitian school second hall.
1128 Charles V, emperor, painted by Vandyck: in the Tribune.

1183 e 1227 Cappello Bianca, second wife of Francesco I de' Medici, painted by Bronzino: tuscan school, first hall.
672 Dangeville, madame, painted by Grimaux : french school.
1207 Dante Alighieri, by an unknow painter : tuscan school, first hall.
845 Frederic and John, electors of Saxony, painted by Cranack : flemish school, second hall.
207 Felicia, archduchess of Austria, the archduke Ferdinand Charles' daughter, painted by Carlo Dolci : hall of Baroccio.
895 Ferdinand, infant of Spain, archduke of Austria, painted by Luke of Leyden : dutch school.
155 Folengo Teofilo, burlesque poet, called Merlin Coccai, by an unknown painter : hall of Baroccio.
180 Forman Helen, Rubens' second wife, painted by himself : hall of Baroccio.
1123 Fornarina, painted by Raffaello : in the Tribune.
164 Francavilla, sculptor, painted by Porbus.
199 Francavilla a flemish sculptor : hall of Baroccio.
667 Francis I, king of France, painted by Francis Clouet : french school.
673 Francis William, elector palatine, by an unknown painter : french school.
1214 Gaddi Elena, painted by Manzuoli : tuscan school, first hall.

163 GALILEO, painted by Suster-
mans: hall of Baroccio

76 GAMBETTI Giovanni Battista,
painted by l'Empoli: second
corridor.

571 GATTAMELATA, general, painted
by Giorgione: venit. school,
first hall.

1121 GONZAGA Elisabetta, princess of
Mantua, painted by Man-
tegna: in the Tribune

670 GRIGNAN (DE), countess, painted
by Mignard: french school.

788 GROSS Camilla, painted by An-
thon Moor: flemish school,
second hall

185 HAUREY Elisabeth, daughter of
Haurey, baron of Endrovich,
painted by Down: hall of
Baroccio

196 LORRAINE (DE) Margaret, wife
of prince Gaston of France,
painted b Vandyck: hall
of Baroccio.

676 LOUIS XIV, king of France, by
an unknown painter: french
school.

— LOUIS XIV, king of France, pa-
stello by Nanteuil: hall of
the cameos

647 LUTHER, painted by Cranack:
flemish school, second hall.

1267 MEDICI (De') Cosimo, Pater Pa-
triae, painted by Pontormo:
tuscan school, second hall.

1269 MEDICI (De') Lorenzo, il Ma-
gnifico, painted by Vasari:
tuscan school, second hall.

1281 MEDICI (De') Alessandro, painted
by Vasari: tuscan school, se-
cond hall.

611 MEDICI (De) Giovanni, called
delle Bande Nere, painted
by Tiziano: venitian school,
second hall.

193 MEDICI (De) Giuliano, duke of
Nemours. paint. by Alessan-
dro Allori: hall of Baroccio.

1270 MEDICI (De') Cosimo I, painted
by Pontormo.

1155 MEDICI (De') D. Garzia, painted
by Bronzino: tuscan school,
second hall.

1272 MEDICI (De') Ferdinando I, pain-
ted by Bronzino: tuscan
school, second hall.

1161 MEDICI (De) Marietta, daughter
of Cosimo I, painted by
Bronzino: tuscan school, first
hall.

1273 The same, painted by Bron-
zino: tusc. school, first hall.

920 MEDICI (De') Anna Maria, wife
of Giovanni Guglielmo, elec-
tor palatine, painted by Do-
wen: dutch school.

617 MELANCHTON, and LUTHER, pa-
inted by Cranack: flemish
school, second hall.

— MIGLIARINI Michele Arcangelo:
in the curator's room.

1154 MIRANDOLA (DELLA) Pico. by
an unknown tuscany artist:
first hall.

1115 MONFORT (DE) John, painted by
Van-Dyck: in the Tribune.

— MONK general George, painted
by Federigo Baroccio: in
the curator's room.

1302 MONTEFELTRO Federigo, duke
of Urbino, paitend by Piero
della Francesca: hall of the
old masters.

799 MORE Thomas, painted by Hol-
bein: flemish school, second
hall.

140 OSSORY, lord general, by sir
Peter Lely: hall Niobe.

159 PANCIATICHI Bartolommeo, pa-
intend by Bronzino: in the
hall of Baroccio.

151 PANCIATICHI Lucrezia (de'PUCCI),
painted by Bronzino: hall
of Baroccio.

213 PANIGAROLA, a milanese prea-
cher, painted by Lavinia
Fontana: hall of Baroccio.

612 PANTERA Antonio, by Morone:
venitian school, second hall.

131 PAOLI Pasquale, general, pain-
ted by Cosway: third cor-
ridor.

1203 PETRARCA, painted by an unk-
nown tuscan painter: first
hall.

210 PHILIPP IV, king of Spain, by
Velasquez: hall of Baroccio.

699 PULICIANI, a florentine gentle-
man, paint by Sustermans:
flemish school, first hall.

709 PULICIANI Caterina, his wife,
born Carini, by Sustermans:
flemish school, first hall.

141 ROBERT prince palatine. by
sir Peter Lely: hall of Niobe.

674 ROUSSEAU John Baptist, poet,
by Largillière: french school.

605 ROVERE (DELLA) Franc. Maria,
duke of Urbino, painted by
Tiziano: venitian school first
hall.

597 ROVERE (DELLA), duchess of Ur-
bino, painted by Tiziano:
venitian school, first hall.

1119 ROVERE (DELLA) Francesco II, duke of Urbino. painted by Baroccio : in the Tribune.

1131 ROVERE (DELLA) pope Giulio. painted by Raffaello : in the Tribune.

576 SANSOVINO, sculptor and architect, painted by Tiziano : venitian school.

638 The same, paint. by Tintoretto : venit. school, second hall.

1251 SARPI fra Paolo, paint. by Volterrano : tuscan school, second hall.

1147 SARTO (DEL) Andrea, painted by himself : tuscan school, first hall.

1124 SCAPPI Evangelista, paint. by Francia Francois : in the Tribune.

— SEIMOUR-DAMNER Anna, a marble bust sculptured by herself : in a room of the Director's office.

688 SÉVIGNÉ (DE), marchioness, paintend by Mignard : french school.

1302 SFORZA Baptist, duchess of Urbino, and FREDERIC OF MONTEFELTRO, by Pietro della Francesca : hall of the old masters.

118 SFORZA Caterina, daughter of Galeazzo Sforza, and wife of John de' Medici, by an unknown painter : third corr.

675 SOUTHWELL Richard, painted by Holbein : flemish school, second hall.

647 STROZZI, the poet, painted by Tinelli : venitian school, second hall.

205 TASSO Torquato : hall of Baroccio.

1189 TOLEDO (DI) Eleanor, wife of Cosimo I, painted by Bronzino ; tusc. shool, first hall.

172 TOLEDO (DI) Eleanor, painted with her son Ferdinand I, by Bronzino : hall of Baroccio.

— TURENNE (the marshal of), pastello by Nanteuil : hall of cameos

599 VENIERO, venitian admiral, paintend by Tintoretto : venit. school, first hall.

1163 VERROCCHIO Andrea, painter and sculptor, painted by Lorenzo di Credi : tuscan school, first hall

784 ZUINGLIO, the swiss reformer, paitend by Holbein ; flemish school, first hall.

ND - #0016 - 160522 - C0 - 229/152/13 [15] - CB - 9780265458907 - Gloss Lamination